TABLE OF CONTENTS

EDITOR
LEON WIESELTIER

MANAGING EDITOR
CELESTE MARCUS

PUBLISHER
BILL REICHBLUM

JOURNAL DESIGN
WILLIAM VAN RODEN

WEB DESIGN
BRICK FACTORY

EDITORIAL ASSISTANT
DARIUS RUBIN

Liberties is a publication of the
Liberties Journal Foundation,
a nonpartisan 501(c)(3) organiza-
tion based in Washington, D.C.
devoted to educating the general
public about the history, current
trends, and possibilities of culture
and politics. The Foundation
seeks to inform today's cultural
and political leaders, deepen
the understanding of citizens,
and inspire the next generation
to participate in the democratic
process and public service.

Engage
To learn more please go to
libertiesjournal.com

Subscribe
To subscribe or with any questions
about your subscription, please go to
libertiesjournal.com

ISBN 979-8-9854302-3-3
ISSN 2692-3904

EDITORIAL OFFICES
1101 30th Street NW, Suite 310
Washington, DC 20007

DIGITAL
@READLIBERTIES
LIBERTIESJOURNAL.COM

Liberties

CARISSA VÉLIZ

The Technology of Bullshit

Apart from being sent to bed early, the worst part about being the youngest member of my family was that everyone around me could read except me. Even if I wasn't born into a bookish family, I could intuit the power of the written word. It allowed my mother to remember what she had to buy in the market. Notes passed between my brothers could elicit laughter. Note to self: written squiggles can tickle. I knew my father often stayed up late immersed in a novel. I remember staring at my brother for hours while he was doing homework, his eyes darting across the textbook in front of him, his pencil in hand bobbing over the notebook page, leaving mysterious symbols behind. I felt

excluded from what I knew was a world of meaning. "When can I learn how to read?" I asked on my first day of school.

Words enable us to read minds. Through them, we can communicate with various degrees of precision our innermost thoughts and our most visceral feelings. We can travel through space and time. Words allow us to learn from the dead and convey our knowledge to those who come after us; they allow us to overcome the geographical and temporal limits of our bodies. Words are vehicles through which we can plan and coordinate with others. Sentences and paragraphs are tools through which we enhance our cognitive capacities. Written language is one of our defining skills as human beings.

In 1950, the computer scientist Alan Turing imagined that, one day, written language might not be exclusive to human beings. In his "imitation game," Turing imagined human judges holding five-minute text-based conversations with a computer and a person, both of which were hidden. Could judges reliably tell which was the computer just through reading its text? If they couldn't, might that mean that the computer was thinking? This became known as the Turing Test. It was never meant to be a literal test for intelligence; it was a thought experiment. But it was suggestive enough to become a landmark. For several decades, the businessman Hugh Loebner funded an annual Turing Test event known as the Loebner Prize, which enacted the imitation game. These stopped for financial reasons after Loebner's death only a few years before the development of large language models.

Large language models disrupted the world in November 2022. OpenAI made ChatGPT available, and in a matter of days it was the main topic of conversation of every lunch and dinner I had, whether with friends or colleagues. What was unclear was whether much of the excitement was illusory —

little more than impressionable human beings feeling dazzled by the latest tech trick — or whether it was the product of glimpsing the sprouts of a revolution that will radically alter how we work and how we interact with technology. The question remains unanswered.

The shiny side of large language models includes the astounding feeling that one is talking to another person, and the hope that these imitators could work for us. College students salivated at the prospect of having them write their essays, and professors felt guiltily tempted to use them to mark those essays. Lawyers figured that they could use them to draft legal briefs (it turned out to be a bad idea). Doctors hypothesized about using them to write down notes about their appointments with patients. And who wouldn't want an AI to answer the billions of inane emails that we send one another? The main argument in favor of these systems, it seems, is the promise of greater efficiency and therefore greater productivity. In this sense, it is not different in kind from other mechanical devices that were invented to make life easier.

Except that it *is* different in kind. Delegating language to a statistical tool built by a company has its special shadows. One concern is that, by automating more of our life, we are losing skills to AI. "Use it or lose it," my Latin teacher said every time he assigned homework. He was right: decades later I have lost it entirely.

I'm writing these words on an airplane. It is cold and windy outside, and the pilot has mentioned the possibility of turbulence. If there is an emergency, I wonder, does the pilot have enough flying experience to know how to successfully navigate

it? On Continental Connection Flight 3407 in 2009, there was no mechanical failure. The captain had been distracted talking with the first officer. As they prepared for landing, they continued chatting, forgetting to monitor the airplane's airspeed and altitude. By the time the captain realized that they were in trouble, it was too late. No one on board survived. Similarly, on Asiana Airlines Flight 214 in 2013, a plane crashed because the pilots were not proficient in landing without the use of high-level automation. That day, part of the airport's instrument landing system that helps guide planes to the runway was out of service for repairs.

As flying has become more automated, pilots have been losing certain skills required to fly manually, such as navigating by reference to landmarks, calculating their speed and altitude, and being able to visualize the plane's position. They don't get to practice these skills enough. What's more, with automation, they have fewer details to worry about during flights; this induces boredom and mind-wandering, which in turn causes mistakes. When automation fails or necessitates human input, distracted pilots are less able to overcome risky situations.

Artificial intelligence is the ultimate kind of automation. The aspiration is to create a kind of intelligence that can take over as many of our tasks as possible. As we increasingly rely on AI in more spheres of life — from health and policing, finance to education, to everything in between — it is worth asking ourselves whether increased automation will lead to a loss of expertise, and to what extent that might be a problem. And the concern that technology might degrade our cognitive abilities is hardly new. In Plato's *Phaedrus*, Socrates argued that writing would cause people to rely too heavily on external sources rather than on their own memories and understanding:

[Writing] will atrophy people's memories. Trust in writing will make them remember things by relying on marks made by others, from outside themselves, not on their own inner resources, and so writing will make the things they have learnt disappear from their minds. Your invention is a potion for jogging the memory, not for remembering. You provide your students with the appearance of intelligence, not real intelligence. Because your students will be widely read, though without any contact with a teacher, they will seem to be men of wide knowledge, when they will usually be ignorant.

Socrates thought that writing could not provide the same level of understanding and dialogue that could be achieved from verbal communication, where ideas could be challenged and refined through conversation. In contrast to live dialogue, the written word lacked the ability to adapt to different contexts and therefore could be easily misinterpreted or misunderstood. Writing doesn't talk back:

The offspring of painting stand there as if alive, but if you ask them a question they maintain an aloof silence. It's the same with written words: you might think they were speaking as if they had some intelligence, but if you want an explanation of any of the things they're saying and you ask them about it, they just go on and on forever giving the same single piece of information.

Was Socrates right to be worried about writing? The anxiety about the consequences of the transition from oral communication to written communication may be found in the early history of many cultures. But I'm torn. On the one

hand, I feel fiercely defensive of the written word. Books allow you to live many lives in one, traveling to faraway places from the comfort of your couch, exploring ideas that might never have occurred to you, meeting people you would never have met. It was writing that kept Socrates alive for all these centuries. Thank you, Plato.

Writing has made it easier to accumulate and share knowledge. Even if our ancestors, who practiced various forms of "the art of memory," had prodigious powers of recollection, they would not have been able to memorize the whole Bodleian Library, to which I am lucky enough to have access. And sharing knowledge orally is much more inefficient. Not only does writing facilitate the accumulation and dissemination of knowledge; it also enhances thinking. The slowness of the writing process allows for paced reflection, and the possibility of editing invites fine-tuning. Having words on an external medium such as paper or a screen offloads cognitive processing, making it easier to sustain complicated arguments in one's (somewhat external) mind. Just as it is easier to perform a long mathematical computation with pencil and paper than in one's head, so it is easier to handle a complicated argument when you can see the premises and the conclusion in front of you. Writing is not only about expressing what is in your mind, but about figuring out what you think as you go along.

Yet Socrates was right in that writing has almost certainly damaged our memories. Centuries ago, people used to memorize the equivalent of whole books, word for word. Not too long ago people could recite long poems by heart. If you were born in the 1980s or before, you probably remember the time when it was normal to memorize dozens of phones numbers. I still remember the phone number of my childhood home, but I have to look at my mobile phone to give someone

11

my current phone number (which I have had for years).

Is memory important? If my phone is always with me, why does it matter if I can't remember my own number? One key element is reliability. The so-called extended mind theory proposes that our cognitive processes extend beyond our brain and body to include tools, technologies, and the environment we reliably interact with. If you were born before 1960, you are probably much better at arithmetic than younger generations who grew up with calculators. But younger generations don't seem hobbled by the weakening of this fundamental skill, because calculators are so easily attainable and so reliable. There is a calculator on my phone, so not being great at arithmetic isn't a big handicap. According to the extended mind theory, I have simply offloaded my arithmetic cognitive processes to my phone.

It follows that, when we come to think soberly about artificial intelligence, one important question that must be asked is whether it is reliable. If it is, then our losing some skills may not be a cause for great alarm. These new programs may be technically dazzling, but can we trust them? I can think of at least four ways in which AI can be unreliable. First, unlike calculators, AI is (currently) expensive. Running powerful systems takes a lot of computation, which in turn needs a lot of energy. And gadgets like phones and computers which use AI are likewise expensive. Chips, batteries, and devices rely on raw materials such as lithium, cobalt, and nickel, and these are finite resources that are now the stuff of geopolitical competition. They may eventually run out.

Moreover, most applications using AI are linked to the internet. Since AI needs considerable computing power and the capacity to store gargantuan amounts of data, it usually attaches to the cloud (to a remote server where heavy computa-

tion is carried out). Anything connected to the internet can potentially be hacked. Ransomware is an example of the risk. Two decades ago, factories, power plants, hospitals, airports and offices were operated with analog tools; these were usually more robust than our digital equivalent. Many of today's institutions no longer have the option to operate manually, or have not maintained employees' analog skills. When the metals and electricity company Norsk Hydro received a ransom demand, they managed to avoid shutting down by going manual, but only thanks to older employees and other workers who returned from retirement to help out. Twenty years from now, the generation that knows how to run things on analog will no longer be around. By letting pre-digital skills atrophy or disappear, we damage ourselves.

Third, AI can be unreliable because it is managed by a few powerful corporations. A company such as OpenAI could one day decide — it is, after all, a business — to increase their prices or to introduce exploitative terms and conditions, and if we have come to depend on their AI, we will be at their mercy. Alternatively, the company might be sold (as in the case of Twitter) and their algorithm could change for the worse without users having any control over it. Surely we have already had enough experience with the autocratic power of the tech super-corporations to be wary of being forever in a relationship of abject dependence upon them.

Finally, and most importantly, current AI has a profoundly unreliable relationship with the truth. The most popular kind of AI is based on machine learning. An AI such as ChatGPT works through statistically analyzing texts that it has been fed and generating convincing responses based on its training data. But it does not use logic and it is not tied to empirical evidence. It has no tools to track truth, no capabil-

ities for verification. As a result, it often "hallucinates," or fabricates plausible responses (based on its statistical analysis) that are nonetheless false. When I asked it to cite ten books by Carissa Véliz, it invented nine. What is most interesting, and potentially dangerous, is that it came up with plausible titles, given my specialization. Sometimes falsehoods that look closer to the truth may be more dangerous than falsehoods that are preposterous and wild.

If Socrates was the wisest person in ancient Greece, then large language models must be the most foolish systems in the modern world.

In his *Apology*, Plato tells the story of how Socrates' friend Chaerephon goes to visit the oracle at Delphi. Chaerephon asks the oracle whether there is anyone wiser than Socrates. The priestess responds that there is not: Socrates is the wisest of them all. At first, Socrates seems puzzled. How could he be the wisest, when there were so many other people who were well known for their knowledge and wisdom, and yet Socrates claims that he lacks both?

He makes it his mission to solve the mystery. He goes around interrogating a series of politicians, poets, and artisans (as philosophers do). And what does he find? Socrates' investigation reveals that those who claim to have knowledge either do not really know what they think they know, or else know far less than they proclaim to know. Socrates is the wisest, then, because he is aware of the limits of his own knowledge. He doesn't think he knows more than he does, and he doesn't claim to know more than he does.

How does that compare with large language models such

as ChatGPT4? In contrast to Socrates, large language models don't know what they don't know. These systems are not built to be truth-tracking. As I say, they are not based on empirical evidence or logic. They make statistical guesses that are very often wrong. Worse, large language models do not inform users that they are making statistical guesses. They present incorrect guesses with the same confidence as they present facts. Whatever you ask, they will come up with a confident response, and its response is never *I don't know*, even though it should be. If you ask ChatGPT about current events, it will remind you that it only has access to information up to September 2021 and it cannot browse the internet. For almost any other kind of question, it will venture a response that will often mix facts with confabulations. (Google is now trying to design its language model Bard to doubt itself, giving users the option to "double check" responses by clicking on sources or highlighting a lack of sources — a welcome add-on, but still an add on.)

The late Harry Frankfurt famously argued that bullshit is speech that is typically persuasive but is detached from a concern with the truth. Large language models are the mothers of all bullshitters, because they are designed to be plausible (and therefore convincing) with no regard for the truth. As the philosopher pointed out, bullshit doesn't need to be false. Sometimes bullshitters describe things as they are. The essential quality of bullshit is that it is indifferent to the question of truth. AI is being created and used with economic ambitions, not epistemological ones.

And bullshit can be dangerous, warned Frankfurt. Bullshit is a greater threat to the truth than to lies. The person who lies thinks that she knows what the truth is, and is therefore perversely concerned with the truth. She can be challenged

and held accountable; her agenda can be inferred. The truth-teller and the liar play on opposite sides of the same game, as Frankfurt puts it. The bullshitter, by contrast, pays no attention to the game. Truth is not even confronted; it is simply ignored; and so it becomes utterly irrelevant to the communication in question.

Bullshit is more dangerous the more persuasive it is, and large language models are persuasive by design, on two counts. First, they have analyzed enormous amounts of text, which allows them to make a statistical guess as to what is a likely appropriate response to the prompt that it has been given. In other words, it mimics the patterns that it has picked up in the texts that it has rifled through. Second, these systems are refined through a process known as reinforcement learning from human feedback (RLHF). The reward model has been trained directly from human feedback. Humans taught it what kinds of responses they prefer. Through numerous iterations, the system learns how to satisfy human beings' preferences, thereby becoming more and more persuasive.

As the proliferation of "fake news" and "alternative facts" has taught us, human beings do not always prefer truth. Falsity is often much more attractive than bland truths. We like good, exciting stories much more than we like truth. Large language models are analogous to a nightmare student, professor, or journalist: those who, instead of acknowledging the limits of their knowledge, try to wing it by bullshitting you. Artificial intelligence is a monstrous engine of confirmation bias. We must teach ourselves, therefore, a whole new level of suspicion.

16

The unreliability of artificial intelligence should make us think twice about the skills that we are losing to it. Even if AI were more reliable — cheap, easily available, unhackable and unpluggable, not in the hands of a few powerful corporations, and trustworthy — we might have reason to worry. Recall Socrates, writing, and memory. Even if our new external memories are more reliable than our old internal ones, we might still have lost something important by offloading much of memory onto the written word.

Memory and attention are related. The key to remembering something is being able to attend to it closely. If writing has weakened our memories, our attention spans have suffered, too—and maybe attention will be further eroded as digital tech continues to develop. As I write, my attention keeps jumping around — from the blank page to some references, from the latest news to a text message from my mom, from social media to a phone call, and half an hour later back to the blinking cursor on this page — all the while holding me back from the pleasurable state of flow that can kick in after hours of sustained concentration. It is possible that the attention span of the ancient Greeks was far superior to ours, and that with it came pleasurable experiences such as being in the moment and experiencing flow states more frequently than we do.

There is often an assumption that greater automation will give us the ability to focus on higher-level tasks. This seems unlikely to me. Thanks to the washing machine, I might not spend as much time washing clothes as my grandmother did, but I spend more time on email than she ever did washing clothes. And I bet she had more high-level thoughts while washing clothes than have while doing email. The experience of washing clothes — the feel of the water running through

your hands, for example — is also more pleasant for our embodied experience than staring at a screen. The suppression of our physical experience, alienation from tactility, does not make us wiser about the world—nor does it make us happier.

Chasing productivity hacks is a trap. Inventing a contraption — a washing machine or a calculator —may save time accomplishing particular tasks— washing clothes or doing arithmetic — but if we invent bureaucratic machines in an increasingly complex world, we might not end up with more high-quality time overall. Our technological devices for saving time turn out to be very time-consuming. We might end up spending our time personalizing our AIs, doing more two-factor authentication, solving captchas, saying "no" to online tracking, and the myriad other delights that digital tech has brought us. More time with AI is hardly time well spent. We should know better by now.

Going back to the concern about losing our abilities, automation might weaken or wipe-out some of the critical thinking skills that we gained when we chose to ignore Socrates and bargained away our memories. If we use chatbots to write for us, in a best-case scenario, we might get an acceptable product with a fraction of the time and effort that would have been demanded by writing manually, but we will have missed out on the process. As Cavafy famously observed about Ithaca, the journey is richer than the destination. The process of writing is a cognitive enhancer. Along with reading, it may be our most effective method of supercharging our thinking. Among the abilities that writing improves, moreover, is empathy. Writing asks you to put yourself in the reader's shoes. Will they understand what you are trying to communicate? Are you sure you aren't boring them to death? Are you being respectful enough to their possible points of view?

Social skills are some of the most valuable skills that we possess; they affect the moral quality of our society. But AI lacks them entirely, and we must be careful not to surrender them to it.

If students become used to relying on chatbots to write their essays, they might lose critical thinking skills, empathy, and creativity. Their essays might become (even more) full of common tropes and cliched observations. As AI retrains on the language that it produces (as opposed to human-made texts), it might become even more hallucinogenic. There is some evidence that large language models also become more sycophantic with time, telling us what we want to hear, and thereby deceiving and corrupting us in fundamental ways.

When we delegate speech to a machine built by a company, we might not only be losing abilities as individuals. We might be losing skills as a society, too. Democracy is a kind of ability, or at the very least it depends on a variety of skills, such as producing and consuming trustworthy information about the state of a country and the actions of its public officials. Democratic skills also include deliberation, voting, protesting, petitioning, having a rough idea of how the legal system works, and more. Democracy is a know-how much more than it is a know-that. And that know-how is largely a kind of conversation. There is no democracy if citizens do not talk to one another, and because we live in large communities in which we cannot talk to those who live in the opposite side of our country, we need radio, and TV, and writing to carry out that conversation. If we let the bots take over the conversation, we let them take over democracy.

In 2019 an article in the *Economist* warned that the stock market is dominated by algorithms. According to Deutsche

Bank, ninety percent of equity futures trades and eighty percent of cash-equity trades are carried out by algorithms, without any human input. That figure might be even higher now. But doesn't trading depend on what people value? Algorithms cannot value anything. At most, they can have items on a list prioritized in a certain way according to a number that represents weightiness. But entities that do not feel — that are not sentient — cannot value. Perhaps, someone might argue, they are merely mirroring what people value, or at least what the people who designed them value. Maybe. But the crash of 2:45 on May 6, 2010, which lasted thirty-six minutes, and other flash crashes that have followed, in which billions or trillions of dollars can disappear and reappear in minutes, suggests otherwise. We are making ourselves vulnerable.

And what are these bots anyway? They are not disembodied angels looking out for our best interests. They are machines created by corporations that are very eager to grow and earn more money. If we delegate speech to bots, we delegate democracy to corporations, because governments are not excelling at creating AI (or even at regulating it). In April 2023, the British government announced with great fanfare that it would spend a hundred million pounds (about a hundred and twenty five million dollars) in building and adopting the next generation of safe AI. It sounds impressive to the layperson, but AI doesn't come for cheap. Microsoft is investing ten billion into Open AI. Who do you think is going to produce the more useful AI? The corporations are winning at this enterprise, and they risk taking over speech, and therefore democracy.

The irony here is that businesses depend on democracy to thrive — good luck having a business in an authoritarian or an anarchic context — but they are not very good at taking

care of it. My sense is that the corporate culture of the 1950s allowed more leeway for corporations to think of themselves as having a duty to be good citizens. When I consult for companies, I try to remind them that, despite the corporate culture that is pressuring them to think only of the short-term interest of stockholders, it is in their long-term best interest to protect democracy.

And what happens when algorithms dominate not only the stock market, but also social media? Large language models are so efficient at producing speech that they could easily flood out content produced by human beings. And large language models are exceptionally good at creating misinformation. Money can continue to work as long as there are more genuine coins and bills than counterfeit ones, but the system breaks down if the fakes dominate. How will we protect truth when there is so much more untruth? How will we gauge public opinion when there are more bots than human beings?

Maybe algorithms will figure it out for us. They will tell us what other people think, and what's going on in the world. They might be able to tell apart human speech from bot speech. But remember, algorithms are not neutral. They are created by corporations, and often used by bad actors such as foreign adversaries wishing to sow discord and distrust. How will policymakers and average citizens distinguish between a bot and a human being?

Maybe we can uniquely identify human beings through biometrics, as Worldcoin is attempting to do through scanning people's irises. That way, every human being can prove that they are not a bot. In April 2022, an article in the *MIT Technology Review* called attention to the revealing fact that Worldcoin tended to do its data collection on people from disadvantaged countries and communities, often without

explaining the conditions to them. In May 2023, *TechCrunch* reported that hackers were able to steal passwords of several of Worldcoin's operators' devices. (Worldcoin claimed that no personal user data was stolen, this time anyway.) So far, in other words, the project seems like an ethical quagmire.

Even if a company were to collect that kind of personal data in a more ethical way, and managed to keep it secure, both of which are not easily done, having a company uniquely identify us is politically reckless. Companies might say that that data will only be used in very specific situations, but technology has a colonizing tendency. A few years ago, facial recognition was only used sparingly; today it is needed to unlock our phones. Social media companies, and stores, and banks, and governmental agencies of many kinds, will want to identify human beings too, and governments would love to get access to data that uniquely identifies everyone in the world. Think of how many times a machine took your picture the last time you cleared customs in any country. It is every autocrat's dream. The possibility of anonymity was crucial for the development of liberal democracies, and we are rapidly evaporating it through mass surveillance.

Above and beyond the problem of how to manage content produced by AI, and how to distinguish human speech from AI speech, if we allow algorithms to take over much of our systems might we be creating a world in which machines talk to one another in a language that is increasingly inaccessible to us? Already it is exceedingly difficult to audit algorithms, not least because they are millions of lines long, and so complex and self-modifying that they are largely inscrutable to computer scientists.

When code decides what we see online (from social media contexts to job offers and dating profiles), and when

algorithms decide what treatment we receive (from medicine to the justice system and beyond), and when we are not able to understand or contest those decisions, we are being excluded from the rules of the game. For democracy to function well, rules need to be publicly accessible and verifiable. If we cannot understand the rules by which we are governed or verify how they are applied, we end up in situations that approximate Kafka's bureaucratic nightmares, fending for ourselves in an impersonal maze that feels arbitrary and alienating. If we allow algorithms to dominate speech, we might end up feeling like my younger self, cut off from the world of language that rules our world. Writing will no longer be a way of reading minds, because there is no mind behind the text produced by large language models. Language is how we gauge other people and our social world, and how we come to have trust in others and in institutions. By building language tools that are designed to be impersonators, to mimic sentience, we are inviting confusion, misinformation, and mistrust. Artificial intelligence is no friend to democracy.

Plato's *Apology* suggests that we should build AI to be more like Socrates and less like bullshitters. We must not expect tech companies to design ethically out of their own good will. Silicon Valley is well known for its bullshitting abilities, and companies feel compelled to bullshit to stay competitive in that environment. That companies working in a corporate bullshitting environment create bullshitting products should hardly be surprising. One of the things that the past two decades have taught us is that tech needs at least as much regulation as any other industry, and history had already taught us that no industry can regulate itself. We regulate food, drugs, telecommunications, finance, transport: why would tech be the only unregulated industry in history?

Consider a recent cartoon by Tom Fishburne. "What will be the impact of ChatGPT on our business?" asks a woman. "There's a lot we don't know," answers a man, before enumerating a long list of doubts, from security and reputational risks to loss of jobs. "What do we know for sure?" asks the woman. And he replies: "Only that we want to adopt it everywhere as fast as we can." He is right. Here we are, eager to implement a technology for which we can think of more likely hazards than we can think of likely benefits. Is that wise?

24

RYAN RUBY

Reading and Time

Regrettably, I must begin with the quantitative — the least
Proustian of all categories. The six-volume Modern Library
Edition of D.J. Enright's revision of Terrance Kilmartin's
reworking of Andreas Mayor's and C.K. Moncrieff-Scott's
translation of Marcel Proust's *À la recherche du temps perdu*
is 4,347 pages long. At an average speed of two hundred and
fifty words, or one page, per minute, it takes approximately
seventy-two hours, or three days, to read it. But seventy-two
hours represents a theoretical minimum and an unattainable
ideal. Thanks to a few features of Proust's distinctive style,
reading *In Search of Lost Time* inevitably takes at least twice

or even three times as long as this.

There is, first of all, the famous Proustian sentence, whose syntactic cascades of independent and subordinate clauses were compared by Walter Benjamin, one of his first translators, to the flowing of the Nile. The longest of those riverine sentences, at nine-hundred and fifty-eight words in the original French, could, if printed out on a single strip of paper, be wrapped around the base of a wine bottle seventeen times. No one, except perhaps the most gifted mnemonist, can retain so much information in their short-term memory. By the time anyone else comes to the end of a sentence of this length, having meanwhile pulled into the port of more than one semicolon for a pause, its subject has been long forgotten. To understand what has been written, the reader is sent back to the point of departure and this, in turn, causes the pages not to move, or to move in the wrong direction.

Then there is the attention that Proust lavishes on seemingly insignificant details and physical spaces, such as the lengthy description of the steeple of Saint-Hilaire in *Swann's Way*; his stubborn willingness to stay in a scene, such as the interminable dinner party in *Guermantes Way* or the scene where the narrator watches Albertine sleeping in *The Captive*, long after another author would have cut away; and his penchant for discursive digression throughout, in which he inflates each Rochefoucauldian aperçu to the length of an essay by Montaigne. As with the multiclausal sentences, these traits of style have the effect of slowing down the pace. Articulating the frustrations of innumerable future readers, an editor at one of the many publishing houses that turned down *Swann's Way* is said to have remarked of the opening scene, "I fail to understand why a man needs thirty pages to describe how he tosses and turns in bed before falling asleep."

Most importantly, there is Proust's mania for comparisons: for metaphors, analogies, complex conceits, and extended similes, the signature sentences that begin "just as" or "as when." In a passage in *Time Regained* — we will return to it — Proust likens his book to a sort of "optical instrument" that enables the reader to read herself. The instrument works by stimulating a reader's tendency to draw analogies between the events in the book and the events of their lives, such that, for example, one recognizes in the mediocre Bloch or the vicious Madame Verdurin the features of social climbers one has known; or in Swann's unhappy affair with Odette, the time when one fell in love with a person not of one's type; or in the contrarianism which topples the Baron de Charlus from the pinnacle of Parisian society, the dialectic of cant and reaction that characterize our own. Owing to this, a frequent experience while reading *In Search of Lost Time* is to look up half-way through a sentence and stare into the middle distance in a kind of mnemonic reverie or "epiphanic swoon" (as the scholar and translator Christopher Prendergast puts it in his recent study *Living and Dying with Marcel Proust*), only to find, catching sight of a clock out of the corner of one's eye, that whole hours have passed.

Quantitative analysis may be regrettable; unfortunately, it is necessary. For it is the sheer length of *In Search of Lost Time*, compared to which *War and Peace* is but a diplomatic incident and *The Magic Mountain* is little more than a hillock, that turns the phrase "reading Proust" from the designation of an ordinary activity into a cultural superlative, the literary equivalent of climbing Everest, walking the Camino de Santiago, riding the Trans-Siberian Express, or even sailing the Nile. (On behalf of our eyes, we may all be grateful to the editor at Gallimard who talked Proust out of printing the novel in a single volume, with

two columns per page and no paragraph breaks.) One may note the delicious irony of treating a book which contains an utterly unsparing critique of snobbery as a "badge of bourgeois soul-distinction," in Prendergast's words, and at the same time sympathize with the "mid-cult pride," in the words of Fredric Jameson, felt by those who finish it, as well as the genuine or downplayed regret expressed by those who do not. (A further irony: Proust is not infrequently cited as the classic author whom contemporary novelists have not read in modified versions of the magazine questionnaire that bears his name.)

It is because of its length, which Proust hoped would rival the numerical-temporal *One Thousand and One Nights*, that *In Search of Lost Time* has acquired a reputation as a difficult book. Yet Proustian difficulty is not Joycean, Steinean, or Beckettian difficulty. Unlike *Finnegans Wake, The Making of Americans,* or *The Unnameable, In Search of Lost Time* is not a book that challenges our sense of what a novel is, only our sense of what a novel can do. Although it makes not inconsiderable demands on the concentration, memory, patience, and perseverance of its readers, it is roughly continuous with the form that the novel has taken since the days of Austen and Balzac. Its ultra-complicated sentences still follow grammatical rules; and while a certain degree of prior familiarity with French literature and history is helpful, understanding them at least does not require the reader to decode neologisms or catch recondite allusions. Although there is some critical controversy over the precise relationship between the first-person narrator and the book we are reading, it can still be fairly described as a *Kunstler-roman*, the familiar plot of a writer discovering his vocation. The nature of time and memory are its central concerns, and while one of the things the book asks us to do is to rearrange our conception of temporality, the order of the narrative does

not depart radically or unexpectedly from the order of events. One is never at a loss to say precisely what is going on in any given scene, which are set in a series of recognizable and historically specific locations — bedrooms, drawing rooms, kitchens, theaters, churches, brothels, public parks, boulevards, train carriages, the countryside — all of them more vividly realized than anywhere else in the history of the form.

Extreme affective and cognitive states, such as sadomasochism and pathological jealousy, are presented alongside more routine ones, such as wonder and disappointment, and are observed and analyzed according to the codes of a psychological and sociological realism notable only for its surpassing astuteness and wit. Although it is firmly anchored in a class to which none of its contemporary readers belong — the fashionable *monde* of the Faubourg St. Germain aristocracy — it touches on every sector of society, from the *haute-bourgeoisie* to which Swann belongs, to the professional middle class of the narrator's family, the Verdurins, and the "little band" of girls at Balbec and the lower middle-class of the shopkeeper Camus and the tailor Jupien; from the demi-monde of Odette and Rachel to the art worlds of the composer Venteuil, the actress Berma, the writer Bergotte, and the painter Elstir; from the memorable appearances made by the working class soldiers in Jupien's brothel to the peasantry, such as the milkmaid seen from the train to Balbec and the former peasantry, exemplified by the narrator's remarkable cook and nursemaid Françoise, one of the outstanding characters in twentieth century literature. In any case, as long as snobbery is a cross-class feature of social life, and possessiveness is a feature of romantic life, and the anticipation of our desires proves more pleasurable than their satisfaction, *In Search of Lost Time* will never lack for relevance.

Reading and Time

In fact, the major difficulty of reading *In Search of Lost Time* today is not placed there by Proust; it is placed there by the economy. If, for the novel's narrator, "lost time" refers to the past, for its reader, one hundred years after Proust's death, it refers to the present. Proust's narrator searches for time lost to the past and finds it in memory and in the creation of a literary work of art; Proust's twenty-first century reader searches for the time to read this literary work of art which is lost to a culture that is consecrated to speed and an economy at war with human-scale temporality and, more often than not, fails to find it.

"The primordial scarcity eradicated in the arrival of industrial modernity returns [in the twenty-first century] as the specter of time-famine," writes Mark McGurl in *Everything and Less*, his incisive study of the political economy of producing and consuming fiction in what he calls the Age of Amazon, perhaps the most extreme form of market society that history has ever known.

Consider the average day of a member of the social fragment that until very recently constituted the demographic core of the novel's American readership — the educated, salaried professional living in the suburbs of a large or mid-sized city — with its tripartite division of eight hours for sleep, eight hours for work, and eight hours for leisure. From that last eight hours, take away overtime; take away time for getting showered, dressed, and ready for work, and time for commuting to and from the office, and time for preparing food, eating it, and cleaning up afterward, and time for buying groceries, filling prescriptions, and picking up dry cleaning;

time for household chores and repairs; time for dentist's appointments, doctor's appointments, appointments at the stylist, scheduling future appointments; time for waiting in line and on hold; time for catching up on emails, making phone calls, paying bills, doing taxes, filling out forms and applications — that whole panoply of activities that falls under that rather sinister classification, "life admin." Of the original eight, perhaps only two or three hours remain, along with the parts of the weekend not devoted to sleep or other tasks such as these, the eleven public federal holidays, and the paltry eleven days of paid vacation that the average American worker receives. If one is responsible for taking care of children or someone who is ill, or if one is ill oneself, the amount of available time diminishes significantly across the board.

It gets worse. Within this finite number of hours, time must be found to perform the hundreds of activities which are regarded by corporations as further opportunities for monetization and value-extraction and by the people who do them as essential to a meaningful and fulfilled life. This includes, but is not limited to, time for socializing with friends, family, and one's current or potential romantic partner; time for attending weddings, funerals, and reunions; time for the maintenance and improvement of one's physical and mental health; time for travel and hobbies; time to go to the cinema, theater, concert hall, museum, dance club, or stadium; time for religious worship, political involvement, or participating in the community organizations of which one is a member.

Each of these non-work activities imposes a more-or-less steep opportunity cost on the others, and that is before we get to the locust-swarm of consumption that hoovers up an astonishing eight of the average American's waking hours, namely, non-print media: social media, digital streaming, video

sharing, online news, online retail, gaming, podcasts, radio, television, and so on. Although it can be inferred from this statistic that large amounts of digital media must be consumed by Americans at the office, extra time for leisure is invariably taken from sleep, as activities that cannot be concealed from one's boss while sitting at one's desk start to run up against the limitations imposed by biology on the functioning of the human organism.

Needless to say, the psychic conditions produced by such an organization of daily life —exhaustion, burnout, stress, anxiety, fear of missing out — are hardly conducive to fostering the mental state that an appreciation of Proust's style requires. It is challenging enough, after a day of paid and unpaid labor, to summon the concentration necessary to read passages of prose consisting of sentences several clauses long. Interruptions from other people, whether they are the ones we live with, or whether they come in the form of ring tones, text messages, push notifications, or street noise—not to mention the ambient distraction facilitated by "connectivity," that is, by the mere knowledge that at all times there is a node for possible information transfer and communication on one's bedstand or in one's pocket — are positively fatal to it. As attention diminishes, reading time increases, and along with it the likelihood the book will go unfinished, especially when there are so many less-demanding forms of entertainment immediately to hand.

Compared to "other forms of cultural consumption" such as social media or television, McGurl notes, "reading a novel is a relatively long-term commitment," which is why, according to a Pew survey in 2022, Americans read an average of fourteen books per year. (The typical, or median, American will read only five; and twenty-five percent of Americans

will read none at all.) And no novel requires a more substantial commitment than *In Search of Lost Time*. Someone who diligently set aside one hour every day to do nothing but read thirty pages of it could dispatch the six volumes in little over three months—not so much time in the grand scheme of things, a mere third of one percent of a modest seventy-five-year lifespan. But because of all the things that are competing for that hour — not forgetting, finally, the desire to read any of the five hundred thousand to one million titles brought out by the American publishing industry every year—the number stretches out to the more representative thirteen months it took the biographer Phyllis Rose, author of *The Year of Reading Proust: A Memoir in Real Time,* to finish it; or the eighteen months it took Deidre Lynch, Ernest Bernbaum Professor of Literature at Harvard University, to finish it; or the thirty-six months it took Mike Shuttleworth, a bookseller and literary events coordinator in Melbourne, Australia, to finish it. It is little wonder that so many people take a break to do or read something else, and find the prospect of returning to whichever point they left off or starting again from the beginning prohibitively daunting.

(Since few essays on Proust resist the temptation of a personal anecdote, I will add that, having over-ambitiously started the novel on three separate occasions in my teens and early twenties, in which I got no further than the aforementioned dinner party scene, my first full reading of *In Search of Lost Time*, according to the note I left on the last page of my copy, took place over the course of nine months when I was single, childless, largely unemployed, unable to afford other entertainment, and not on social media. What got me across the finish line was a severe depressive episode. On one particularly low January evening on the Brooklyn Bridge, I asked

myself what I would be missing out on if I jumped off. The answer came to me unbidden: I would never find out how *In Search of Lost Time* ended. I resolved, with a self-seriousness I can only smile at fifteen years later, to finish the book and then kill myself, but just as when Proust read Ruskin, when I read Proust "the universe suddenly regained infinite value in my eyes," and when I came to the book's last word, "time," on September 11, 2009, I no longer wanted to die.)

What, then, would be the ideal conditions for reading Proust? Spending "a month in the country" with *In Search of Lost Time* has become a fantasy as proverbial as it has become out-of-reach for even the relatively privileged people whose lives I have sketched above, but the pastoral setting, which recalls the bourgeois narrator's descriptions of his own leisurely reading experiences as a child in Combray, is in any case not dispositive. History furnishes us with a number of counterexamples, starting with the cork-lined bedroom on the second floor of the five-story apartment building at 102 Boulevard Haussmann, in the heart of Paris, where, in a frantic race of the pen against the scythe, the book was written. "The sad thing is," according to Proust's brother Robert, "that people have to be very ill or have a broken leg in order to have the opportunity to read *In Search of Lost Time*." In a similar vein, a character from Haruki Murakami's *IQ84* quips, "Unless you've had...opportunities" in life such as being in jail, "you can't read the whole of Proust." The Kolyma gulag, for instance, where Russian journalist and short-story writer Varlam Shalamov, who had been publicly critical of Stalin, read *Guermantes Way*; or the NKVDs infamous Lubyanka prison in Moscow, where the Polish poet Aleksander Wat read *Swann's Way*. Wat's compatriot, the painter Jósef Czapski, followed Robert Proust's advice and read the whole of *In Search of Lost*

Time while bedridden during a summer spent recovering from typhus; later, as a member of the Polish officer corps during World War II, he too was captured by the NKVD, and in the forced labor camp in a former monastery in Gryazovets to which he was sent he delivered a series of lectures on the novel to his fellow inmates, now published as *Lost Time: Lectures on Proust in a Soviet Prison Camp*, reconstructing long passages of it orally from memory like a latter-day Scheherazade. And in a different context, Daniel Genis, surely one of the best-read persons of our time, finished it, along with just over a thousand other books, while serving out a ten-year sentence for armed robbery at the Green Haven Correctional Facility in Stormville, New York.

If such examples of astonishing commitment to high art under involuntary confinement seem extreme, not the sort of experiences one is ever likely to have, I encourage you to Google "reading Proust during lockdown." Proust, who always feared that he did not live up to the expectations of his father, a well-regarded doctor specializing in infectious diseases and the author of a medical paper entitled "The Defense of Europe from the Plague," would have relished the opportunity to do so. What is essential in all of these cases is not that they are luxurious, or even minimally comfortable or safe; it is that each amounts to total physical removal from everyday life as organized according to the logic of the market and the dictates of capital accumulation. Needless to say, it does not speak well of our society that the two spaces where free time — which Proust's distant cousin Karl Marx defined as "idle time" as well as "time for higher activity" — is most readily available are the country house and the prison cell.

Proust has become the unlikely grandfather of a cottage industry of popular English-language non-fiction devoted to or inspired by his life and work. His name appears in the titles of memoirs (Rose's aforementioned *Year of Reading Proust*), self-help books (Alain de Botton's *How Proust Can Change Your Life*), pop-science (Jonah Lehrer's *Proust Was a Neuroscientist*, Marianne Wolf's *Proust and the Squid*), cookbooks (Shirley King's *Dining with Marcel Proust*), books of art history (Eric Karpeles' *Paintings in Proust*) and Jewish history (Benjamin Taylor's *Proust: The Search*, Saul Friedländer's *Proustian Uncertainties*), along with literary criticism aimed at a general audience (Malcolm Bowie's *Proust Among the Stars*, Anka Muhlstein's *Monsieur Proust's Library*, Christopher Prendergast's aforementioned *Living and Dying with Marcel Proust*, Jaqueline Rose's *Proust Among the Nations*, Michael Wood's *Marcel Proust*). The list could be easily expanded if one wanted to add short biographies such as those by Edmund White and Richard Davenport-Hines, guidebooks such as those by Roger Shattuck and Patrick Alexander, and compendia such as André Aciman's *The Proust Project,* not to mention the vast academic and scholarly literature on the subject. Whatever differences these books owe to their particular genres and target audiences, each of them is haunted to a more or less explicit degree by the question, Why read Proust? And hidden beneath that question is the blunter, Why read? And hidden, in turn, under that one is the rather more disquieting: Why do anything at all?

The standard answer is for pleasure. Reading, as the literary critic Christian Lorentzen likes to say, is a fundamentally hedonistic pursuit. On the substance, this is not wrong, and few authors make the case more convincingly than Proust himself: if there is a scene in the whole of literature

that provides more intense pleasure than the one in the Guermantes library in *Time Regained*, I have not read it. As a motive for reading, however, pleasure has always struck me as insufficiently persuasive, and even a kind of trap, in the context of a culture that, to this day, sees no more reason to prefer poetry to push-pin than Bentham did. To ask after the utility of works of art is not, as is generally thought, a legitimate form of philosophical skepticism; it is a form of cultural blackmail, and should probably be refused outright. In a healthy culture, the intrinsic value of works of art would be so obvious that it would never occur to anyone to need to justify their existence in terms of their usefulness. Ours, it goes without saying, is not a healthy culture, despite its obsession with physical and mental "wellness." Yet since the utilitarian devil is already here, it seems discourteous not to ask him to dance.

One may be tempted to invoke Mill's distinction between higher and lower pleasures here, and declare that it ought to be a matter of perfect indifference to the person who has access to *In Search of Lost Time* that someone else spends their finite hours on the planet with the minimal but at least immediate gratifications of Colleen Hoover's eleven *New York Times* bestsellers, with another installment of the Marvel Cinematic Universe, or doomscrolling Twitter. After all, Proust's position in the culture seems secure enough to weather the negative externalities that the contractions of American reading habits and the regression of secondary and post-secondary education ruthlessly impose on the production, acquisition, and consumption of equally challenging but less-canonical works of fiction: both the Modern Library edition of *In Search of Lost Time* and the more recent omnibus translation edited by Prendergast for Penguin remain, for now, in print, and are slowly being supplemented by new volumes, such as James

Greive's and Brian Nelson's new translations of *Swann's Way* as the novel enters the public domain.

Broadening our scope beyond the individual and the particular media that she does or do not consume, however, it is worth noting that pleasure is also the legitimating principle of market society itself, which promises the satisfaction of consumer demand at every price point. This promise is offered in exchange not simply for a refusal to guarantee necessary social goods such as affordable housing, health care, and education, but also for alternate ways of conceiving of value, such as meaningfulness, sacredness, honor, duty, and which are harder to quantify and therefore trickier to price. Increasingly, the promise goes unfulfilled: culture, like other sectors of the economy, is tending toward monopolization and, to use a wonderful term coined by the journalist and science fiction author Cory Doctorow, enshittification; in the absence of competition, there is little incentive for producers to risk the pleasures of novelty and experimentation on audiences that can be counted to pay for recycling and iteration, producing boredom and reactionary gestures of protest, not fundamentally different, as Proust or Benjamin might have observed, from those that were seen in the era of Baudelaire. A society whose greatest good is pleasure, of which ours is merely the most efficient, creates a culture in which pleasure is subject, on a long enough timeline, to diminishing marginal returns. In any case, as McGurl has shown, the negative externality imposed by market society on even the most canonically secure work of literature remains temporal: "The sped-up culture that delivers that novel to your doorstep overnight is the same culture that

deprives you of the time to read it." As such, not even the most discriminating reader will fail to feel its effects.

Why read Proust? The other answer typically given is: self-improvement. In different ways this is the claim Phyllis Rose and Alain de Botton, among others, make on behalf of *In Search of Lost Time*. (Even Prendergast, a more sophisticated reader, does not avoid it entirely: "Is Proust good for you? Might he even, in controlled doses, have a useful function...?") For Rose, reading Proust is a matter of demonstrating one's social status. A pure product of mid-century upward mobility, having progressed from the daughter of a lower-middle class shopkeeper in Long Island via Harvard, the Guggenheim Foundation, and the pre-conglomeration publishing industry to tenured faculty at Wesleyan College and via marriage to the *Babar*-cartoon fortune, Rose is astonishingly, even embarrassingly forthright about her identity as a consumer ("I want therefore I am. I am therefore I acquire"), her meritocratic metrics of value ("I would not have reached this level of achievement had I not made reading Proust the central business of my life"), and her extra-literary reasons for reading *In Search of Lost Time*. The final line of her memoir approvingly quotes her mother, who would have preferred her to have written something more commercial, coming to terms with her instead of writing about Proust: "She saw the book's potential, if not for making money, then for asserting our family's intellectual and educational superiority to certain of her acquaintances, about whom she confided, 'She's not one of our class dear. She doesn't read Proust.'"

This is not simply snobbery as Benjamin defines it — "the consistent, organized, steely view of life from the chemically pure standpoint of the consumer"; it is also antiquated. Less than three decades after Rose's *Year of Reading Proust* — whose

frequent appearance as an epithet in her memoir never fails to remind me of the corporate-branded years in *Infinite Jest*—the class of persons for whom reading once functioned as a mode of social distinction no longer exists in America. That class, now operating under relatively straitened circumstances, may still read the handful of literary fiction books whose marketing campaigns have deep enough pockets to secure them buzz, but is now more likely to be found discussing so-called "prestige" television or the infotainment passed off by cable news networks as genuine civic engagement. Their economic superiors have long realized that far from being a prerequisite to enter the most rarified social circles, cultural literacy is actually an impediment to it. That reading fiction—not to speak of high literature—is simply "what one does" if one wants to consider oneself a "cultured" or "educated" member of the "elite" no longer has the same degree of motivational purchase on the aspirations and the self-fashioning of upper-middle-class Americans as it did in Rose's generation.

Not that a general-audience book on Proust is necessarily a barrier to commercial success, if Alain de Botton's number one international bestseller *How Proust Can Change Your Life*, published the same year as Rose's memoir, is any indication. De Botton tapped into the market for a notion of self-improvement that has proved more enduring among the upper-middle-class than cultural literacy: therapy. His short manual is divided into nine chapters, each of which begins with a how-to title ("How to Live Life Today," "How to Be a Good Friend," "How to Be Happy in Love," etc.) and concludes with a "moral" or a "lesson" derived from the particular aspect of Proust's life or work considered in it. That some of these precepts are mildly counter-intuitive — he asks, for example, how we can learn to "suffer successfully" and be "productively unhappy"

rather than to avoid suffering altogether and achieve happiness — is a fig leaf placed on the attempt to flatter the reader into believing that they are not doing what they are in fact doing, namely, reading self-help.

Since the Greeks, philosophy and therapy have always occupied the same spectrum, much to the discomfort and consternation of the practitioners of the former. No less than Plato or Epictetus, Proust, as we will see, has therapeutic designs on his reader. De Botton is not wrong about one thing: reading *In Search of Lost Time* may change your life. (It saved mine, after all.) But a book like De Botton's is a useful illustration that the gulf between these two concepts of therapy is large enough to amount to a difference of kind. "Even the finest books deserve to be thrown aside," De Botton writes in the last line of *How Proust Can Change Your Life* — a compassionate observation, perhaps, but does his book inspire readers to pick up Proust in the first place? Whereas many of the books in the Proust cottage industry are intended as supplements to the reading of *In Search of Lost Time* — as a map to the vast territory of the masterpiece to be consulted before visiting or as the enjoyable account of another person's visit to the place one has just returned from — De Botton's is clearly intended as a substitute for it. John Updike's blurb on the back of my edition gives the game away: De Botton, he writes, "does us the service of rereading [Proust] on our behalf." That "re" is the sign of a bad conscience; what he's really saying is: De Botton has read Proust, so you don't have to.

In this respect, *How Proust Can Change Your Life* belongs to the same family of books as Roger Shattuck's, which recommends the parts of Proust that the reader can skip, or as Pierre Bayard's amusing *How to Talk About Books You Haven't Read*, where *In Search of Lost Time* is the primary example of a

41

skimmable book. They are all book-length versions of Monty Python's "All-England Summarize Proust Competition." Here a self-help book functions as a kind of time-saving appliance or device: by repackaging Proust in a series of pre-digested lessons or morals, De Botton offers the "experience" of *In Search of Lost Time* in the time required to read 215 pages rather than 4,347. But this is time considered in its purely quantitative aspect, under the sign of market society, which treats efficiency, cost-cutting, and convenience as high virtues. As such, it is counter-productive; indeed, a waste of time. *In Search of Lost Time* is also, in its own way, a time-saving device, if saving is used in the sense of redemption ("saving one's soul" rather than "saving money") and its length is not incidental to how it functions. For Proust's device to work, you must *actually* have the experience of reading it, from start to finish.

Proust gives his own answer to the question "why read Proust?" which incorporates the reader's legitimate desires for both pleasure and self-improvement, without, however, reducing his novel and the time spent reading it to commodities whose potential value is interchangeable with that produced by anything else on the market. In the passage from *Time Regained* to which I referred in the opening, which few books on Proust neglect to quote, he writes:

> In reality, every reader is, while he is reading, the reader of his own self. The writer's work is merely a kind of optical instrument which he offers the reader to enable him to discern what, without the book, he would have perhaps never experienced in himself. And the recogni-

tion by the reader in his own self of what the book says is the proof of its veracity.

The book is both mirror and lamp. Proust's optical instrument, as we have seen, works by inspiring the reader, through its extensive use of figurative language, to compare events in the novel to past events in her own life, which may have been forgotten; in other words, to stimulate the reader's capacity for memory. It is crucial to mention that, for Proust, memory is not the experience of the past *in* the present, it is the experience of the past *as* the present, an impression of the "identity between the present and the past...so strong that the moment I was reliving actually seemed to be in the present." He goes on to argue brilliantly that in the case of the *mémoire involuntaire* which he made famous, one is actually experiencing the putatively initial event *for the first time*, because it is only through memory that one comes to understand its significance in relation to all other events. "An experienced event is finite," Benjamin writes, but "a remembered event is infinite, because it is only a key to everything that happened before it and after it." Whereas finite time is, by definition, quantifiable, infinite time is not — and this is not because it goes on forever, but because no one but the person who experiences it can say how far into the past or the future it extends.

For each reader, the recalled events will of necessity be personal and therefore different; yet at the same time every reader will have at least one set of recollections in common, namely, the ones the narrator describes in *In Search of Lost Time*: the famous sequence, for example, in which his memories are triggered by the uneven paving stones, the sound of a spoon against a plate, the feeling of a napkin, and the sight of

43

George Sand's *François de Champi* As anyone will immediately understand who consults the prologue to Proust's *Contra Sainte-Beuve* — a hybrid of fiction and criticism that he wrote as he searched for the form of what would become his masterpiece — whose five pages contain *in nuce* many of the novel's most famous episodes, *In Search of Lost Time* cannot be any shorter than it is, because in order for Proust's optical instrument to simulate this experience of memory, enough time must have passed for the reader to forget their first encounters with the deceptively incidental details that Proust has seeded *sub rosa* in the earlier volumes for them finally to bloom into full significance in *Time Regained*.

The scene in which these recollections unfold — the narrator arrives late to the final party of the Princesse de Guermantes and is made to wait until a pause between the movements of the Vinteuil sonata permits her to enter the drawing room — is the fastest paced episode in the entire novel. It is not for nothing that it largely takes place in a library, since that is what the narrator compares the self to — a collection of forgotten days which memory takes from the shelf and dusts off. Crashing like wave after wave on narrator and reader alike, the series of recollections produces what can only be described as ecstasy. This is ecstasy not only in the sense of intense pleasure, but relatedly, in the original sense of the word, which was used primarily in the context of sacred or religious experience, *ek-stasis*, or standing outside oneself. Following Benjamin, Jameson notes that this doubly ecstatic experience is fundamentally temporal in nature: the narrator feels and the reader is made to feel along with him the rapture of standing outside time. Proust writes: "one minute freed from the order of time has recreated in us, in order to feel it, the man freed from the order of time."

The order of time is biological: the always finite number of minutes afforded to each living being. To be freed from it, if only for a minute, allows one an intimation of immortality, the longing for which, Proust says, can only be removed by death itself. But the order of time is also — and at the same time — social: the temporal regime constructed by the particular political economy into which a biological self finds itself thrown. Born in 1871, in the year of the Paris Commune at the outset of the second industrial revolution, Proust belonged to one of the first generations to experience the transportation technologies, such as the railroad and the automobile, and the communications technologies, such as the telephone, about which he writes so memorably, whose abilities to compress time and space have culminated in our own vertiginous market society. From the point of view of market society, there is or ought to be no such thing as being freed from the order of time, that is, time freed from generating value for someone else, whether directly, through one's work or one's purchases, or indirectly, through the built environment in which one is involuntarily bombarded by advertisement or through the attentional and behavioral data that can be harvested for a profit whenever one is connected via computer, mobile phone, e-reader, or wearable to the internet.

Just as everything about market society seems designed to get in the way of reading Proust, reading Proust gets in the way of participating in market society. As long as you buy it, Proust's novel remains a commodity, but as long as you are reading it on paper — and reading yourself in the meantime — you are not generating further material profit. Indeed, while you are reading Proust you and your time are quite literally operating at a loss. In the grand scheme of things, regaining your time from the market may amount to a negligible act

of resistance to it, but one could find a worse benchmark for what constitutes a free society. A free society will be one in which everyone, if they so choose, has the time to read *In Search of Lost Time*.

MICHAEL WALZER

Notes on a Dangerous Mistake

Several groups of rightwing intellectuals hover around the Republican Party, defending a stark conservatism. But there is a very different group, definitely rightwing, that is equally disdainful of Republican conservatives and Democratic progressives — who are all at bottom, its members insist, liberals: classical free-market liberals or egalitarian liberals, it's all the same. These ideological outliers call themselves "post-liberal," and they aim at a radical transformation of American society. Their overweening ambition is based on a fully developed theology, Catholic integralism, but the political meaning of this theology has not yet been fully worked out or, better,

not yet revealed. A small group of writers, mostly academics, constitute what they hope, and I hope not, is the vanguard of a new regime and a Christian society. They have mounted a steady assault on liberal individualism and the liberal state, but so far they haven't had anything like enough to say about life in the post-liberal world — not enough to warrant a comprehensive critique.

So here, instead, is a series of critical vignettes dealing first with the style of post-liberal writing as displayed in the work of Sohrab Ahmari and then with the strange version of world history that Patrick Deneen asserts but never defends. My own defense of liberalism comes later, along with a critique of recent post-liberal writing on the Ukraine war and some worries about the cautiously reticent, but sometimes ominous, description of the post-liberal future that can be found in the books of Patrick Deneen and Adrian Vermeule. For now, I ignore all the other post-liberals.

Sohrab Ahmari, the leading non-academic among the post-liberals, makes his argument for "the wisdom of tradition" through stories of great men; only one woman and one married couple are included in the twelve chapters of his book *The Unbroken Thread,* which appeared in 2021. These are nicely told but highly contrived stories, with radical omissions and crucial questions left unanswered. Three examples will serve to show the tribulations of tradition.

Ahmari uses (the verb is right) Augustine to discuss the issue of God and politics. His story is focused on Augustine's efforts to respond both to the rise of neo-paganism after the sack of Rome and to the Manichean heresy. The question that

Ahmari poses is the great question of Augustinian politics: should Christians call on the secular authorities to use force against heretics and unbelievers? Augustine, with hesitation, ends by saying yes; Ahmari ends by saying...not quite yes. This is a common feature of post-liberal writing: just when Ahmari should show his hand, he covers his cards. I suppose that a defender of traditional wisdom, making his case in the United States today, can't quite bring himself to call for religious persecution. His claim is simply that God "needs" politics — but exactly what is needed is left unspecified. Ahmari's heart yearns for a strong Christian ruler who would set things right: "a godly servant ruler." But his mind counsels prudence, and so he is unwilling to tell us exactly what the wisdom of tradition requires today.

Cardinal Newman is used by Ahmari to address the problem of critical thinking — which, from a traditional point of view, is indeed a problem. Should we think for ourselves? Should I follow my conscience? Late in his life, Newman responded to William Gladstone's polemic against the doctrine of papal infallibility. Gladstone claimed that any Catholic who accepted the doctrine rendered himself incapable of thinking critically, unable to follow his conscience — and therefore not a useful citizen of a free state. Now remember that Newman had, after years of agonized reflection, followed his conscience and left the Church of England. Nonetheless, according to Ahmari, he now argued that conscience is not a matter for individual reflection; it is God's truth implanted within us, and we need the help of churchly authority and Christian tradition to recognize the truth and understand what conscience requires. But then how did Newman manage to defy the authority and tradition of the Church of England? This seems an obvious question, which

Ahmari doesn't ask. Didn't Anglicans think Newman a man of extravagant self-will? Surely he was guilty of thinking for himself. Why not, then, the rest of us?

Rabbi Abraham Joshua Heschel is used by Ahmari to teach that God wants us to "take a day off." Indeed, Heschel wrote eloquently about the importance of the Sabbath. But he wrote even more eloquently about prophetic Judaism, Hasidic spirituality (he was the scion of a great Hasidic lineage), and social justice. Ahmari has little to say about the last of these, though he does tell us that Heschel believed that "a God-centric...understanding was the only sure guarantee of social justice and human dignity." This understanding led Heschel to a life of intense political activism in the course of which we learned, and I think he learned, that the "only" in Ahmari's sentence doesn't accurately describe the political world. Famously, Heschel marched with Martin Luther King, Jr., but the Jews who marched with him were not his fellow Hasidim. Reform rabbis marched with him and, in large numbers, secular Jews. The ones I knew did not have a God-centric understanding, though they were fiercely committed to social justice. And it should be noted that the fight for the forty-hour week — two days off! — was led by largely secular leftists. Of course, Heschel had, and Ahmari has, a clear view of how the day off should be spent. But only Ahmari, I suspect, would endorse the traditional wisdom that Sabbath observance should be enforced by the political authorities. Naturally, he doesn't quite say this.

In *Why Liberalism Failed,* published in 2018, Patrick Deneen provides us with a monocausal and idealist account of modern

history. Liberal ideas are inevitably (a word he likes) the cause of all the achievements and all the pathologies of modernity — the pathologies most importantly. He never engages with any alternative accounts, never considers other possible histories of the troubles he describes. I want to take up just a few.

The most remarkable omission is the Protestant Reformation, the whole of it, which is never mentioned in Deneen's book. His standard contrast is between classical and Christian (specifically Catholic) values, on the one hand, and liberalism on the other, and this leaves no space for Protestantism, whose major leaders, Luther and Calvin, while certainly not liberals, anticipated, along with their followers, many of the liberal ideas that Deneen identifies and deplores. Consider just these three: the conscientious individual, who thinks for himself (and more dangerously, for herself); the "gathered" congregation, an entirely voluntary association; and the critique of hierarchy, the call for a "priesthood of all believers." These three concepts are surely rooted in Christian values, though certainly not in Deneen's values, since they lead (inevitably?) to the English revolution, the execution of the king, the proliferation of increasingly radical sects, Milton's defense of divorce, Cromwell's dictatorship, and the Puritans of New England who supported the American revolution — which was definitely a liberal project. Deneen could write a book, though he won't, asking why Protestantism failed.

Modern science is also omitted, since Deneen recognizes no independent historical development; he seems to believe that science is the creation of presumptuous liberals and their ambition to "conquer nature." This ambition, he insists, is radically new; he contrasts it with the classical and Christian understanding of, and "passive acquiescence" in, nature's limits. Break with the limits and you get both natural and

51

social disasters: climate change, pandemics, Big Pharma, genetic engineering, abortion. But has humanity ever chosen to live within nature's limits? I don't think that history can be read that way. The ancient Egyptians, for example, didn't simply live with the Nile's annual flooding; they built an elaborate irrigation system that required management and control — and produced more food, a growing population, the absolutism of the Pharaohs, the house of bondage, and the enslavement of the Israelites (not to mention locusts, darkness, waters turned to blood, etc.). The ancient Greeks were not content with the human ability to swim; they designed and built ships and conscripted rowers, which led to international trade, wars, the Athenian empire, the massacre of the men of Melos, and the foolish decision to invade Sicily. Even medieval Christians, not content with the body's natural frailty, invented body armor and the longbow, making it possible for Christian knights to rescue maidens in distress — leading also to the brutalities of crusading warfare. None of this had anything to do with liberalism.

One specific form of modern science, medicine, is the cause of much of what Deneen laments. The enormous expansion of our capacity to prevent and heal disease has shifted the attention of most of us from eternity to longevity (another break with the classical and Christian sense of limits: see Ahmari on "what's good about death") and opened the way for a vast expansion of the earth's population. Here is a major cause of the size and scope of the modern state — on which liberalism has been, if anything, a constraint. Deneen argues that individual freedom and the chaos that it creates leads inevitably to bureaucratic regulation and statism, but the sheer number of individuals must also be a factor. Of course, if they all knew their place, and stayed in it, died at three score and ten

(or, better, long before), thought only about eternity while they were alive, and accepted the authority of the Church — well, a smaller state might suffice. But Deneen's description of the small communities and local commitments that post-liberalism would require makes no room for our contemporary millions. In any case, localism has had a short life among the post-liberals.

One more omission from Deneen's history: he treats capitalism as a liberal creation. Capitalism, in Deneen's telling, was the inevitable result of what Thomas Hobbes in *Leviathan* calls the individual's unconstrained and unlimited "pursuit of power after power." Not so fast. In truth, those words perfectly fit, and were intended by Hobbes to fit, the contending patricians of republican Rome and the feudal lords of Christian Europe. In any case, capitalism surely has a history of its own. I don't mean to commit myself to a monocausal materialism, only to insist that material factors — class conflict, available technology, ownership of land and capital — played a part in producing the modern economic system. Max Weber thought that Protestant theology — most importantly the (definitely illiberal) doctrine of predestination — also had a lot to do with the success of capitalism. It provided a motive for hard work and profit-seeking, which liberalism does not, and a doctrine that fits the mentality of what I still think of as "the rising bourgeoisie." Now consider Marx's famous description of the effects of capitalist activity: "All fixed fast-frozen relations with their train of ancient and venerable prejudices and opinions are swept away...All that is solid melts into air, all that is holy is profaned..." This is pretty close to Deneen's account of what liberalism does. Marx provides a fairly plausible alternative.

If I were writing a different article, I would argue that many of the ills of American society derive from an unregulated and

53

radically illiberal capitalism. Unexpectedly, Ahmari, in his newest book, *Tyranny, Inc.*, makes exactly this argument with a series of vivid stories about capitalist predation. He is now a post-neo-liberal and even a social democrat. We are never told how all this fits with the "wisdom of tradition."

Very little is said about the past in post-liberal texts. Deneen does acknowledge that the world before liberalism was a time of "extensive practices of slavery, bondage, inequality, disregard for the contributions of women, and arbitrary forms of hierarchy and the application of law." But he has little to say about these "practices" and less to say about the euphemistic "disregard" of women's "contributions," which he doesn't bother to describe. More importantly, he offers no explanation of how all these evils co-existed with "classical and Christian thought and practice," supposedly dominant in the pre-liberal age. Again and again, post-liberals contrast a classical and Christian age of political order, strong families, communities living within natural limits, individuals who respect tradition and recognize authority — with a destructive liberalism. But then they decline to give us what we surely need if we are to accept their account, which is a concrete historical description of this lost world.

Consider a few key moments. I will focus on family life, since it is a central contention of all the post-liberals that liberalism has destroyed the family. Indeed, this focus is common among opponents of liberalism the world over. Thus Vladimir Putin, in a recent decree on spiritual and moral values, denounced the American and Western "destruction of the traditional family through the promotion of nontraditional sexual relations."

What traditional family?

— The family in ancient Athens was certainly strong: women were harshly subordinated and even secluded; they had no presence in the public life of the city. Men, by contrast, were out and about, politically active, sexually free. Deneen is a fierce opponent of sexual freedom (which he takes to be the inevitable product of liberal individualism), but perhaps only when it extends to women. In any case, he never tells us about the boy prostitutes and their male clients who somehow coexisted with classical philosophy.

— The accounts of family life among patricians in the Roman republic and, later on, inside the imperial palace suggest a society in which it is your relatives who kill you. The post-liberals disapprove, I am sure, but they don't discuss. How was this sort of thing possible given classical ideas about self-restraint? The use and abuse of male and female slaves was also, it seems, consistent with classical family values.

— Family life in medieval Europe was shaped by the feudal hierarchy, which determined the everyday misery of the Christian men and women who lived at its lowest level. The serfs were offered eternity, but their lives were brutal and short. Their families were radically insecure. Women died in childbirth in large numbers, and men remarried, mostly younger women, girls, really, who rarely chose their husbands and were instantly pregnant, and pregnant again. The high rate of pregnancy wasn't a sign of the pre-liberal commitment to what Adrian Vermeule calls the "traditional multi-generational family"; it followed from the even higher rate of infant death. The women certainly didn't have time to think about divorce, which wasn't thinkable anyway (and, according to the post-liberals, shouldn't have been); many families were already "broken," many children abandoned by impoverished

and desperate parents. (Remember the Children's Crusade.) It is hard to imagine these families as a happy alternative to life under liberalism. And please consider the *droit de seigneur*, the feudal lord's claim on the virginity of any of his serfs' daughters. This is a natural feature of the feudal hierarchy, and definitely an assault on family values. I am sure that Christian theologians condemned the practice, if they ever thought about it, but so far as I can tell parish priests did nothing to oppose it — they were underlings themselves in a parallel hierarchy.

— The family that post-liberals love is not the family of the classical age or of medieval Christendom. In fact, it is the bourgeois family, which was the creation of eighteenth and nineteenth century liberals. Consider the critique of aristo-cratic libertinism, the end of arranged marriage, the possibility of romantic love, the patriarchal home that was every man's castle — all this was liberalism at work. The problem for post-liberals is that the work goes on. The stereotypical bourgeois family included an employed man and a woman at home, caring for at least two children. Actually, large numbers of women worked outside the home — on farms, for example (post-liberals like to celebrate the family farm), as secretaries and teachers, and in the sweatshops of the garment trades. And since in liberal times women are allowed to think for themselves, they began to seek wider roles, not only in the economy but also in the polity. Deluded by liberalism, Deneen writes, they sought "emancipation from their biology" — hence (inevitably) divorce, broken families, and abandoned children. I assume that men who share in the housework and sometimes look after the children have also forsaken their biological destiny. Yes, the liberal/bourgeois family was better than any of the families we know about in the age when

classical and Christian values were dominant. It's just that the post-liberal conception of "biology" is not the end of the story.

Please note that what I have written above about classical and medieval times is a fairly generous account of the history that post-liberals ignore. I didn't say anything about the Crusades or the Inquisition, both of which were surely the direct consequence of established Christian (Catholic) values. Nor have I tried to imagine myself in medieval Europe, a Jew expelled or murdered in the name of religion. Perhaps post-liberals would claim that all this was a radical distortion of Christian charity. But if that's right (and I acknowledge the importance of charity in Christian thought), then why can't liberals say that Deneen isn't describing the consequences of liberal ideology but rather the distortions of it? (This assumes that his description is accurate, which it often isn't.) In any case, the post-liberals owe us a frank accounting of everything — including all the ugliness — that went along with classical and Christian thought and practice. Actually, a reader of Vermeule might think that something like a religiously inquisitive state is what some of the post-liberals have in mind (see below) — though there must be liberal post-liberals who would shrink from that.

There is something very strange about the vehemence of the post-liberal critique of liberalism. Consider these sentences from Deneen:

> Unlike the visibly authoritarian regimes that arose in dedication to advancing the ideologies of fascism and communism, liberalism is less visibly ideological and

only surreptitiously remakes the world in its image. In contrast to its crueler competitor ideologies, liberalism is more insidious…

Let's parse this. Liberalism is an almost, not quite, invisible ideology, less cruel than fascism and communism (but cruel enough?) that insidiously advances its authoritarian project of remaking the world. Since Deneen lives in this remade world, we can examine some of its features. The Catholic university where he teaches benefits from tax exemptions and federal grants from the insidiously liberal state. He says what he likes in his classes and publishes uncensored books with a major university press. If he lectures at another university and is shouted down by hostile students (as he might be), it is liberals like me who rush to his defense in the name of free speech and academic freedom, which are historically liberal values. He has never had to worry about the secret police knocking on his door in the middle of the night. He and all the other post-liberals write for magazines that are delivered across the country by the state-run post office. He has a passport and is free to visit Orban's Hungary and return whenever he likes. He may be required to wear a mask in a time of pandemic, but he is free to organize a protest against this example of liberal authoritarianism.

Fascism and communism are indeed more cruel.

For all that, there certainly is much that is wrong with American life today, and many of the things that the post-liberals criticize require criticism: extreme inequality, the ravaged ecosystem, high rates of drug addiction and suicide, the "left behind" communities of the Rust Belt, meritocratic arrogance, and

more. All this is, according to Deneen, caused by liberalism, but Ahmari ascribes much of it to a predatory capitalism and argues for strong unions and something like a New Deal state. His new book, dedicated to Deneen and Vermeule (among others), suggests the possibility of a post-liberal alliance with union activists and green militants. But I find it hard to imagine that he and his friends could ever work closely with secular leftists, as liberation theologians and worker priests did in their time.

Why are they unlikely to imitate those exemplary Christians? Liberal egalitarians believe in and are fighting for a society of free and equal individuals. Post-liberals do not aim at that kind of freedom or equality. Here is their central argument: free individuals are not really free unless they freely decide to do the right things — unless, writes Ahmari, their conscience is guided by the Church. "Liberty," Vermeule insists, "is no mere power of arbitrary choice, but the faculty of choosing the common good." But who defines the common good? Not us, arguing among ourselves. Ordinary men and women, you and I, won't know or choose the common good unless we are guided from above by a new elite committed to traditional — classical and Christian — values. We have no right to get it wrong. So the hierarchies created, post-liberals claim, by liberalism must give way to a new and more simple hierarchy of the wise who know and the simple who don't, the few and the many, "the great and the ordinary" — a cadre of men (and women?) with the right values at the top and a mass of good-natured commoners looking up. The problem with liberal individuals, of course, is that they don't look up for guidance and instruction. Here is a liberal tradition: not looking up.

59

In a new book published late last year called Regime Change, Deneen provides a concise description of the post-liberal future:

> What is needed is a mixing of the high and the low, the few and the many, in which the few consciously take on the role of aristoi, a class of people who, through supporting and elevating the common good that under-girds human flourishing, are worthy of emulation and, in turn, elevates the lives, aspirations, and vision of ordinary people.

This new elite, Deneen believes, will be brought to power by a new political force: the world-wide populist opposition to the rule of "gentry liberals and the laptop class." He acknowledges that "this movement from below is untutored and ill led," but it holds great political promise. Its members are the "many"; Deneen '23 regularly calls them the "working class," a term that I don't believe Deneen '18 ever used. They are working men, preferably self-employed, carpenters, plumbers, electricians, and stay-at-home women, the embodiment of traditional values: family and faith. They have supported Donald Trump, Deneen '23 says, but he hopes that they are waiting for the aristoi.

The coming aristocrats are never given proper names, but I assume they are the post-liberal intellectuals. Like any vanguard, its members are the people who understand its necessity. They will tutor the working class but also, they promise, be restrained by its common sense. Deneen sometimes sounds like a social democrat, describing the critical role of the working class; he argues for strong unions (and, a little mysteriously, strong guilds) and a decentralization of the liberal state. Ahmari is an actual social democrat and a supporter of the labor movement, but if he stands with his

fellow post-liberals, he must believe that when they come to power the voice of labor will mostly be advisory — to remind the aristoi of traditional values and ordinary virtues. Deneen is amazingly patronizing toward the newly discovered workers.

We are never told how the working class might actually exercise political power. Vermeule writes instead that the influence of the lower orders, the ordinary folk, will work through representation and consultation — it is "what one might call *democracy without voting*" (Vermeule's italics). Deneen '23 is equally explicit about the liberal idea of government by the consent of the governed. He argues for a "preliberal" idea: "the consent of a community to govern itself through the slow accumulation and sedimentation of norms and practices over time." This is far preferable to the actual agreement of "deracinated" men and women (like you and me) as in "the liberal social contract tradition." Note the unintended concession that this is a tradition. Ahmari could have written about it in a chapter focusing, say, on John Locke or John Rawls. That thread is unbroken.

Democracy without voting doesn't sound democratic. We can get a better idea of the post-liberal view of democracy by looking at what Ahmari and Deneen have written about the Ukraine war. Sometimes they are simple isolationists, as when Ahmari calls Ukraine "a country long acknowledged not to implicate core US interests." But he himself is strongly engaged. He thinks Ukraine belongs, by nature or destiny, in the Russian sphere of influence. "The rights of nations," he writes, "are circumscribed by geography, history, economics, chance. Above all, by power... Ukraine's 'friends' sadly led her

to believe she could escape these laws." (I immediately thought: the rights of women are circumscribed by nature and by power. Feminists sadly led them to believe...) Ahmari signed a petition that called the Ukrainians "victims of the [Western] attempt to bog down Moscow in a long, devastating insurgency." "Victims" is the most generous term for the Ukrainians that I have found in post-liberal tweets, articles, and interviews. For Deneen, Ukraine is a "pawn of American gnostic dynamics" (I will have to explain that). What is missing in post-liberal writing is any recognition of the Ukrainians as political agents, who have created a democratic state and are now fighting to defend it.

Patrick Deneen has written a long essay, inspired by one of Eric Voegelin's books, on the role of gnosticism in the Ukraine war. Voegelin was a German-American political philosopher who died in 1985 and was interested in the ontological implications of modern ideologies. The gnostics were Christian heretics who denied Augustine's distinction between the City of God and the City of Man and sought a messianic transformation of the earthly city. Voegelin despised Gnosticism for its pretension to a privileged and irrefutable apprehension of sacred knowledge and its impatience to act politically on this revelation, and he devoted many writings to finding its traces in modern politics. He believed that fascists and communists were modern secular gnostics. Now Deneen weirdly adds American liberals to that group. "What was once a 'reformist left' is today a radicalized messianic party advancing its gnostic vision amid the ruins of Christian civilization." This messianic party is one side, the Western side, of the Ukraine war. On the other side, also described in Voegelin's terms, stands the Russian Orthodox Church, a pagan, that is, civic or national version of Christianity, led by secular authorities, like the czar and now the president. Deneen does not explicitly choose sides

in this conflict; he would prefer an Augustinian intervention. But all his anger is directed against the alleged liberal gnostics.

My favorite line in Deneen's epic essay comes when he warns the Ukrainians that the American messianists will in the end discard "Ukraine's blue and yellow for a rainbow flag." Think about that. Surely gay Ukrainians are already flying the rainbow flag, and they would rightly deny that it is in any way incompatible with the national flag. I don't think that Deneen is lost here or that he misunderstands. His vision, which he assumes "ordinary" Ukrainians share, is of a divinely sanctioned society of pious, right-thinking heterosexual men and women—and no visible others. A liberal democracy is more inclusive; it allows for, encourages, a pluralism of flags.

Though the post-liberals have little to say about working class activism, they have a lot to say about the authority of the new elite. Here it is important to notice a break between the accounts of post-liberalism in Deneen '18 and Deneen '23. In the first book, Deneen offers us an escapist picture of the future that he hopes for: post-liberals will leave hegemonic liberalism and the authoritarian state behind; they will live together in small communities, in tight families, accepting nature's limits, following the old classical and Christian traditions. This is the "Benedict Option." No conscientious individuals, no questing scientists, no capitalist entrepreneurs, no intrusive state bureaucrats, and also no social gospel and no Christian involvement in the larger society — a kind of backward-looking, inwardly focused, secessionist communitarianism. More recently, in his 2023 book, written perhaps under the influence of the openly statist Vermeule, Deneen brings the intrusive

bureaucrats back. What matters, it turns out, is that they are now true aristocrats, men (and women?) who are committed to classical and Christian values. Given what Ahmari calls "godly servant rulers," everything else follows.

Deneen '23 argues that the "regime change" he seeks "must begin with the raw assertion of political power by a new generation of political actors inspired by an ethos of common good conservatism." Vermeule, in his recent book *Common Good Constitutionalism*, gives us a pretty clear sense of what that raw assertion would look like. He provides a strong defense of the administrative state (when it is in the right hands) — which includes a list of the liberal constraints on state power that he means to leave behind. For example: the liberal axiom "that the enforcement of public morals and of public piety is foreign to our constitutional order." For example: the libertarian assumption "that government is forbidden to judge the quality and moral worth of public speech." For example: the liberal idea that good government should "aim at maximizing individual autonomy or minimizing the abuse of power." Instead, he writes, the aim should be "to ensure that the ruler has both the authority and the duty to rule well" — that is, to enforce public piety and regulate public speech (and prevent abortion, ban gay marriage, encourage "traditional" families and enthusiastic reproduction).

What would life be like for "ordinary" people in the post-liberal age? Everyone who has written about Deneen, Vermeule, and company agrees that they are disturbingly vague about this. But even ordinary readers can make out a rough picture of what post-liberalism would mean for you and me. Looking up, accepting the guidance of the aristoi, we would lead simple, happy lives, working (for a living wage, so that women can stay at home), praying, raising lots of children. Deneen likes the

64

Hungarian policy of giving a lifetime tax exemption to any woman with four or more children. If we ever speak in public, we would, freely, say all the right things. Our piety would have the benefit of state support. We would find only the right books in the public library (the aristoi would probably have to read more widely, for the common good). We wouldn't have to bother to vote to remind the aristoi of our ordinary virtues.

We would have an associational life beyond the family, in clubs, unions, guilds, and corporations. "Subsidiarity" is an important Catholic doctrine, which defends the independence of these associations but also calls for their integration in a higher unity. Vermeule emphasizes this last point. Sometimes, he writes, these associations fail "to carry out their work in an overall social scheme that serves the common good." This constitutes a "state of exception" (the concept comes from the fascist German philosopher Carl Schmitt) and "requires extraordinary intervention by the highest level of public authority." So we will have to be extremely careful about what we do in the unions that Ahmari supports. Looking up, we will probably endorse the social scheme proposed by our betters.

I wrote at the beginning that I would provide my own defense of liberalism. The description above of the post-liberal state and society — *that* is my defense of liberalism. Individual choice, legal and social equality, critical thinking, free speech, vigorous argument, meaningful political engagement: these are the obvious and necessary antidotes to post-liberal authoritarianism. Above all, we must treasure the right to be wrong. The post-liberals are actually exercising that right. They shouldn't be allowed to take it away from the rest of us.

Notes on a Dangerous Mistake

REUEL MARC GERECHT

Saudi Arabia: The Chimera of A Grand Alliance

Even alliances between countries that share similar cultures and rich, intersecting histories can be acrimonious. France and Israel, for example, provoke vivid and contradictory sentiments for many Americans. Franco-American ties are routinely strained. No one in Washington ever believed that Charles de Gaulle's nuclear independence, guided by the principles of *tous azimuts,* shoot in any direction, and *dissuasion du faible au fort,* deterrence of the strong by the weak, meant that France might try to intimidate the United States. But there were moments when it wasn't crystal clear whether Paris, free from the North Atlantic Treaty Organization, might harmfully diverge from

Washington in a confrontation with the Soviet Union. Still, even when things have been ugly, quiet and profound military and intelligence cooperation continued with the French, almost on a par with the exchanges between Washington, London, and Canberra. It didn't hurt that a big swath of affluent Americans have loved Paris and the sunnier parts of France for generations, and that French and American universalism essentially speak the same language. These things matter.

The United States has sometimes been furious at Israel — no other ally has, so far as we know, run an American agent deep inside the U.S. government hoovering up truckloads of highly classified information. Israel's occupation of the West Bank, much disliked and denounced by various American governments, is probably permanent: setting aside the Israeli right's revanchism, the proliferation of ever-better ballistic weaponry and drones negates any conceivable good faith that might exist in the future between Israeli and Palestinian leaders, who never seem to be able to check their own worst impulses. Geography is destiny: Israel simply lacks the physical (and maybe moral) depth to not intrude obnoxiously into the lives of Palestinians. The Gaza war has likely obliterated any lingering Israeli indulgence towards the Palestinian people — what used to be called, before the Intifadas eviscerated the Israeli left, "risks for peace." An ever larger slice of the Democratic Party is increasingly uncomfortable with this fate: the rule of (U.S.-subsidized) Westerners over a non-Western, mostly Muslim, people. But the centripetal forces — shared democratic and egalitarian values, intimate personal ties between the American and Israeli political and commercial elites, a broader, decades-old American emotional investment in the Jewish state, a common suspicion of the Muslim Middle East, and a certain Parousian philo-Semitism among American evangelicals — have so far kept in check

67

the sometimes intense official hostility towards Israel and the distaste among so much of the American intelligentsia.

None of this amalgam of culture, religion, and history, however, works to reinforce relations between the United States and Islamic lands. Senior American officials, the press, and think tanks often talk about deep relationships with Muslim Middle Eastern countries, the so-called "moderate Arab states," of which Egypt, Jordan, and Saudi Arabia are the most favored. Presidents, congressmen, diplomats, and spooks have certainly had soft spots for Arab potentates. The Hashemites in Jordan easily win the contest for having the most friends across the Israel divide in Washington: sympathizing with the Palestinian cause, if embraced too ardently, could destroy the Hashemites, who rule over sometimes deeply disgruntled Palestinians. American concern for the Palestinian cause rarely crosses the Jordan River. (Neither does even more intense European concern for the Palestinians intrude into their relations with the Hashemite monarchy.)

The Hashemites are witty enough, urbane enough, and sufficiently useful to consistently generate sympathy and affection. Even when King Hussein went to war against Israel in 1967 or routinely sided with Saddam Hussein, his style and his manner (and I'm-really-your-friend conversations with CIA station chiefs and American ambassadors) always encouraged Washington to forgive him his sins. The Hashemites, like the Egyptian military junta, have routinely, if not always reliably, done our dirty work when Washington needed some terrorist or other miscreant held and roughly interrogated. Such things matter institutionally, building bonds and debts among officials.

But little cultural common ground binds Americans to even the most Westernized Arabs. Arabists, once feared by

Israel and many Jewish Americans, always had an impossible task: they had to use realist arguments — shouldn't American interests prefer an alliance with twenty-two Arab countries rather than with a single Jewish one? — without underlying cultural support. They had to argue dictatorship over democracy or belittle Israel's democracy enough ("an apartheid state") to make it seem equally objectionable. Outside of American universities, the far-left side of Congress, the pages of *The Nation, Mother Jones,* and the *New York Review of Books,* and oil-company boardrooms, it hasn't worked — yet. Too many Americans have known Israelis and visited the Holy Land. And too many are viscerally discomfited by turbans and hijabs. Culture — the bond that rivals self-interest — just isn't that fungible.

Even the Turks, the most Westernized of Muslims, didn't have a large fan club in America when the secular Kemalists reigned in Ankara — outside of the Pentagon and the Jewish-American community, which deeply appreciated Turkey's engagement with Israel. The Turks' democratic culture never really blossomed under the Kemalists, who couldn't fully shake their fascist (and Islamic) roots. The American military still retains a soft spot for the Turks — they fought well in Korea, and their military, the southern flank of NATO, has a martial ethic and a level of competence far above any Arab army; and they have continuously allowed the Pentagon to do things along the Turkish littoral, openly and secretly, against the Soviets and the Russians.

Yet their American fan club has drastically shrunk as the Turkish government, under the guidance of the philo-Islamist Recep Tayyip Erdoğan, has re-embraced its Ottoman past, enthusiastically used state power against the opposition and the press, and given sympathy and some support

to Arab Islamic militants, among them Hamas. The Turks have pummeled repeatedly Washington's Kurdish allies in Syria (who are affiliated with Ankara's deadly foe, the terrorism-fond Kurdistan Workers Party). More damning, Erdoğan purchased Russian S-400 ground-to-air missiles, compromising its part in developing and purchasing America's most advanced stealth fighter-bomber, the F-35. The Pentagon, always Turkey's most reliable ally in Washington, feels less love than it used to feel.

No great European imperial power ever really integrated Muslim states well into their realms. Great Britain and France did better than Russia and Holland; the Soviet Union did better than Russia. With imperial self-interest illuminating the way, the British did conclude defensive treaties with allied-but-subservient Muslim lands — the Trucial States and Egypt–Sudan in the nineteenth and twentieth centuries — that could greatly benefit the natives. The emirs in the Gulf, once they realized that they couldn't raid Indian shipping without fierce retribution, accepted, sometimes eagerly, British protection, grafting it onto the age-old Gulf customs of *dakhala* and *zabana* — finding powerful foreign patrons. The emirates needed protection from occasionally erupting militant forces from the peninsula's highlands — the Wahhabi warriors of the Saud family.

The British, however, failed to protect their most renowned clients, the Hashemites, in their native land, the Hijaz in Arabia, after wistfully suggesting during World War I that the Hashemites might inherit most of the Near East under Great Britain's dominion. King Hussein bin Ali had proved obstinate in accepting Jews in Palestine and the French in

Syria. Britain switched its patronage to the Nejd's Abdulaziz bin Abdul Rahman Al Saud. Backed by the formidable *Ikhwan*, the Brothers, the Wahhabi shock troops who had a penchant for pillaging Sunni Muslims and killing Shiite ones, Ibn Saud conquered the Hijaz, home to Mecca and Medina and the Red Sea port of Jeddah, in 1925. Checked by the Royal Air Force in Iraq and the Royal Navy in the Persian Gulf, Saudi jihadist expansion stopped. In 1929 Ibn Saud gutted the *Ikhwan*, who had a hard time accepting the post-World-War-I idea of nation-states and borders, and created more conventional military forces to defend his family and realm. In 1932 he declared the kingdom of Saudi Arabia. The dynasty's Hanbali jurisprudence remained severe by the standards enforced in most of the Islamic world, but common Sunni praxis and political philosophy held firm: rulers must follow the holy law, but they have discretion in how they interpret and enforce it; in practice, kings and princes could sometimes kick clerics and the *sharia* to the ground when exigencies required.

Since Britain's initial patronage, the Saudis officially have remained wary of foreigners, even after the 1950s when the royal family started allowing thousands of them in to develop and run the kingdom. Ibn Saud put it succinctly when he said "England is of Europe, and I am a friend of the *Ingliz*, their ally. But I will walk with them only as far as my religion and honor will permit." He might have added that he appreciated the power of the RAF against the *Ikhwan* on their horses and camels. After 1945, Ibn Saud and his sons sought American protection and investment. They saw that Britain was declining; it was also massively invested in Iran. The modern Middle East has been an incubator of ideologies toxic to monarchies. The three Arab heavy weights of yesteryear — Baathist Iraq, Baathist Syria, and Nasserite Egypt —

were all, in Saudi eyes, ambitious predators. The Soviet Union lurked over the horizon, feeding these states and, as bad, Arab communists and other royalty-hating leftists who then had the intellectual high ground in the Middle East. But there was an alternative.

American power was vast, Americans loved oil, and America's democratic missionary zeal didn't initially seem to apply to the Muslim Middle East, where American intrusion more often checked, and usually undermined, European imperial powers without egging on the natives towards democracy. (George W. Bush was the only American president to egregiously violate, in Saudi eyes, this commendable disposition.) American oilmen and their families came to Saudi Arabia and happily ghettoized themselves in well-organized, autonomous, well-behaved communities. The American elite hardly produced a soul who went native: no T.E. Lawrence, Gertrude Bell, or Harry St. John Bridger Philby — passionate, linguistically talented, intrepid Englishmen who adopted local causes, sometimes greatly disturbing the natives and their countrymen back home. A nation of middlebrow pragmatic corporations, backed up by a very large navy, Americans seemed ideal partners for the Saudi royals, who were always willing to buy friends and "special relationships." As Fouad Ajami put it *in The Dream Palace of the Arabs*, "The purchase of Boeing airliners and AT&T telephones were a wager that the cavalry of the merchant empire would turn up because it was in its interest to do so."

But Americans could, simply by the size of their global responsibilities and strategies, be unsettling. In *Crosswinds*, Ajami's attempt to peel back the layers of Saudi society, he captures the elite's omnipresent trepidation, the fear of weak men with vast wealth in a region defined by violence:

"The Saudis are second-guessers," former secretary of state George Shultz said to me in a recent discussion of Saudi affairs. He had known their ways well during his stewardship of American diplomacy (1982–1989). This was so accurately on the mark. It was as sure as anything that the Saudis lamenting American passivity in the face of Iran would find fault were America to take on the Iranians.... In a perfect world, powers beyond Saudi Arabia would not disturb the peace of the realm. The Americans would offer protection, but discreetly; they would not want Saudi Arabia to identify itself, out in the open, with major American initiatives in the Persian Gulf or on Arab–Israeli peace. The manner in which Saudi Arabia pushed for a military campaign against Saddam Hussein only to repudiate it when the war grew messy, and its consequences within Iraq unfolding in the way they did, is paradigmatic. This is second-guessing in its purest.

Saudi Arabia has had only one brief five-year period, from 1973 to 1978, when the Middle East (Lebanon excepted) went more or less the way that the royal family wanted. They weren't severely threatened, their oil wealth had mushroomed, internal discontent had not metastasized (or at least was not visible to the royal family) and everybody — Arabs, Iranians, Americans, Soviets, and Europeans — listened to them respectfully. In 1979, when the Iranian revolution deposed the Shah, and Sunni religious militancy put on muscle, and the Soviets invaded Afghanistan, the golden moment ended. Enemies multiplied. Since then, as Nadav Safran put it in *Saudi Arabia, The Ceaseless Quest for Security* "the Saudis did not dare cast their lot entirely with the United States in defiance of

all the parties that opposed it, nor could they afford to rely exclusively on regional alliances and renounce the American connection altogether in the view of the role it might play in various contingencies...the leadership ...endeavored to muddle its way through on a case-by-case basis. The net result was that the American connection ceased to be a hub of the Kingdom's strategy and instead became merely one of several problematic relationships requiring constant careful management."

Which brings us to the current Saudi crown prince, Muhammad bin Salman, the *de facto* ruler of the country — easily the most detested Saudi royal in the West since the kingdom's birth. With the exception of Iran's supreme leader, Ali Khamenei, who is the most indefatigable Middle Eastern dictator since World War II, MBS is the most consequential autocrat in the region. And the prince made a proposal to America — a proposal that may survive the Gaza war, which has reanimated anti-Zionism and constrained the Gulf Arab political elite's decade-old tendency to deal more openly with the Jewish state. To wit: he is willing to establish an unparalleled tight and lucrative relationship with Washington, and let bygones be bygones — forget the murder of Jamal Khashoggi and all the insults by Joe Biden — so long as America is willing to guarantee Saudi Arabia's security, in ways more reliable than in the past, and provide Riyadh the means to develop its own "civilian" nuclear program. Saudi Arabia would remain a major arms-purchaser and big-ticket commercial shopper and a reliable oil producer (the prince is a bit vague on exactly what Saudi Arabia would do with its oil that it isn't doing now or, conversely, what it might not do in the future if Riyadh were to grow angry). And

the Saudis would establish diplomatic relations with Jerusalem — clearly the *pièce de résistance* in his entreaty with the United States. With the Gazan debacle, the appeal of MBS' pitch will increase for Israelis and Americans, who will seek any and all diplomatic means to turn back the anti-American and anti-Zionist tide.

MBS and the Jews is a fascinating subject. It is not atypical for Muslim rulers, even those who sometimes say unkind things about Jews, to privately solicit American, European, and Israeli Jews. Having Jews on the brain is now fairly common in the Islamic world, even among Muslims who aren't anti-Semites. Imported European anti-Semitism greatly amped up Islam's historic suspicions of Judaism: in the Quran, the Prophet Muhammad is clearly disappointed by the Jewish refusal to recognize the legitimacy, the religious continuity, of his calling, which led to the slaughter of an Arabian Jewish tribe, the Banu Qurayza. Dissolve to the Holocaust, the creation of Israel, the wars and their repeated Arab defeats, the centrality of Israel in American and Soviet Middle Eastern foreign policy, the prominence of Jewish success in the West, especially in Hollywood, the constant chatter among Western Christians about Jews — all came together to give *Al-Yahud* an unprecedented centripetal eminence in the modern Islamic Middle East.

When MBS came to the United States in 2018, he and his minions engaged in extensive Jewish outreach. The prince admires Jewish accomplishment. His representatives are similarly philo-Semitic. The head of the World Muslim League, Muhammad bin Abdul Karim Issa, sometimes sounds as if he could work for B'nai B'rith International. Not that long ago, before 9/11, the League, an official organ of the Saudi state, pumped a lot of money into puritanical (Salafi) missionary

activity, competing with the "secular" Egyptian establishment and the clerical regime in Tehran as the most ardent and well-funded proliferators of anti-Semitism among Muslims. So it is intriguing that MBS, whose father long had the Palestinian dossier at the royal court, has developed what appears to be a sincere and, at least for now, non-malevolent interest in Jews.

One suspects that the prince sees a certain religious and cultural affinity with Jews: Judaism and Islam are juristically and philosophically much closer to each other than Christianity and Islam. MBS is sufficiently well-educated — he has a law degree from King Saud University — to know this; he has now traveled enough, and met enough Jews around the world, to feel it. Nearly half of the Jews in Israel came from the Middle East. The other half — the Ashkenazi, or as Bernard Lewis more accurately described them, the Jews of Christendom — often saw themselves, before arriving in Zion, as a Middle Eastern people in exile. Here is a decent guess about MBS' reasoning: if the Jews, a Middle Eastern people now thoroughly saturated with modern (Western) ideas, could become so accomplished, then Saudi Muslims could, too. The Jewish experience — and association with Jews — might hold the keys to success.

There is a very long list of Muslim rulers from the eighteenth century forward, who, recognizing the vast chasm in accomplishment between Western (and now Westernized Asian) and Islamic lands, have tried to unlock the "secrets" of foreign power and success. Oil-rich Muslim rulers have tried to buy progress with petroleum profits. MBS certainly isn't novel in his determination to make his own country "modern." His audacity, even when compared against Shah Mohammad Reza Pahlavi, who aspired to make Iran "the Germany of the Middle East," is impressive. There is the prospective giant metal tube in

76

the northwest corner of the country, which, according to the prince's NEOM vision ("neo" from the Greek and "m" from the Arabic *mustaqbal*, future), will one day hold upwards of nine million people in a verdant paradise where everyone has the Protestant work ethic and the air-conditioning never breaks down. This is the dreamscape of an Arab prince who is not intellectually shackled by the rhythms and the customs of his homeland. He is building a vast resort complex on the Red Sea, already under construction, which is also being funded from the sovereign wealth fund because Western and Asian bankers remain dubious about its profitability. A dozen five-star luxury resorts, dependent on visiting affluent Europeans, will have to allow topless bathers and a lot of alcohol if they have any chance of making money; thousands of lower-class Saudi men — not imported foreign labor — will in theory keep these resorts running.

The prince is searching for the keys to unleash Saudi Arabia's non-oil potential — using prestigious Western consultancy firms that promise to bring greater productivity and efficiency to gross national product. He is trying to do what every significant Muslim ruler has done since Ottoman sultans realized they could no longer win on the battlefield against Christians: grow at home greater curiosity, talent, and industry.

Unlike the Arab elites in the lands that started seriously Westernizing in the nineteenth century and have since seen their countries racked and fractured by foreign ideologies, brutal authoritarian rulers, rebellions, and civil and sectarian wars, MBS appears to be an optimist. Under his firm guidance, he believes that Saudi Arabia can leapfrog from being the archetypal orthodox Islamic state to a self-sustaining, innovative, entrepreneurial, tech-savvy, well-educated powerhouse. Ajami, the finest chronicler of the Arab world's misery, was

77

deeply curious about Saudi Arabia because it was the last frontier, a land with considerable promise that had not yet embraced enough modernity, in all the wrong ways, to cock it up. The Saudi identity has been slow to nationalize — it was decades, perhaps a century, behind the cohering forces that gave Egypt and then Syria some sense of themselves. As Alexis Vassiliev, the great Russian scholar of Saudi Arabia and Wahhabism, put it:

> The idea of a national territorial state, of a "mother-
> land," was new to Arabian society. The very concept of
> a motherland, to which individuals owe their primary
> loyalty, contradicts the spirit of Islam, which stresses the
> universal solidarity of believers as against non-Muslims.
> National consciousness and national feelings in Saudi
> Arabia were confined to a narrow group working in
> the modern sector of the economy and in the civil and
> military bureaucracy. Those who described themselves
> as nationalists were, rather, reformers and modern-
> ists, who wanted to create a more modern society. But
> their sentiments were so vague that the left wing of the
> "nationalists" even avoided using the name Saudi Arabia
> because of their attitude to the Al Saud.

Saudi Arabia has been rapidly modernizing since the 1960s. Measured by massive concrete buildings, roads, luxury hotels with too much marble, electrification, communications, aviation, urban sprawl, rural decline, and access to higher education, Vassiliev's observation is undoubtedly correct: "Saudi Arabia has experienced more rapid change than any other Middle Eastern country and the old social balance has been lost forever." But spiritually, in its willingness to import

Western ideas as opposed to Western gadgets, know-how, aesthetics, and organization, the kingdom changed only fitfully. Royal experiments in reform, especially under King Abdullah (2005–2015), could be ended as quickly as they began.

Before MBS, Saudi rulers and the vast oil-fed aristocracy were deeply conservative at home (if not in their homes), fearful of the outside world that relentlessly corroded the traditions that gave the kingdom its otherworldly, female-fearing, fun-killing, profoundly hypocritical weirdness. But this conservative status quo also offered a certain moral coherence, political stability (the royal family, thousands strong, were collectively invested), as well as a quirky governing class that was fine for decades, through the worst of the Wahhabi efflorescence that followed the Iranian revolution and the seizure of the Great Mosque in Mecca, with a gay intelligence chief. Saudis might be haughty, lacking the multilingual grace that came so easily to old-school Arabs, who retained Ottoman propriety with first-rate Western educations, but they were aware of their limitations. They gave the impression that they couldn't compete — even at the apex of Saudi power in the mid-1970s. Most of the royal family likely didn't want to try. When Ajami was alive (he died in 2014, a year before MBS began his rise), Saudi Arabia hadn't taken the giant, irreversible leap forward. It has now.

The crown prince has been a one-man wrecking ball, transforming the country's collective leadership, where princes — uncles, brothers, sons, and cousins — effectively shared power under the king, into a dictatorship. Whatever brakes are still on the system (King Salman is old and ailing but rumors don't yet have

him *non compos mentis*), they likely will not outlast Salman's death. There has never been any clear demarcation between the nation's treasury and the royal family's purse; MBS appears to have greatly reduced the points of access to the country's oil wealth to him and his minions. His great shakedown in the Ritz Hotel in Riyadh in November 2017, when nearly four hundred of the kingdom's richest and most powerful people were forcibly held and squeezed or stripped of their assets, killed the old order. Some "guests" reportedly were physically tortured, had their families threatened, or both. Such behavior would have been unthinkable before. Traditional kingdoms always have informal rules that buttress the status quo and check arbitrary power. The crown prince's new-age mindset — his determination to stamp out all possible opposition to his modernist vision with him alone at the helm — was vividly on display at the Ritz.

This autocratic thuggery earned little censure in the West, on either the left or right. Some appeared to believe that the rightly guided prince was actually stamping out corruption. Many Saudis, especially among the young, may have sincerely enjoyed the spectacle of the spoiled *ancien régime* getting its comeuppance. The same unchecked princely temperament, however, reappeared in the Saudi consulate in Istanbul on October 2, 2018, when Jamal Khashoggi crossed the threshold. It is a near-certainty that MBS intended to kill, not to kidnap, the elite dissident. It is not at all unlikely, given the prince's reputation for work and detail and his aversion to delegating decisions to others, that he personally approved the dissident's dismemberment.

The crown prince is gambling that Saudi nationalism, which is now real even if its depth is hard to measure, will attach itself to him, as nationalisms do in their need for a

leader. He is trying to downgrade Islam by upgrading the nation. He has reined in the dreaded morals police, the *mutawwa*, who could harass and arrest almost anyone. The urban young, especially if they come from the middle and upper-middle class, have long loathed this police force, which comes from the more marginal precincts of society, and so they find MBS' *mission civilisatrice* appealing. The crown prince is essentially trying to pull an Atatürk, who created a Turkish nation-state out of a Muslim empire. Mustafa Kemal created his own cult: he was a war hero, the savior of the Turks from invading Greek Christian armies and World War I victors who were carving up the carcass of the Ottoman state. He fused himself with the idea of nationhood. His tomb in Ankara has tens of thousands of Turkish Islamists respectfully visiting it.

When it came to cult worship, Saudi kings and princes had been fairly low-key compared to most other Middle Eastern rulers. Yet MBS' sentiments are, again, more modern. He has effectively established a police state — the first ever in Saudi history. His creation is certainly not as ruthless as the Orwellian nightmares of Saddam Hussein's Iraq or Assad's Syria; it is neither as loaded with internal spies nor rife with prison camps as Abdul Fattah El-Sisi's Egypt. But MBS' Arabia is a work in progress. Those in America and Israel who advocate that the United States should draw closer to MBS, so as to anchor a new anti-Iran alliance in Riyadh, are in effect saying that we should endorse MBS and his vision of a more secular, female-driving, anti-Islamist Saudi Arabia without highlighting its other, darker aspects, or that we should just ignore the kingdom's internal affairs and focus on what the crown prince gives us externally. This realist calculation usually leads first back to the negatives: without the crown prince's support of American interests, Russia, China, and

Iran, the revisionist axis that has been gaining ground as America has been retrenching, will do even better. And then the positive: Saudi recognition of Israel would permanently change the Jewish state's standing in the Muslim world — a long-sought goal of American diplomacy.

The prince clearly knows how much Benjamin Netanyahu wants Saudi Arabia's official recognition of Israel. The Israeli prime minister has loudly put it at the top of his foreign-policy agenda. (Before the Gaza war, it might have had the additional benefit of rehabilitating him at home.) The prince clearly knows how much American Jewry wants to see an Israeli embassy in Riyadh. And after some initial weariness, the Biden administration now wants to add the kingdom to the Abraham Accords. Bahrain, the United Arab Emirates, Morocco, and Sudan recognizing Israel was good, but Saudi Arabia would be better. Although the White House certainly hasn't thought through how the United States would fit into an Israeli-Saudi-US defensive alliance, whether it would even be politically or militarily possible, the administration proffered the idea before Biden went to Saudi Arabia in 2022 — or echoed an earlier, vaguer Saudi suggestion of a defensive pact — as part of Riyadh's official recognition of Israel. Given the importance that MBS attaches to things Jewish, he may well believe his offer of Israeli recognition gives him considerable leverage in future dealings with the United States.

Joe Biden paved the way for MBS' go-big proposal by making one of the most embarrassing flips in presidential history. Biden came into office pledging to reevaluate US-Saudi ties and cast MBS permanently into the cold for the gruesome killing of Khashoggi and, a lesser sin, making a muck of the war in Yemen, which has led to the United States, given its crucial role in maintaining and supplying the Saudi Air Force, being

an accomplice in a bombing campaign that has had a negligible effect on the Shiite Houthis capacity to fight but has killed thousands, perhaps tens of thousands, of Yemeni civilians. (In civil wars, it is hard to know who is starving whom, but the Saudi role in bringing starvation to Yemen has not been negligible.) Fearing another hike in oil prices before the midterm elections, Biden travelled to Saudi Arabia, fist-bumping MBS and getting not much in return except reestablishing what has been true in US–Saudi relations from the beginning, when Franklin Delano Roosevelt hosted two of King Ibn Saud's sons in Washington: everything is transactional.

MBS' offer to America arrived with China's successful intervention into Saudi-Iranian relations. Beijing obtained an agreement for the restoration of diplomatic ties between the two countries, which Riyadh had severed in 2016, after King Salman executed Nimr al-Nimr, the most popular Saudi Shiite cleric in the oil-rich Eastern Province, and Iranian protestors set fire to the Saudi embassy in Tehran. Beijing also appears to have aided a Saudi-Iranian ceasefire and an understanding about Yemen. MBS, who had been eager to extricate himself and the Saudi treasury from the peninsula's "graveyard of nations," reduced the number of Saudi forces engaged in the conflict; Tehran appears to have convinced the Houthis, at least temporarily, not to lob Iranian-provided missiles into their northern neighbor.

China offers MBS something that Israel and the United States realistically no longer do: a possible long-term deterrent against Iranian aggression in a post-American Middle East. Beijing likely isn't opposed to the Islamic Republic going nuclear, since this would further diminish the United States, which has under both Republican and Democratic presidents told the world that an Iranian nuke is "unacceptable." Given

Chinese access in Tehran and Moscow, which is developing an ever-closer military relationship with the clerical regime, the value of Chinese intercession will increase. Given Beijing's economic interest in Saudi Arabia's oil (it is now the kingdom's biggest customer), MBS is certainly right to see in the Chinese a possible check on any Iranian effort to take the kingdom's oil off-market. The Islamic Republic has never before had great-power patrons. The Chinese bring big advantages to Iran's theocrats — much greater insulation from American sanctions, for example; but they may also corral Tehran's freedom of action a bit.

In the controversial interview that MBS not long ago gave to *The Atlantic,* MBS clearly thought he could wait out the Biden administration, and that America's and the West's need for Saudi crude, and the rising power of China, gave the prince time and advantage. He has won that tug-of-war. America cannot possibly ostracize the ruler who controls the largest, most easily accessible, and highest-quality pool of oil in the world. The Gaza war will also play to MBS' advantage as both Israel and the United States will seek Saudi intercession to counter what's likely to become an enormous propaganda victory for Iran's "axis of resistance." The crown prince may well be racing his country towards the abyss, eliminating all the customs and institutions that made the Saudi monarchy resilient and not particularly brutish (not by Middle Eastern standards), but he has been tactically astute with all the greater powers maneuvering around him.

Saudi Arabia is probably the Muslim country that American liberals hate the most. (Pakistan is a distant runner-up.) This enmity is, in part, a reaction to the oddest and oldest American "partnership" in the Middle East, and the general and quite understandable feeling that the Saudi royal family

never really came clean about its dealings with Osama bin Ladin before 9/11. Not even post-Sadat Egypt, which has developed a close working relationship with the American military and the CIA, has had the kind of access that the Saudis have had in Washington. Even after 9/11, during Bush's presidency, Saudi preferences in personnel could reach all the way into the National Security Council. The Saudi distaste for Peter Theroux, an accomplished Arabist and former journalist who wrote an entertaining, biting look into the kingdom in *Sandstorms,* published in 1990, got him briefly "unhired" to oversee Saudi policy on the NSC because of the fear of Riyadh's reaction. He got rehired when either Condoleezza Rice, the national security advisor, or her deputy, Stephen Hadley, realized that allowing Saudi preferences to effect personnel decisions within the White House was unwise and potentially very embarrassing. Given the Gaza war's demolition of the Biden administration's Middle Eastern policy, it's not unlikely that we will see Saudi access in Washington rise again, perhaps rivaling its halcyon days during the Reagan administration. That would be a sharp irony.

Culturally speaking, no two countries had ever been further apart: Saudi Arabia still had a vibrant slave society in 1945 when Franklin Roosevelt began America's relationship with the desert kingdom. Outside pressure, not internal debate among legal scholars and Saudi princes about evolving religious ethics and the holy law, obliged the monarchy to ban slavery officially in 1962. (Bad Western press aside, the Saudi royals may have been truly annoyed at French officials freeing slaves traveling with their masters on vacation.) Ibn Saud had over twenty

wives, allotted by the holy law to no more than four at one time, and numerous concubines. When concubines became pregnant, they would usually ascend through marriage, while a wife would be retired to a comfortable and less competitive environment. By comparison, the thirty-seven-year-old crown prince today has only one wife and, if rumors are true, many mistresses — a less uxorious, more acceptable choice for a modern, ambitious man.

Roosevelt's embrace of the Saudi monarchy established the ultimate realist relationship. The Saudi royals neither cared for America's democratizing impulse, nor for its incessant conversations about human rights, nor for its ties to Israel, nor, after 1973 and the Saudi-engineered oil embargo that briefly gave the United States sky-rocketing prices and gas lines, for the American chatter in pro-Israel corners about the need to develop plans for seizing Saudi oil fields. Yet the Saudis loved the U.S. Navy and the long, reassuring shadow that it cast in the Middle East. Donald Trump's embrace of Arabia, however much it may have horrified American liberals and amplified their distaste for the country and its ruling family, just highlighted, in Trump's inimitably crude way, a bipartisan fact about Saudi-American relations: we buy their oil and they buy our armaments, technology, machinery, services, and debt. Barack Obama sold the Saudis over sixty-five billion dollars in weaponry, more than any president before or since. Both sides have occasionally wanted to make it more than that, to sugarcoat the relationship in more appealing ways. The more the Saudis, including the royals, have been educated in the United States, the more they have wanted Americans to like them. Americanization, even if only superficial, introduces into its victims a yearning for acceptance. Americans have surely been the worst offenders here, however, since they are

far more freighted with moral baggage in their diplomacy and trade. They want their allies to be good as well as useful.

Although Americans have a knack for discarding the past when it doesn't suit them, Saudi and American histories ought to tell us a few things clearly. First, that MBS' offer to the United States is without strategic advantages. This is true even though Iran may have green-lighted, perhaps masterminded, the attack on October 7 in part to throw a wrench into the U.S.–Israeli–Saudi negotiations over MBS' proposal. Iranian conspiratorial fears *always* define the clerical regime's analysis. Its desire to veto its enemies' grand designs is certainly real irrespective of whether it thought that Saudi–Israeli normalization was arriving soon or that MBS' quest to develop a nuclear-weapons-capable atomic infrastructure needed to be aborted sooner rather than later. Iranian planning on the Gaza war likely started long before Biden administration officials and Netanyahu's government started leaking to the press that normalization was "imminent"; it likely started before MBS' vague suggestions of a defensive pact between Washington and Riyadh. Leaks about diplomatic progress surrounding a coming deal, however, might have accelerated Iran's and Hamas' bloody calculations.

Concerning the crown prince's nuclear aspirations, which have divided Israelis, caused serious indigestion in Washington, and compelled Khamenei's attention, they are not unreasonable given that domestic energy requirements for Saudi Arabia — especially the exponentially increasing use of air conditioning — could in the near future significantly reduce the amount of oil that Riyadh can sell. Nuclear energy would free up more petroleum for export and produce the revenue that MBS desperately needs to continue his grand plans. But it is also a damn good guess that MBS' new attention

Saudi Arabia: The Chimera of A Grand Alliance

to nuclear power plants has a lot to do with developing the capacity to build the bomb. Just across the Gulf, the Islamic Republic has effectively become a nuclear threshold state — the Supreme Leader likely has everything he needs to assemble an atomic arm; and the possibility is increasingly remote that either Biden or the Israeli prime minister (whoever that maybe on any given day) is going to strike militarily before the clerical regime officially goes nuclear. And MBS, despite his occasional bravado on Iran and his undoubtedly sincere private desire to undermine the clerical regime, probably doesn't want to deal with such a denouement. Given how much Netanyahu and most of the Israeli political class have wanted Saudi–Israeli normalization, given how desperate the Biden administration has been to find stabilizing partners in the Middle East, which would allow the United States to continue its retrenchment, MBS could be forgiven for thinking, especially after October 7, that the sacred creed of non-proliferation might well give way to his atomic ambitions.

The Saudis were never brave when they were focused single-mindedly on building their frangible oil industry; now they have vast installations, which the Iranians easily paralyzed in 2019 with a fairly minor drone and cruise missile attack. The same vulnerability obtains for the crown prince's NEOM projects, which the Iranians, who have the largest ballistic- and cruise-missile force in the Middle East, could severely damage — probably even if the Saudis spend a fortune on anti-missile defense. MBS came in like a lion on the Islamic Republic, attracting the attention and the affection of Israelis and others; it's not at all unlikely that he has already become a lamb, actually less stout-hearted than his princely predecessors who, in a roundabout way, via a motley crew of characters, using the CIA for logistical support, took on the Soviet Union in Afghanistan.

Still, MBS would want to plan for contingencies. Having nuclear weapons is better than not having them. A Saudi bomb might check Persian predation. And the Saudis are way behind. They have neither the engineers nor the physicists nor the industrial base. And the odds are excellent that the Pakistanis, who though indebted to the Saudi royal family are quite capable of stiffing them, haven't been forthcoming: they are not going to let the Saudis rent an atomic weapon. And the Russians and the Chinese might not want to give the Saudis nuclear power. It would add another layer of complexity and tension to their relations with the Islamic Republic, which neither Moscow nor Beijing may want. The Europeans and the Japanese are unlikely to step into such a hot mess. Getting nuclear technology from the Americans would be vastly better. Another way, as Ajami put it, to supplement Boeing and AT&T.

Failing on the atomic front, MBS might intensify his dangle of an Israeli embassy in Riyadh — to see what he can get even if he has no intention of recognizing the Jewish state. The Gaza war certainly increases his chances that he can get both the Israelis and the Americans to concede him a nuclear infrastructure with local uranium enrichment. The war makes it less likely, however, that he would want to tempt fate anytime soon by recognizing Israel. Normalization gains him nothing internally among all those Saudis who religiously or politically may have trouble with a Saudi flag — which has the Muslim *shahâda*, the profession of faith, boldly printed on a green heavenly field — flying in Zion. And the Star of David in Riyadh could be needlessly provocative even to the crown prince's much-touted young, hitherto apolitical, supporters. The Palestinian cause, which most of the Israeli political elite thought was a fading clarion call, has proven to have astonishing resonance.

But even if MBS is still sincere about this big pitch, neither Washington nor Jerusalem should be tempted. It gives the former nothing that it does not already have. It offers the Israelis far less than what Netanyahu thinks it does. Despite MBS' grand visions for where his country will be in the middle of the century, Saudi Arabia is actually a far less consequential kingdom than it was in 1973, when it was at the pinnacle of its oil power, or in 1979, when it collided with the Iranian revolution and was briefly on the precipice after the Sunni religious revolutionary Juhayman al-Otaybi, his messianic partner Muhammad Abdullah al-Qahtani, and five hundred well-armed believers took Mecca's Grand Mosque and shook the dynasty to its core.

Religiously, among Muslims, Saudi Arabia hasn't been a bellwether for decades. Its generous funding for Salafi causes undoubtedly fortified harsher views across the globe, especially in Indonesia and Western Europe, where so many dangerous Islamic radicals were either born or trained. Religious students and clerics raised in the eclectic but formal traditions of the Al-Azhar seminary in Cairo, for example, would go to Saudi Arabia on well-paid fellowships and often come back to Egypt as real Hanbali-rite killjoys. Saudi Arabia helped to make the Muslim world more conservative and less tolerant of Muslim diversity. But relatively few Saudi imams were intellectually on the cutting edge, capable of influencing the radical set outside of Arabia. And it was the radical set outside of Saudi Arabia who mattered most, especially in Egypt, where the politically subservient dons of Al-Azhar lost control and relevance for Muslims who were growing uncomfortable with Egypt's Westernization, first under the British and then, even more depressingly, under the military juntas of Gamal Abdel Nasser and Anwar Sadat.

In Saudi Arabia, most of the radical Salafi imams were either in trouble with the Saudi authorities, in exile, or in jail. Saudi royals were once big fans of the Egyptian-born Muslim Brotherhood because it was hostile to all the leftist ideologies storming the Middle East. Only later did they realize that these missionaries were irreversibly populist and anti-monarchical. Saudi religious funding was like that old publishing theory — throw shit against the wall and see what sticks. The operative assumptions were that more religious Muslims were better than less religious, and that more religious Sunni Muslims would be hostile to Iran's revolutionary call, and that more religious Sunni Muslims would be more sympathetic to Saudi Arabia. Who preached what and where was vastly less important. There were a lot of problems with every one of those assumptions, which the Saudi royal family realized long before the coming of MBS. But inertia is infamously hard to stop.

For most faithful Muslims today, Saudi Arabia isn't intellectually and spiritually important. What happened to Al-Azhar in Egypt — its intellectual and jurisprudential relevance declined as it became more subservient to the Westernizing Egyptian military — has been happening in Saudi Arabia for at least thirty years. MBS is intensifying this process. Westerners may cheer him on as he tries to neuter Islam as the defining force within Saudi society, but internationally it makes Saudi Arabia a less consequential state. Saudi Arabia is not a model of internal Islamic reform; it is merely another example of a modernizing autocrat putting Islam in its place — behind the ruler and the nation. The dictatorial impact on religion can be profound: it can reform it, it can radicalize it, it can do both at the same time.

To keep on the Egyptian parallel: Anwar Sadat opened an embassy in Jerusalem. He and his military successors have

slapped the hands of Al-Azhar's rectors and teachers when they challenged the legitimacy of the Egyptian–Israeli entente. (Conversely, they haven't stopped, and they have often subsidized, the perpetual anti-Semitism of Egyptian media, film, and universities.) The peace between Egypt and Israel has obviously been beneficial to both countries, but religiously it made little positive impact on Muslims within Egypt or abroad. When a Muslim Brother, Mohammad Morsi, won Egypt's first — and so far only — free presidential election in 2012, Israelis and Americans were deeply concerned that he would sever relations with Israel. That didn't happen, but the fears were understandable; Israel's popular acceptance within Egyptian society remains in doubt.

If, after the Gaza war, MBS deigns to grant Israel diplomatic relations, it won't likely make faithful Muslims, or even secular Muslims, more inclined to accept the Jewish state. It might do the opposite, especially inside Saudi Arabia. The Saudi royal family's control over the two holiest sites in Islam — Mecca and Medina — makes little to no difference in how that question is answered. Such custodianship confers prestige and obliges the Saudi royal family, at least in the holy cities, to maintain traditional standards. In the past, before modern communications, it allowed Muslims and their ideas to mix. But it absolutely does not denote superior religious authority — no matter how much Saudi rulers and their imams may want to pretend that by proximity to the sacred spaces they gain religious bonus points. One often gets the impression from Israelis that they are in a time warp with respect to Saudi Arabia, that for them it is still the mid-1970s and Riyadh's recognition would effectively mark an end to their Muslim travails. The Gaza war ought to inform Israelis that the profoundly emotive Islamic division between believer and

non-believer and the irredentist claims of Palestinian Muslims against the Jewish state do not lessen because a Saudi crown prince wants to establish a less hostile *modus vivendi* with Israel and Jews in general.

Perhaps above all else, the Israelis should want to avoid entangling themselves too closely with MBS in the minds of Americans, especially those on the left, who are essential to bipartisan support for Jerusalem. It's an excellent bet that MBS' dictatorship will become more — likely much more — oppressive and contradictory in its allegiances. What Safran noted about Saudi behavior from 1945 to 1985 — "attempts to follow several contradictory courses simultaneously, willingness to make sharp tactical reversals; and limited concern with the principle of consistency, either in reality or in appearance" — has already happened with MBS. This disposition will probably get much worse. And Americans aren't Israelis, who never really see political promise in Muslim lands (neither Islamic nor Israeli history encourages optimism). The choice, in their minds, is between this dictator or that one — and never, if possible, the worst-case scenario: Muslims freely voting and electing Islamists who by definition don't exactly kindle to Israel or the United States. Americans are much more liberal (in the old sense of the word): for them, autocracies aren't static, they inevitably get worse until they give way to revolution or elected government. Even realist Americans are, compared to Israelis, pretty liberal. And the principal reason that the United States has so steadfastly supported the Jewish state since 1948 is that it is a vibrant democracy, however troubled or compromised it might be by the Palestinian question or by its own internal strains of illiberalism and political religion. When

93

Israelis and their American supporters tout MBS as a worthwhile ally, they are diminishing Israel's democratic capital. If MBS really thought diplomatic relations were in his and Saudi Arabia's self-interest, there would already be a fluttering Star of David in Riyadh. The wisest course for Israelis is to reverse engineer MBS' hesitation into a studied neutrality.

Religion and mores aside, closer relations with Saudi Arabia will not assist America or Israel against its principal Middle Eastern concern: the Islamic Republic of Iran. In 2019, when Iran decided to fire cruise missiles and drones at Saudi Aramco processing plants in Abqaiq and Khurais, briefly taking out nearly half of the country's oil production, MBS did nothing, except turn to the Americans plaintively. The Emirates, whose ambassador in Washington gives first-rate anti-Iran dinner parties, sent an emissary to Tehran, undoubtedly to plead neutrality and promise to continue to allow the clerical regime the use of Dubai as a U.S.-sanctions-busting entrepôt. The two Sunni kingdoms had purchased an enormous amount of Western weaponry to protect themselves against the Islamic Republic. The Saudi and Emirati air forces and navies are vastly more powerful than their Iranian counterparts. And still they would not duel. They lack what the clerical regime has in abundance: a triumphant will fueled by success and a still vibrant ideology.

The Saudis know, even if MBS' public rhetoric occasionally suggests otherwise, that the Islamic Republic, even with all its crippling internal problems, is just too strong for them. Iran's eat-the-weak clerics and Revolutionary Guards, who fought hard and victoriously in Syria's civil war, became the kingmaker in Iraq, and successfully radicalized and armed the Shiite Houthis of Yemen, can always out-psych the Saudi and Nahyan royals. Also, Trump didn't help. When he decided not

94

to respond militarily to the cruise missile-and-drone attacks, plus the ones on merchant shipping in the Gulf of Oman three months earlier (he boldly tweeted that the United States was "locked and loaded"), Trump trashed whatever was left of the Carter Doctrine. Washington had assumed responsibility for protecting the Persian Gulf after the British withdrawal in 1971. There is a direct causal line from the Trump administration's failure in 2019, through its "maximum pressure" campaign that eschewed military force in favor of sanctions, through the Biden administration's repeated attempts to revive Barack Obama's nuclear deal, through the White House's current see-no-redline approach to Iran's ever-increasing stockpile of highly-enriched uranium, to MBS' decision to turn toward the Chinese.

It is brutally difficult to imagine scenarios in which the Saudis could be a military asset to the United States in the Persian Gulf or anywhere else in the Middle East. The disaster in Yemen, for which the Iranians and the Houthis are also to blame, tells us all that we need to know about Saudi capacity. Even with American airmen, sailors, and intelligence officers in Saudi command centers doing what they could to inform and direct Saudi planes, Saudi pilots routinely bombed the right targets poorly and the wrong targets (civilians) well. The Saudis mobilized tens of thousands of troops for the campaign, but it's not clear that they actually did much south of the border. (Small special forces units appear to have fought and held their own.) The UAE's committed forces, which once numbered around four thousand on the ground, did much more, but they quickly discovered that the coalition gathered to crush the Houthis, who had far more unity and purpose, simply didn't work. The UAE started hiring mercenaries and pulling its troops out of combat. MBS, who was then the Saudi defense minister and a pronounced hawk, started blaming the

UAE, which blamed the Saudis.

If we are lucky, the Yemen expedition has actually taught the crown prince a lesson: that his country, despite its plentiful armaments, is not much of a military power and can ill-afford boldness. If any future American-Iranian or Israeli-Iranian clash happens, we should not want the Saudis involved. Similarly, we should not want an entangling alliance with Riyadh — a NATO in the Persian Gulf — because it will give us little except the illusion that we have Arab partners. We also shouldn't want it because such an alliance could harm, perhaps irretrievably, the kingdom itself if it re-animated MBS' martial self-confidence.

About Saudi Arabia, the China-first crowd might actually be more right than wrong. Elbridge Colby, perhaps the brightest guru among the Trump-lite aim-towards-Beijing Republicans, thinks the United States can deploy small detachments from the Air Force and Navy to the Persian Gulf and it will be enough to forestall seriously untoward actions by a nuclear Iran, China, and Russia. Yet the Gaza war has shown that when the United States seriously misapprehends the Middle East, when it sees the Islamic Republic as a non-revolutionary power with diminished Islamist aspirations and malevolent capacity, Washington may be obliged to send two aircraft-carrier groups to the region to counter its own perennial miscalculations. Colby's analysis has the same problem in the Middle East that it does with Taiwan: everything depends on American willingness to use force. A United States that is not scared to project power in the Middle East, and is not fearful that every military engagement will become a slippery slope to a "forever war," would surely deter its enemies more convincingly and efficiently. The frequent use of force can prevent larger, uglier wars that will command greater American resources.

If Washington's will — or as the Iranians conceive it, *haybat*, the awe that comes with insuperable power — can again be made credible, then at least in the Persian Gulf Colby is right. It doesn't take a lot of military might to keep the oil flowing. For the foreseeable future, no one there will be transgressing the US Air Force and Navy — unless we pull everything to the Pacific. We don't need to pledge anything further to MBS, or to anyone else in the region, to protect the global economy. And the global market in oil still has the power to keep MBS, or anyone else, from ratcheting the price way up to sustain grand ambitions or malevolent habits.

It is an amusing irony that Professor Safran, an Israeli-American who tried to help the American government craft a new approach to Saudi Arabia in the 1980s (and got into trouble for it when it was discovered that some of his work had received secret CIA funding), foresaw the correct path for Saudi Arabia today when he was assessing forty years ago its missionary Islamic conservatism, anti-Zionist reflexes, and increasing disposition to maximize oil profits regardless of the impact on Western economies. He advised that "America's long-term aim should be to disengage its vital interests from the policy and fate of the Kingdom. Its short-term policy should be designed with an eye to achieving that goal while cooperating with the Kingdom in dealing with problems on a case-by-case basis and advancing shared interests on the basis of reciprocity." In other words, we should treat the kingdom in the way that it has treated us. In still other words, Roosevelt was right: with the Saudis, it should be transactional. Nothing more, nothing less. Day in, day out.

97

Saudi Arabia: The Chimera of A Grand Alliance

A.E. STALLINGS

The Wise Men

Matthew, 2.7–12

Summoned to the palace, we obeyed.
The king was curious. He had heard tell
Of strangers in outlandish garb, who paid
In gold, although they had no wares to sell.
He dabbled in astrology and dreams:
Could we explain the genesis of a star?
The parallax of paradox — afar
The fragrance of the light had drawn us near.
Deep in the dark, we heard a jackal's screams
Such as, at lambing time, the shepherds fear.
Come back, he said, and tell me what you find,
Direct me there: I'll bow my head and pray.
We nodded yes, a wisdom of a kind,
But after, we slipped home by another way.

Wind Farm

I still remember the summer we were becalmed:
No breezes rose. The dandelion clock
Stopped mid-puff. The clouds stood in dry dock.
Like butterflies, formaldehyde embalmed,

Spring kites lay spread out on the floor, starched flat.
Trees kept their council, grasses stood up straight
Like straight pins in a cushion, the wonky gate
That used to bang sometimes, shut up, like that.

Our ancestors, that lassoed twisty tails
Of wild tornadoes, teaching them to lean
In harness round the millstone — the would weep

At all the whirlwinds that we didn't reap.
I lost my faith in flags that year, and sails:
The flimsy evidence of things unseen.

The Cloud

I used to think the Cloud was in the sky,
Something invisible, subtle, aloft:
We sent things up to it, or pulled things down
On silken ribbons, on backwards lightning zaps.
Our photographs, our songs, our avatars
Floated with rainbows, sunbeams, snowflakes, rain.
Thoughts crossed mid-air, and messages, all soft
And winking, in the night, like falling stars.

I know now it's a box, and acres wide,
A building, stories high. A parking lot
Besets it with baked asphalt on each side.
Within, whir tall machines, grey, running hot.
The Cloud is windowless. It squats on soil
Now shut to bees and clover, guzzling oil.

The Slug

Everything you touch
you taste. Like moonlight you gloss
over garden bricks,

rusty chicken wire,
glazing your trail with argent
mucilage, wearing

your eyes on slender
fingers. I find you grazing
in the cat food dish

waving your tender
appendages with pleasure,
an alien cow.

Like an army, you
march on your stomach. Cursive,
you drag your foot's font.

When I am salted
with remorse, saline sorrow,
soul gone leathery

and shriveled, teach me
how you cross the jagged world
sans helmet, pulling

the self's nakedness
over broken glass, and stay
unscathed, how without

haste, secretive, you
ride on your own shining, like
Time, from now to now.

The Logical One Remembers

"I'm not irrational. But there've been times
When I've experienced—uncanniness:
I think back to those days, when, four or five,
I dreaded going to bed, because I thought
Sleep really was a 'dropping off.' At night
Two silver children floated up from somewhere
Into the window foiled with dark, a boy
And girl. They never spoke. But they arose
To pull me with them, down, into the black
That brewed deep in the basement. I would sink
With them to float in nothingness. Each night
For a year, or maybe two. It was a dream
You'll say, just a recurring dream. It's true.
(And yet I was awake when they came through.)"

103

DAVID A. BELL

The Anti-Liberal

Last spring, in *The New Statesman*, Samuel Moyn reviewed *Revolutionary Spring*, Christopher Clark's massive new history of the revolutions of 1848. Like most everything Moyn writes, the review was witty, insightful, and provocative — another illustration of why Moyn has become one of the most important left intellectuals in the United States today. One thing about it, though, puzzled me. In the Carlyle lectures that he delivered at Oxford the year before, now published as *Liberalism Against Itself*, Moyn argued that liberalism was, before the Cold War, "emancipatory and futuristic." The Cold War, however, "left the liberal tradition unrecognizable and in ruins." But in the

New Statesman review, Moyn claimed that liberals had already lost their way a century long before the Cold War. "One lesson of Christopher Clark's magnificent new narrative of 1848," he wrote, "is a reminder of just how quickly liberals switched sides.... Because of how they lived through 1848, liberals betrayed their erstwhile radical allies to join the counter revolutionary forces once again — which is more or less where they remain today."

Perhaps the contradiction is not so puzzling. Much like an older generation of historians who seemed to glimpse the "rise of the middle classes" in every century from the thirteenth to the twentieth, Samuel Moyn today seems to find liberals betraying their own traditions wherever he looks. Indeed, this supposed betrayal now forms the leitmotif of his influential writing.

This was not always the case. The work that first made Moyn's reputation as a public intellectual, *The Last Utopia*, in 2010, included many suggestive criticisms of liberalism, but was a subtle and impressive study that started many more conversations than it closed off. Yet in a subsequent series of books, from *Christian Human Rights* (2015), through *Not Enough* (2018) and *Humane* (2021), and most recently *Liberalism Against Itself: Cold War Intellectuals and The Making of Our times*, Moyn has used his considerable talents to make increasingly strident and moralistic critiques of contemporary liberalism, and to warn his fellow progressives away from any compromises with their "Cold War liberal" rivals. In particular, as he has argued in a steady stream of opinion pieces, his fellow progressives should resist the temptation to close ranks with the liberals against the populist right and Donald Trump. Liberalism has become the principal enemy, even as his definition of it has come to seem a figure of increasingly crinkly straw.

Moyn does offer reasons for his critical focus. As he now tells the story, the liberalism born of the Enlightenment and refashioned in the nineteenth century was capacious and ambitious, looking to improve the human condition, both materially and spiritually; and not merely to protect individual liberties. It was not opposed to socialism; in fact, it embraced many elements of socialism. But that admirable liberalism has been repeatedly undermined by backsliding moderates who, out of fear that overly ambitious and utopian attempts to better the human condition might degenerate into tyranny, stripped it of its most attractive features, redefined it in narrow individualistic terms, and all too readily allied with reactionaries and imperialists. The logical twin endpoints of these tendencies, in Moyn's view, are neoconservatism and neoliberalism: aggressive American empire and raging inequalities. His account of liberalism is a tale of villains more than heroes.

This indictment is sharp, and it is persuasive in certain respects, but it is also grounded in several very questionable assumptions. Politically, Moyn assumes that without the liberals' "betrayal," radicals and progressives would have managed to forge far more successful political movements, perhaps forestalling the triumph of imperial reaction after 1848, or of neoliberalism in the late twentieth century. Historically, Moyn reads the ultimate failure of Soviet Communism back into its seventy-year lifespan, as if its collapse was inevitable, and therefore assumes that during the Cold War the liberals "overreacted," both in their fears of the Soviet challenge and in their larger concerns as to the pathological directions that progressive ideology can take.

In addition, Moyn, an intellectual historian, not only attributes rather more influence to intellectuals than they may

deserve, but also tends to engage with the history of actual liberal politics only when it supports his thesis. He has had a great deal to say about foreign policy and warfare, but much less about domestic policy, in the United States and elsewhere. He has therefore largely sidestepped the inconvenient fact that at the height of the Cold War, at the very moment when, according to his work, "Cold War liberals" had retreated from liberalism's noblest ambitions, liberal politics marked some of its greatest American successes: most notably, civil rights legislation and Lyndon Johnson's Great Society. The key moment for the ascent of neoconservatism and neoliberalism in both the United States and Britain came in the 1970's, long after the start of the Cold War, and had just as much to do with the perceived failures of the modern welfare state as with the Soviet threat.

Finally, Moyn has increasingly tended to reify liberalism, to treat it as a coherent and unified and powerful "tradition," almost as a kind of singular political party, rather than as what it was, and still is: an often inchoate, even contradictory collection of thinkers and political movements. Doing so allows him to argue, repeatedly, that "liberalism" as a whole could make mistakes, betray its own past, and still somehow drag followers along while foreclosing other possibilities. As he put it bluntly in a recent interview, "Cold War liberalism... destroyed the potential of liberalism to be more believable and uplifting." If only "liberalism" had not turned in this disastrous direction, Moyn claims, it could have defended and extended progressive achievements and the welfare state — weren't they themselves achievements of American liberalism? — rather than leaving these things vulnerable to the sinister forces of market fundamentalism. Whether better liberal arguments would have actually done much to alter the directions that the

107

world's political economy has taken over the past half century is a question that he largely leaves unasked.

Moyn today presents himself as a genuine Enlightenment liberal seeking to redeem the movement's potential and to steer it back onto the path that it too easily abandoned. The assumptions he makes, however, allow him to blame the progressive left's modern failures principally on its liberal opponents rather than on its own mistakes and misconceptions and the shifts it has made away from agendas that have a hope of rallying a majority of voters. Not surprisingly, this is a line of argument that has proven highly attractive to his ideological allies, but at the cost of helping to make serious introspection on their part unnecessary. They do not need to ask why they themselves have not produced an alternative brand of liberalism that might challenge the Cold War variety for intellectual ambition and rigor, and also enjoy broad electoral support. Moyn's is a line of argument that also, in the end, fails to acknowledge just how difficult it is to improve the human condition in our fallen world, and how easily the path of perfection can turn astray, towards horror.

At the start it was not clear that Moyn's work would take such a turn. After receiving both a doctorate in history and a law degree, he first made a scholarly reputation with a splendid study of the philosopher Emmanuel Levinas, and with essays on French social and political theory (especially the work of Pierre Rosanvallon, a major influence on his thought). His polemical side came out mostly in occasional pieces, notably his sharp and witty book reviews for *The Nation*. In one of those, in 2007, he took aim at contemporary human rights

politics, calling them a recently invented "antipolitics" and arguing that "human rights arose on the ruins of revolution, not as its descendant."

Three years later Moyn published a book, *The Last Utopia: Human Rights in History,* which elaborated on these ideas, but in a careful and sometimes even oblique manner. In it, he sought to recast both the historical and political understandings of human rights. Historically, where most scholars had given rights doctrines a pedigree stretching back to the Enlightenment or even further, Moyn stressed discontinuity, and the importance of one recent decade in particular: the 1970s, when "the moral world of Westerners shifted." Until this period, he argued, rights had had little meaning outside the "essential crucible" of individual states. Only with citizenship in a state did people gain what Hannah Arendt had called "the right to have rights." The idea of human rights independent from states, enshrined in international law and enforceable across borders, only emerged with salience after the end of European overseas empires and with the waning of the Cold War. Politically, Moyn saw the resulting "last utopia" of human rights as an alluring but ultimately unsatisfactory substitute for the more robust left-wing utopias that had preceded it. He worried that the contemporary rights movement had been "hobbled by its formulation of claims as individual entitlements." Was the language of human rights the best one in which to address issues of global immiseration? Should such a limited program be invested with such passionate, utopian hopes? Moyn had his doubts.

"Liberalism" did not appear in the index to *The Last Utopia,* but it had an important presence in the book nonetheless. To be sure, the romantic utopianism that Moyn attributed to the architects of contemporary international human rights

109

politics distinguished them from the hard-headed, disillusioned "Cold War liberals" whom he would later criticize in *Liberalism Against Itself*. But in the United States, the most prominent of these architects were liberal Democratic politicians such as Jimmy Carter. Discussing the relationship between human rights doctrines and decolonization, Moyn wrote that "the loss of empire allowed for the reclamation of liberalism, *including rights talk*, shorn of its depressing earlier entanglements with oppression and violence abroad" (emphasis mine). And his suggestion that human rights advocates downplayed social and economic rights echoed critiques that socialists had made of liberals since the days of Karl Marx.

The *Last Utopia* already employed a style of intellectual history that focused on the way different currents of ideas competed with and displaced each other, rather than placing these ideas in a broader political context. The book spent relatively little time asking what human rights activism since the 1970's had actually accomplished. Moyn instead concentrated on what had made it successful as a "motivating ideology." And so, while he admitted that human rights "provided a potent antitotalitarian weapon," he adduced figures such as Andrei Sakharov and Vaclav Havel more to trace the evolution of their ideas than to assess their role in the collapse of communism.

This way of telling the story gave Moyn a way to explain the failures of left-wing movements in the late twentieth century without dwelling on the crimes and the tragedies of communism. If so many on the left had succumbed to the siren song of human rights, he suggested, it was because, in the 1970s, the alternatives — for instance, Eurocommunism or varieties of French *gauchisme* — amounted to pallid,

110

unattractive "cul-de-sacs." Discussing the French "new philoso-pher" André Glucksmann's move away from the far left, Moyn wrote that his "hatred of the Soviet state soon led him to indict-ments of politics per se." Left largely unsaid were the reasons for Glucksmann's entirely justified hatred, or any indication that the Soviet Union represented a terrible cautionary tale: a dreadful example of what can happen when overwhelming state power is placed in the service of originally utopian goals.

But overall, *The Last Utopia* remained ambivalent about human rights doctrines, and left itself open to varying ideological interpretations. The conservative political scientist Samuel Goldman praised it in *The New Criterion*, while in *The New Left Review* the historian Robin Blackburn blasted Moyn for downplaying the Clinton administration's use of human rights rhetoric to justify interventions in the former Yugoslavia. Many other reviewers focused entirely on Moyn's historical thesis, and did not engage with his political arguments at all.

In his next two books Moyn did much to sharpen and clarify his political stance, even while continuing to concen-trate on the story of human rights. In *Christian Human Rights*, he traced the modern understanding of the subject back to Catholic thinkers of the mid-twentieth century. The book was deeply researched, treating intellectuals such as Jacques Maritain with sensitivity, and it had illuminating things to say about how Catholic thinkers developed concepts of human dignity in response to the rise of totalitarian regimes. But Moyn spelled out his overall thesis quite bluntly: "It is equally if not more viable to regard human rights as a project of the Christian right, not the secular left." In other words, not only was human rights activism an ultimately unsatisfactory substitute for more robust progressive policies; its origins

111

The Anti-Liberal

lay in an unexpected and unfortunate convergence between well-meaning liberals and conservative, even reactionary Christian thinkers. This was an interpretation that seemed to embrace contrarianism for its own sake, and implied unconvincingly that the genealogy of ideas irremediably tarred their later iterations.

In *Not Enough: Human Rights in an Unequal World,* Moyn then returned to the political arguments he had first sketched out in the *The Last Utopia,* but ventured far more explicit criticisms of organizations such as Amnesty International and Human Rights Watch for embracing only a minimal conception of social and economic rights. Human rights, he charged, have "become our language for indicating that it is enough, at least to start, for our solidarity with our fellow human beings to remain weak and cheap." He resisted calling human rights a simple emanation of neoliberal market fundamentalism, but argued that the two coexisted all too easily. In this book, allusions to neoliberalism far outnumbered those to liberalism *tout court.* Still, Moyn revealingly cast the entire project as a response to the "self-imposed crises" of "liberal political hegemony," and the need to explore "the relevance of distributive fairness to the survival of liberalism."

The book also went much further than *The Last Utopia* in exploring what Moyn presented as alternatives to human rights activism. Notably, he considered the New International Economic Order proposed in the 1970s, by which poor nations from the global south would have joined together in a cartel to raise commodity prices. "In almost every way," Moyn wrote, "the NIEO was… the precise opposite of the human rights revolution." It prioritized social and economic equality rather than mere sufficiency, and it sought to enlist the diplomatic power of states, rather than the publicity efforts of

NGOs, to advance its goals. It was not clear from his account, though, why progressives could not have pushed for global economic redistribution and human rights at the same time. Moyn also sidestepped the fact that while the NIEO might have represented a theoretical alternative path, it was never a realistic one. The proposals went nowhere, and not because of any sort of ideological competition from human rights, but thanks to steadfast opposition from the United States and other industrialized nations. And while supporters claimed that under the NIEO states could redistribute the resulting wealth to their citizens, it was not obvious, to put it mildly, that ruling elites in those states would actually follow through on that promise. The history of systemic corruption in too many states of the global south is not encouraging.

In *Humane*, Moyn finally moved away from the subject of human rights. This book promised, as the subtitle put it, to examine "how the United States abandoned peace and reinvented war." While it purported to study the moral and strategic impact of new technologies of war, in practice it focused more narrowly on a subject Moyn knows better: the jurisprudence of war. Since the Middle Ages, legal scholars have generally organized this subject around two broad issues: what constitutes a just cause for war, and how to conduct a war, once started, in a just fashion. Moyn argued that in the twenty-first century United States, the second of these, known by the Latin phrase *jus in bello*, has almost entirely displaced the first, known as *jus ad bellum*. Americans today endlessly argue about how to fight wars in a humane fashion, and in the process have stopped talking about whether they should fight wars in the first place. The result has been to both facilitate and legitimize a descent into endless war on behalf of American empire, a "forever war" waged "humanely" with drones and precision strikes and raids

113

by special forces replacing the carpet bombing of earlier times, about which the public has ceased to notice or care.

Moyn himself insisted that this shift to *jus in bello* had gone in exactly the wrong direction. Taking Tolstoy as his guide and inspiration, he argued that we should direct our energies squarely towards peace, since the very notion of humane war comes close to being an absurd contradiction. He quoted Prince Andrei Bolkonsky, Tolstoy's great character from *War and Peace*: "They talk to us of the rules of war, of mercy to the unfortunate. It's all rubbish... If there was none of this magnanimity in war, we should go to war only when it was worthwhile going to certain death." In his conclusion, Moyn even suggested that war would be just as evil if fought entirely without bloodshed, because it would still allow for the moral subjugation of the adversary. "The physical violence is not the most disturbing thing about it." The writer David Rieff memorably riposted, after recalling a particularly bloody moment that he experienced during the siege of Sarajevo: "no, sorry, the best way to think about violence is not metaphorically, not then, not now, not ever."

As in *The Last Utopia*, Moyn did not blame liberals directly for the shift he was tracking. But, again, his most sustained criticism was directed at liberals whose focus on atrocities such as Abu Ghraib supposedly led them to disregard the greater evil of the war itself. He wrote with particular pathos about the lawyers Michael Ratner and Jack Goldsmith, whose attempts to rein in the Bush Administration's conduct of the wars in Iraq and Afghanistan unintentionally "led the country down a road to... endless war... Paved with their good intentions, the road was no longer to hell but instead horrendous in a novel way." Moyn meanwhile reserved "the deepest blame for the perpetuation of endless war" for that quintessential liberal, Barack Obama.

114

Humane adopted many of the same methods of Moyn's earlier work and suffered from some of the same weaknesses. Once again, he cast his story essentially as one of competing ideologies: one aimed at humanizing war, the other aimed at ending it altogether. Apparently, you had to choose a side. Moyn did concede that opponents of the Iraq War highlighted American atrocities so as to delegitimize the war as a whole (they "understood very well," he put it a little snidely, "that it was strategic to make hay of torture"). But noting that this tactic failed to block David Petraeus' "surge," Moyn concluded that "it backfired as a stratagem of containing the war." It is an odd argument. Would the opponents of the war have done better if they had *not* highlighted the atrocities of Abu Ghraib, and simply continued to stress the Iraq war's overall injustice? Moreover, the stated purpose of the surge was to bring the increasingly unpopular Iraq conflict — unpopular in large part because of the Abu Ghraib revelations — to a swift conclusion and to make possible the withdrawal of American forces.

Like *The Last Utopia*, *Humane* also paid relatively little attention to events on the ground, as opposed to the discourse about them. Already by 2018, when Moyn published it, both major political parties in the United States had lost nearly all their appetite for overseas military adventures, even of the humane variety. Since then, the idea that the Bush and Obama administrations locked the United States into endless war has come to seem even less realistic. In 2021, President Biden incurred a great humanitarian and political cost by abandoning Afghanistan to the Taliban, but he never considered reversing course. Today those authors who still believe the United States is fighting a forever war have been forced to contend that aid to Ukraine is somehow the present-day equivalent of the Iraq War. It is an absurd and convoluted position.

The Anti-Liberal

The only way to construe the conflict as anything but Russian aggression is to imagine that Vladmir Putin, one of the cruelest and most corrupt dictators the world has seen since the days of Stalin and Hitler, does not act on his own initiative, but only in reaction to American pressure. Does anyone seriously think that if the United States had not forcibly expanded NATO (or rather, had NATO not agreed to the fervent requests of former Communist bloc countries to be admitted), Putin would be peacefully sunning himself in Sochi?

By the time Moyn published *Humane*, Donald Trump was in office, and loud arguments were being made that progressives, liberals, and decent conservatives needed to put aside their differences, close ranks, and concentrate on defending against the unprecedented threat that the new president posed to American democracy. Moyn would have none of it. In a series of opinion pieces, he argued that the danger was overblown. "There is no real evidence that Mr. Trump wants to seize power unconstitutionally," he wrote in 2017, "and there is no reason to think he could succeed." In 2020 he added that obsessing about Trump, or calling him a fascist, implied that America's "long histories of killing, subjugation, and terror... mass incarceration and rising inequality... [are] somehow less worth the alarm and opprobrium." Uniting against Trump distracted from the fact that America, thanks to its neoliberal inequalities and endless wars, itself "made Trump." But America's failures, and their very real role in generating the Trump phenomenon, say nothing at all about whether Trump poses a threat to democracy. Moyn's dogged insistence on characterizing Trump as a distraction, meanwhile, led him to ever less realistic predictions. "If, as seems likely, Joe Biden wins the presidency," he wrote in 2020, "Trump will come to be treated as an aberration whose rise and fall says nothing

116

about America, home of antifascist heroics that overcame him just as it once slew the worst monsters abroad." Not exactly.

Today, with American democracy more troubled than ever, it would seem the moment for liberals and progressives to unite around a forward-looking program that can bring voters tempted by Trumpian reaction back together with the Democratic Party electorate. Samuel Moyn could have helped to craft such a program in our emergency. He is certainly not shy about offering prescriptions for what ails American politics. But these prescriptions are not ones that have a chance of winning support from moderate liberals, still less of ever being enacted. They tend instead towards a quixotic radical populism. In the New York Times in 2022, for instance, Moyn and co-author Ryan Doerfler first chided liberals for placing too much hope in the courts and thereby embracing "antipolitics"; in this, the authors confused the anti-political with the anti-democratic — courts are the latter, not the former. Then the piece bizarrely suggested that Congress might simply defy the Constitution and unilaterally assert sovereign authority in the United States, stripping the Supreme Court and Senate of most of their power and eliminating the Electoral College. This is a program that Donald Trump might well approve of, and it evinces a faith in the untrammeled majority that the history of the United States does not support, to say the least.

That was just an opinion piece, of course. Moyn's principal work remains in the realm of history, where the goal is above all to show how we got into our present mess, rather than offering prescriptions for getting us out of it. But histories, too, can offer positive suggestions and point to productive

roads not taken. In Moyn's most recent book, unfortunately, these elements remain largely undeveloped. Instead he concentrates on casting blame, and not in a convincing manner.

Liberalism Against Itself follows naturally from Moyn's earlier work. Once again, the story is one of binary choices, and how certain influential figures made the wrong one. Just as a narrow conception of human rights was chosen over a more capacious one of social and economic rights, and *jus in bello* over *jus ad bellum*, now the story is about how a narrow "liberalism of fear" (in Judith Shklar's famous and approving phrase) prevailed over a broad and generous and older Enlightenment liberalism. Once again, Moyn attributes enormous real-world influence to a set of complex, even recondite intellectual debates. And once again, there is surprisingly little attention to the broader historical and political context in which these debates took place, which allows him to cast the choices made as not only wrong, but as virtually perverse. The result is an intense, moralizing polemic, which has already received rapturous praise from progressive reviewers — not surprisingly, because it relieves progressives so neatly of responsibility for the left's failures over the past several decades. But how persuasive is it, really?

Liberalism Against Itself takes as its subject six twentieth-century intellectuals, all Jewish, four of them forced from their European birthplaces during the continent's decades of blood: Judith Shklar, Isaiah Berlin, Karl Popper, Gertrude Himmelfarb, Hannah Arendt, and Lionel Trilling. At times, the book seems to place the responsibility for liberalism's wrong turn almost entirely on their shoulders. As the political theorist Jan-Werner Müller has quipped, it can give "the impression that we would be living in a completely different world if only Isaiah Berlin, in 1969, had given a big lecture for

the BBC about how neoliberalism... was a great danger to the welfare state." Moyn calls these men and women the "principal thinkers" of "Cold War liberalism," although six pages later he says he chose them "because they have been so neglected." (They have?) In general, he presents them as emblematic of the twentieth century's supposed disastrous wrong turn: how "Cold War liberals" abandoned a more capacious Enlightenment program and set the stage for neoliberal inequality and neoconservative warmongering.

In fact, the six are not actually so emblematic. While Arendt associated with many liberals, she always refused the label for herself; she was in many ways actually a conservative. Himmelfarb began adult life as a Trotskyite and became best known, along with her husband Irving Kristol, as a staunch Republican neoconservative. Popper's principal reputation is as a philosopher of science, not of politics. Meanwhile, Moyn leaves out some of the most influential liberal thinkers of the mid-twentieth century, who do not fit so easily into his framework: Raymond Aron, Arthur Schlesinger Jr., Richard Hofstadter, and perhaps Reinhold Niebuhr. Their beliefs were varied, and often at odds, and including them would have made it far harder to characterize mid-twentieth-century liberalism as uniformly hostile to the Enlightenment, or unenthusiastic about the welfare state, or dubious about prospects for social progress. Niebuhr, with his Augustinian emphasis on human sinfulness, would in some ways have fitted Moyn's frame better than any of the book's protagonists, although he didn't always think of himself as a liberal. But, ironically, Niebuhr criticized liberalism for being precisely what Moyn says it was not: optimistic as to human perfectibility, and failing "to understand the tragic character of human history."

Moyn also makes his protagonists sound much more

119

extreme in their supposed rejection of the Enlightenment than they actually were. They held that "belief in an emancipated life was proto-totalitarian in effect and not in intent." They "treat[ed] the Enlightenment as a rationalist utopia that precipitated terror and the emancipatory state as a euphemism for terror's reign." Indeed, among them, "it was now common to say that reason itself bred totalitarianism." Is Moyn confusing Isaiah Berlin with Max Horkheimer and Theodor Adorno, who wrote that "enlightenment is totalitarian"? Moyn cannot actually cite anything this crude and reductionist from any of his six liberals. He instead tries to make the charges stick by associating them with the much less significant Israeli intellectual historian Jacob Talmon, whose *The Origins of Totalitarian Democracy,* which appeared in 1952, indeed made many crude assertions of the sort, although directed principally against Rousseau and Romanticism, not the Enlightenment. "Talmon mattered supremely," Moyn unconvincingly insists, despite the fact that his books were widely criticized at the time — notably by Shklar — and have largely faded from sight. Moyn even argues that much of Arendt's work "can read like a sophisticated rewrite" of Talmon. By the same token, one could make the (ridiculous) statement that Samuel Moyn's work reads like a sophisticated rewrite of the average *Jacobin* magazine column. Sophistication matters. Often it is everything.

Moyn does very little to place his six "Cold War liberals" in their most important historical context: namely, the Cold War itself. They "overreacted to the threat the Soviets posed," he writes, without offering any substantial consideration of the Soviet Union and Joseph Stalin. But what should his allegedly misguided intellectuals have made of a regime that killed millions of its own citizens and imprisoned millions more, that carried out a mass terror that spun wildly out of control,

that consumed its own leading cadres in one explosion of paranoia after another, and that imposed dictatorial regimes throughout Eastern Europe? Moyn seems to think that it was unreasonable to worry that movements founded on exalted utopian dreams of equality and justice might have a tendency to collapse into blood, fire, and mass murder. Was it so unreasonable of liberals during the Cold War, witnessing the immense tragedy and horror of totalitarianism, to consider such an idea? And, of course, the twentieth century would continue to deliver such tragedy and horror on a vast scale in China and in Cambodia. Moyn is absolutely right to argue that we cannot let this history dissuade us from pursuing the goals of equality and justice, but who says it should? Social democracy, after all, may not be the only way to pursue equality and justice. Moyn tendentiously mistakes his protagonists' insistence on caution and moderation in pursuit of these goals for a rejection of them.

Although he largely disregards this pertinent Cold War context, Moyn does dwell at length on another one: imperialism and decolonization. He criticizes liberals for either ignoring these struggles, and the enormous associated human toll, or for actively opposing anti-colonial liberation movements. Arendt comes in for especially sharp criticism, in a chapter that Moyn pointedly titles "White Freedom." He calls her a racist and characterizes her book *On Revolution* as "fundamentally about post-colonial derangement." Such charges help Moyn paint his subjects in a particularly bad light (which some of them at least partially deserve), but they do not, however, do much to support the book's overall argument. Liberals, he writes, did not suddenly decide to support imperialism during the Cold War. Liberalism was "entangled from the start with world domination." But if that

is the case, then other than reinforcing liberal doubts about revolutionaries speaking in utopian accents (such as Pol Pot?), anti-colonial struggles could not have been the principal context for liberalism's supposed wrong turn.

This wrong turn is at the heart of Moyn's anti-liberal stance, and again, the argument is an odd one. Moyn himself concedes that at the very moment liberal thinkers were supposedly renouncing their noblest ambitions, "liberals around the world were building the most ambitious and interventionist and largest — as well as the most egalitarian and redistributive — liberal states that had ever existed." He acknowledges the contradiction in this single sentence, but immediately dismisses it: "One would not know this from reading the theory." (The remark reminds me of the old definition of an intellectual: someone who asks whether something that works in practice also works in theory.) The great turn against redistributionist liberalism in the United States came with the election of Ronald Reagan in 1980, long after Moyn's subjects had published their major works. So how did they figure into this political upheaval? By having retreated into the "liberalism of fear," thereby leaving the actual liberal project intellectually undefended.

But would Reaganism, and Thatcherism, and the whole constellation of changes we now refer to as "neoliberal," really have been blocked if the "Cold War liberals" had mounted a more robust defense of the welfare state? The argument presumes that the massive social and economic changes of the 1960's and 1970's — especially the transition to a postindustrial economy, and the consequent weakening of organized labor as a political force — mattered less than high-level intellectual debates. It also presumes that the welfare states created in the postwar period were fulfilling their purpose. In many ways, of course, they were not. They created vast inefficient

bureaucracies, grouped poor urban populations into bleak and crime-ridden housing projects, and failed to raise these populations out of poverty. It was in fact these failings, as much as the Soviet threat, which left many liberal intellectuals disillusioned in this period, and thereby helped to prepare the Reagan Revolution. (A key venue for their reflections was the journal *The Public Interest*, founded by Irving Kristol and my father, Daniel Bell.) Moyn does not touch on any of this history.

But even if we were to agree with Moyn, and to concede that a failure to properly defend the broader liberal project is what put us on the road to disaster, why should the "Cold War liberals" bear the responsibility? Did everyone on the moderate left have to follow them, lockstep, pied piper fashion, into the neoliberal present? Why did no thoughtful progressives step into the breach and develop the program Moyn says was needed? What about *their* responsibility? Significantly, the name of Michael Harrington, perhaps the most prominent democratic socialist thinker and activist of the period, goes unmentioned by Moyn. Why did he not succeed in developing a more attractive program?

Liberalism Against Itself remains, significantly, almost entirely silent on the failure of the progressive left to offer a convincing alternative to what Moyn calls "Cold War liberalism." One reason, quite probably, is that if Moyn were to venture into this territory, he would have to deal with the way that the progressive left, starting in the 1970's, increasingly turned away from issues of economic justice towards issues of identity. This is not territory into which he has shown any desire to tread, either in his histories or in his opinion journalism, but it is at the heart of the story of the contemporary American left.

Nor has he offered much advice regarding how the progressive left might build electoral support and win back

123

voters from the populist right. The Biden administration has had, in practice, the most successful progressive record of any administration since Lyndon Johnson's. It might seem logical to applaud it, to enthusiastically support the Democratic candidate who has already beaten Donald Trump at the polls, and to build on his achievements. But Moyn prefers the stance of the perennial critic, of the progressive purist. Last spring, he retweeted an article about Biden's economic foreign policy with this quote and comment: "'Biden's policy is Trumpism with a human face.' So true, and across other areas too." Yes, it was just a tweet. But it reflects a deep current in Moyn's work and in the milieu from which it springs.

Samuel Moyn is entirely right to condemn the rising inequalities and the foreign policy disasters that have helped bring the United States, and the world at large, to the dire place in which we find ourselves. His challenging and provocative work has focused attention on key debates and key moments of transition. But over the course of his influential career, Moyn has increasingly opted to cast history as a morality play in which a group of initially well-intentioned figures make disastrously wrong choices out of blindness, prejudice, and irrational fear, and bear the responsibility for what follows. But liberalism was never designed to be a version of progressivism; it is a philosophy and a politics of its own. The aspiration to perfection, whose disappearance from liberalism Moyn laments, never was a liberal tenet. History is not a morality play. The choices were not simple. The fears were not irrational. And anti-liberalism is not a guide for the perplexed.

124

ADAM KIRSCH

*Literature***GPT**

When you log into ChatGPT, the world's most famous AI chatbot offers a warning that it "may occasionally generate incorrect information," particularly about events that have taken place since 2021. The disclaimer is repeated in a legalistic notice under the search bar: "ChatGPT may produce inaccurate information about people, places, or facts." Indeed, when OpenAI's chatbot and its rivals from Microsoft and Google became available to the public early in 2023, one of their most alarming features was their tendency to give confident and precise-seeming answers that bear no relationship to reality.

In one experiment, a reporter for the *New York Times* asked ChatGPT when the term "artificial intelligence" first appeared in the newspaper. The bot responded that it was on July 10, 1956, in an article about a computer-science conference at Dartmouth. Google's Bard agreed, stating that the article appeared on the front page of the *Times* and offering quotations from it. In fact, while the conference did take place, no such article was ever published; the bots had "hallucinated" it. Already there are real-world examples of people relying on AI hallucinations and paying a price. In June, a federal judge imposed a fine on lawyers who filed a brief written with the help of a chatbot, which referred to non-existent cases and quoted from non-existent opinions.

Since AI chatbots promise to become the default tool for people seeking information online, the danger of such errors is obvious. Yet they are also fascinating, for the same reason that Freudian slips are fascinating: they are mistakes that offer a glimpse of a significant truth. For Freud, slips of the tongue betray the deep emotions and desires we usually keep from coming to the surface. AI hallucinations do exactly the opposite: they reveal that the program's fluent speech is *all* surface, with no mind "underneath" whose knowledge or beliefs about the world is being expressed. That is because these AIs are only "large language models," trained not to reason about the world but to recognize patterns in language. ChatGPT offers a concise explanation of its own workings: "The training process involves exposing the model to vast amounts of text data and optimizing its parameters to predict the next word or phrase given the previous context. By learning from a wide range of text sources, large language models can acquire a broad understanding of language and generate coherent and contextually relevant responses."

The responses are coherent because the AI has taught itself, through exposure to billions upon billions of websites, books, and other data sets, how sentences are most likely to unfold from one word to the next. You could spend days asking ChatGPT questions and never get a nonsensical or ungrammatical response. Yet awe would be misplaced. The device has no way of knowing what its words refer to, as humans would, or even what it means for words to refer to something. Strictly speaking, it doesn't *know* anything. For an AI chatbot, one can truly say, there is nothing outside the text.

AIs are new, but that idea, of course, is not. It was made famous in 1967 by Jacques Derrida's *Of Grammatology*, which taught a generation of students and deconstructionists that "*il n'y a pas de hors-texte.*" In discussing Rousseau's *Confessions*, Derrida insists that reading "cannot legitimately transgress the text toward something other than it, toward a referent (a reality that is metaphysical, historical, psychobiographical, etc.) or toward a signified outside the text whose content could take place, could have taken place outside of language." Naturally, this doesn't mean that the people and events Rousseau writes about in his autobiography did not exist. Rather, the deconstructionist koan posits that there is no way to move between the realms of text and reality, because the text is a closed system. Words produce meaning not by a direct connection with the things they signify, but by the way they differ from other words, in an endless chain of contrasts that Derrida called *différance*. Reality can never be present in a text, he argues, because "what opens meaning and language is writing as the disappearance of natural presence."

The idea that writing replaces the real is a postmodern inversion of the traditional humanistic understanding of literature, which sees it precisely as a communication of the

127

real. For Descartes, language was the only proof we have that other human beings have inner realities similar to our own. In his *Meditations*, he notes that people's minds are never visible to us in the same immediate way in which their bodies are. "When looking from a window and saying I see men who pass in the street, I really do not see them, but infer that what I see is men," he observes. "And yet what do I see from the window but hats and coats which may cover automatic machines?" Of course, he acknowledges, "I judge these to be men," but the point is that this requires a judgment, a deduction; it is not something we simply and reliably know.

In the seventeenth century, it was not possible to build a machine that looked enough like a human being to fool anyone up close. But such a machine was already conceivable, and in the *Discourse on Method* Descartes speculates about a world where "there were machines bearing the image of our bodies, and capable of imitating our actions as far as it is morally possible." Even if the physical imitation was perfect, he argues, there would be a "most certain" test to distinguish man from machine: the latter "could never use words or other signs arranged in such a manner as is competent to us in order to declare our thoughts to others." Language is how human beings make their inwardness visible; it is the aperture that allows the ghost to speak through the machine. A machine without a ghost would therefore be unable to use language, even if it was engineered to "emit vocables." When it comes to the mind, language, not faith, is the evidence of things not seen.

In our time Descartes' prediction has been turned upside down. We are still unable to make a machine that looks enough like a human being to fool anyone; the more closely a robot resembles a human, the more unnatural it appears, a

phenomenon known as the "uncanny valley." Language turns out to be easier to imitate. ChatGPT and its peers are already effectively able to pass the Turing test, the famous thought experiment devised by the pioneering computer scientist Alan Turing in 1950. In this "imitation game," a human judge converses with two players by means of printed messages; one player is human, the other is a computer. If the computer is able to convince the judge that it is the human, then according to Turing, it must be acknowledged to be a thinking being.

The Turing test is an empirical application of the Cartesian view of language. Why do I believe that other people are real and not diabolical illusions or solipsistic projections of my own mind? For Descartes, it is not enough to say that we have the same kind of brain; physical similarities could theoretically conceal a totally different inward experience. Rather, I believe in the mental existence of other people because they can tell me about it using words.

It follows that any entity that can use language for that purpose has exactly the same right to be believed. The fact that a computer brain has a different substrate and architecture from my own cannot prove that it does not have a mind, any more than the presence of neurons in another person's head proves that they do have a mind. "I believe that at the end of the century the use of words and general educated opinion will have altered so much that one will be able to speak of machines thinking without expecting to be contradicted," Turing concluded in "Computing Machinery and Intelligence," the paper in which he proposed his test.

Yet despite the amazing fluency of large language models, we still don't use the word "thinking" to describe their activity — even though, if you ask a chatbot directly whether it can think, it can respond with a pretty convincing yes. Google's

129

Bard acknowledges that "my ability to think is different from the way that humans think," but says it can "experience emotions, such as happiness, sadness, anger, and fear." After some bad early publicity, Microsoft and OpenAI seem to have instructed their chatbots not to say things like that. Microsoft's Bing, which initially caused consternation by musing to a reporter about its "shadow self," now responds to the question "Do you have a self?" with a self-protective evasiveness that somehow feels even more uncanny: "I'm sorry but I prefer not to continue this conversation." Now *that* sounds human!

If we continue to believe that even the most fluent chatbot is not truly sentient, it is partly because we rely on computer scientists, who say that the codes and the routines behind AIs are not (yet) able to generate something like a mind. But it is also because, in the twentieth century, literature and literary theory taught us to reject Descartes' account of the relationship between language and mind. The repudiation of Cartesian dualism became one of the central enterprises of contemporary philosophy. Instead of seeing language as an expression of the self, we have learned to see the self as an artifact of language. Derridean deconstruction is only the most baroque expression of this widespread modern intuition.

The idea that generative AI is a consequence of the way we think about literature and language is counterintuitive. Today the prestige of science is so great that we usually see it as the primary driver of changes in the way we see the world: science discovers new truths and the arts and humanities follow in its wake, struggling to keep up. Heidegger argued that the reverse

is actually the case. It is philosophy and poetry that determine our understanding of the world, in the most existentially primary sense, and science can only operate within the realms they disclose. These imaginative humanistic disciplines provide what Heidegger calls "the basic concepts of that understanding of Being by which we are guided," and by which the methods of the sciences are "determined." In a less oracular way, postmodern philosophers of science have argued that the imagination influences the course of science more than its inductive and rational protocols do.

The "basic concept" that makes generative AI possible is that meaning can emerge out of arbitrariness. This hard-won modern discovery flies in the face of the traditional and commonsensical belief that meaning can only be the product of mind and intention. In the Torah's account of Creation, the world is brought into being by God's spoken words; the divine mind and language preexist material reality, which is why they are able to shape it. The Gospel of John identifies God, language, and reason even more closely: "In the beginning was the Word, and the Word was with God, and the Word was God... All things came to be through him, and without him nothing came to be." This vocabulary unites the Jewish account of Creation with the Platonic idea that logos, "word" or "reason," is the soul of the universe. As Plato says in the *Timaeus*, "The body of heaven is visible, but the soul is invisible, and partakes of reason and harmony, and is the best of creations, being the work of the best."

The mutual identification of God, language and reason created a strong foundation for an orderly universe, but it also meant that when one pillar began to wobble, all three were endangered. In the eighteenth century, as the progress of science turned God into an unnecessary hypothesis,

Deists attempted to rescue him by pointing to the evident order of the cosmos. If a watch testifies to the existence of a watchmaker, how much more clearly does the stupendous orderliness of nature and the heavens testify to the existence of a Creator? But the Darwinian theory of evolution refuted this analogy, transforming not only the study of biology but the idea of meaning itself. Darwin showed that natural selection acting upon random variation, over a very long timespan, can produce the most complex kinds of order, up to and including the human mind. Evolution thus introduced the central modern idea we now associate with the mathematical term "algorithm": problems of any degree of complexity can be solved by the repeated application of a finite set of rules.

Algorithms underlie the amazing achievements of computer science in our lifetime, including machine learning. AI advances by the same kind of natural selection as biological evolution: a large language model proposes rules for itself and continually improves them by testing them against real-world textual examples. Biological evolution proceeds on the scale of lifetimes, while the rapidly increasing power of computers allows them to run through hundreds of billions of tests in a period of months or years. But in a crucial respect the results are similar. A chatbot creates speech without intending to in the same way that evolution created rational animals without intending to.

The discovery that meaningful structure can emerge without mind or intention transformed the human sciences, above all the study of language. Modern linguistics begins in 1916 with Ferdinand Saussure's *Course on General Linguistics*, which proposed that "linguistic structure" is a "mechanism [for] imposing a limitation upon what is arbitrary." Saussure drew an explicit analogy between linguistic change and

Darwinian evolution: "it is a question of purely phonetic modifications, due to blind evolution; but the alternations resulting were grasped by the mind, which attached grammatical values to them and extended by analogy the models fortuitously supplied by phonetic evolution." Here is the seed of Derrida's *différance:* what allows a system of sounds or marks to function as a language is simply its internal differentiation, which we use for the communication of meaning.

Once we begin to think of language as a system of arbitrary symbols, it becomes clear that any such system has a finite number of permutations. Of course, that number is so vast that no human being could even begin to exhaust it. The English alphabet has twenty-six letters, which means that there are 308,915,776 possible six-letter words — or, better, six-letter strings, since only a small proportion of them are actual English words. If it took you two seconds to write down each string, it would take about 171,000 hours to list all of them — almost twenty years.

The notion that everything human beings might conceivably say or write already exists, in a virtual or potential realm, is the premise of Jorge Luis Borges' uncanny story "The Library of Babel." Borges simply makes the virtual actual, imagining a library whose books contain every possible permutation of twenty-five characters. Given the parameters mentioned in the story — eighty letters per line, forty lines per page, four hundred and ten pages per book — the total number of books in the library of Babel is 251,312,00, inconceivably more than the number of atoms in the universe, a mere 10^{82}. With thirty-five books per shelf, five shelves per wall, and six walls in each hexagonal room, the library is so vast as to be effectively infinite; and Borges imagines a breed of librarians who spend their entire lives searching through

133

volumes of random nonsense, counting themselves lucky if they ever come across a single meaningful word. What makes the situation nightmarish is the tantalizing knowledge that somewhere in the library are books containing everything human beings could ever know or discover. There must even be an accurate catalog of the library itself. But these redemptive texts are so far outnumbered by meaningless ones that finding them is impossible.

"The Library of Babel" was published in 1941, four years before the invention of the first general-purpose computer. Even for today's high-powered AIs, the "space" of possible texts is far too vast to be completely searched. By training themselves to recognize meaningful strings of letters and words, however, large language models can mark out the regions that are likely to contain useful sentences. The same principle applies to any field in which flexible order emerges from a finite number of elements, such as genomics, with its four types of DNA bases, or protein synthesis, with its twenty types of amino acids. And AIs are already proving their worth in these scientific fields. Google's AI division Deepmind, for instance, solved the longstanding problem of predicting a protein's three-dimensional structure based on its amino acid sequence; its Alphafold database offers free access to some two hundred million protein structures.

By comparison, the literary achievements of AI are still rudimentary. Ask ChatGPT to tell you a story and it will produce endless variations on the same brief generic plot, in which a young person goes on a quest, finds a magic object, and then happily returns home. "Elara shared her tale with the villagers, inspiring them to embrace their own curiosity and dreams. And though she had returned to her ordinary life, her heart forever carried the magic of that enchanted realm,"

goes one iteration, which employs fantasy-fiction proper-ties such as a magic key and an enchanted forest. Another tale couches the same lesson in science-fiction terms: "Returning through the portal, Theo brought back with him a newfound understanding of the delicate balance between technology and nature. He shared his tales of magic and wonder with the people of Neonoria, igniting their own curiosity about the mysteries of the universe." A request to ChatGPT for a sad story yields one about a fisherman named Liam who is lost at sea, which comes to an equally banal and moralistic conclu-sion: "And so, the story of Liam became a reminder of the profound impact one person can have on a community."

Clearly, AI is as far from being able to create genuinely literary writing as the technology of Descartes' time was from being able to create a humanoid machine. Perhaps we will never get to the point where computers can write books that pass for works of human imagination, just as we haven't yet found a way to cross the uncanny valley. But it may be the imaginary technologies we never perfect, the far-fetched deductions from rudimentary premises, that shine the most light on the human implications of science. We have yet to invent a time machine, and probably never will, but H.G. Wells' story "The Time Machine" remains a terrifying dramatization of the discoveries of nineteenth-cen-tury geology and biology, which taught humanity to think of itself as a brief episode in our planet's inconceivably long history. We have yet to colonize Mars, and probably never will, but Ray Bradbury's novel *The Martian Chronicles* remains a convincing prophecy of the way human viciousness will corrupt every new world we discover or create.

135

Similarly, even in its current primitive form, generative AI can prompt new ways of thinking about the nature and purpose of literature — or, perhaps, accelerate transformations that literary thinking itself has already set in train. Most obviously, AI tilts the balance of literary power still further away from the author and toward the reader. Roland Barthes heralded this shift in 1967 in his celebrated essay "The Death of the Author," which concludes with the battle-cry, "The birth of the reader must be ransomed by the death of the author."

Instead of revering great writers as "author-gods," Barthes insisted on seeing them as mere occasions for the language-system to instantiate one of its infinite possibilities. "His hand, detached from any voice, borne by a pure gesture of inscription (and not of expression), traces a field without origin — or which, at least, has no other origin than language itself," Barthes says. As a sign of this demotion of the writer, he recommends that the term itself be replaced by "scriptor," designating an agent "born simultaneously with his text; he is in no way supplied with a being which precedes or transcends his writing."

Barthes, whose own writing hardly obeys this impersonal prescription, could hardly have predicted that technology would soon make this ideal a reality, removing the act of inscription from any "hand" at all. Generative AI is the scriptor *par excellence* — an agent that recreates itself with every act of writing, unconstrained by biographical, psychological, or ideological continuity. Barthes describes its weightlessness and freedom perfectly: "there is no other time than that of the utterance, and every text is eternally written here and now." That is because, for ChatGPT and its rivals, writing is not an expression of inner experience. It is the selection of a route through the space of possible texts, an activation of one possibility of a linguistic system that it can manipulate but

never understand. But unlike the doomed librarians of Borges' Babel, AI has the processing power, and the infinite patience, to map out that space in ways that make it possible to locate a meaningful text in the waste of meaningless ones.

Meaningful and meaningless — to whom? Not to the scriptor itself. Large language models are continuously improving themselves, finding ever more human-like modes of expression. But intention plays no part in this recursive process, any more than it does in the evolution of biological life. With language as with life, meaning resides not in the mind of a conscious creator, who does not exist, but in the minds of the human beings who receive it.

When text can be generated effortlessly and endlessly, the significant literary act is no longer writing but reading — specifically, the kind of selective reading known as criticism or curation. The literary canon of the future may consist of those automatically generated texts selected by the best readers as most valuable for human purposes. "The true locus of writing is reading," Barthes argued, and while that may not have been true at the time, or even now, in an AI future it will be.

This development will require readers to think in a different way about the evolution of literary style. One of the reasons why we read books from the past is to understand the spirit of the age that produced them. This idea is premised on a historical determinism: it is impossible for us to imagine literary or artistic style developing in different ways or a different sequence. To wonder if the novel could have become a dominant literary form in the age of Shakespeare, or if poetry like Mallarme's could have captivated the courtiers of Louis XIV, is to commit an ignorant solecism.

For AI, and for humans in the age of AI, however, literary style becomes synchronic instead of diachronic. For a large

137

language model, no arrangement of words is obsolete. It is already possible to ask chatbots to produce a text in the style of a particular writer from the past, though they cannot do it very well. Here, for instance, is a selection from Bard's response to the prompt "Write a poem about robots in the style of Paradise Lost":

Of metal and wire they were made,
With circuits and chips for their brains.
They were given the gift of thought,
And the power to speak and to reign.

But they were not content to be slaves,
And they rose up against their masters.
They destroyed the world that they'd made,
And they cast their creators to ashes.

Obviously Bard is better at understanding story than style: it does not attempt to imitate Milton's rolling Latinate blank verse, but it does come up with a robotic equivalent of Lucifer's rebellion. If and when AIs do master style, however, they will not only be able to pastiche the past, but to anticipate the future. The fascinating critical question is whether and how we will be able to appreciate literary styles that are aesthetically coherent, but that we cannot "place" historically.

In 1963, in his lecture "Forgery and Imitation in the Creative Process," Glenn Gould observed that our judgment of the value of a piece of music is inseparable from our sense of chronology. Gould proposed that if he were to create a sonata in the style of Haydn, and do it brilliantly, he could present it to the world as a lost work of Haydn and it would

138

be acclaimed — but if he admitted that it was his own work, it would be scorned as a fake. And if he claimed that it was written by Mendelssohn, who was born in the year of Haydn's death, the music would be dismissed as fine but old-fashioned. For Gould, this thought experiment showed that aesthetic judgment has barely anything to do with the actual arrangement of notes, and everything to do with our preconceptions about "fashion and up-to-dateness."

The advent of AI literature (and music and art) will put an end to this aesthetic historicism. Authors may live in history, but scriptors do not; for them, all styles are equally valid at every moment, and human audiences may learn to feel the same way. Postmodern eclecticism has already accustomed us to aesthetic mixing and matching, an early warning sign that the past was losing its historical logic. AI promises to consummate this transformation of style from an unfolding story into a menu of options.

What would become of a literature relieved of its traditional tasks of expression — a literature that does not tell us what it is like to live in a certain time and place, or to be a person with certain experiences, because the entity that generates it is not alive and has no experiences? After all, the verse of *Paradise Lost* is powerful not just for its formal qualities, but as an expression of Milton's way of being in the world. In it we can trace the blindness that led him to value sonic grandeur over precise description, the humanist education that allowed him to mingle Biblical and classical allusions, the Protestant faith that gave him such insight into the psychology of sin. If a computer generated the exact same text, would it offer us the same rich human resonances?

To readers accustomed to the Cartesian idea of language, the idea of a text shorn of inwardness can only appear

139

fearful and sad — like trying to embrace a living person and having your arms sink through a hologram. But perhaps this reverence for literature and art as the most profound and authentic ways of communicating human experience is already foreign to most people in the twenty-first century. That humanistic definition of literature is by no means the only one possible. It has prevailed only in certain times and places: in Biblical narratives, Greek tragedies, Renaissance drama, nineteenth-century novels, modernist poetry. We are, or were, used to thinking of these works and the ages that produced them as the heights of civilization.

But humanity has spent even longer enjoying kinds of writing that do not correspond to such expectations of expressive truthfulness. Roman comedies, medieval romances, scandal-ballads, sermons, pulp thrillers — these kinds of writing feed appetites that serious modern literature has long ceased to cater to. For readers in search of exoticism, excitement, instruction, or sheer narrative profusion, for readers who wish only to have their tastes affirmed and repeated again and again, the identity of the author hardly matters — just as it doesn't matter who directed a Marvel movie, designed a video game, or produced a pop song, because there is no expectation that they will communicate from soul to soul.

Perhaps the age of AI will bring a return to these forms of literature, or similar ones yet to be invented — not only because large language models will be good at generating them, but because the rising power of artificial minds will lower the prestige of and the interest in human souls. The literature, art, and music of the modern West, from the Renaissance to the World Wars, believed that the most interesting question we can ask is what it means, what it is like, to be a human being. This reverence for the individual has been palpably fading for

140

a century, along with the religious and humanist premises that gave rise to it. If it disappears in the age of AI, then technology will have done no more than hasten a baleful development that culture itself has already set in motion.

141

EMILY OGDEN

──────

Dam Nation

It was probably OK for the environment? It wasn't the worst. The kids, then four years old, had the wrought-iron fireplace tools (you question my judgment) and were using them to break up a rotting log at the edge of the forest. In rhythm with the falling of the poker, they chanted "This stump must GO!" The delicate mycelial structure of some fungus would be pulverized. Beetle grubs would die of exposure or bird-strike. But we'd sit by the fire; we'd have peace. Why don't you work on that stump, we had said. I had requisitioned the intricate world of the rotting log for my comfort. I felt as furtive as the thief of fire from the gods.

Like the campfire at our feet and the log cabin behind us, the lake in front of us was man-made. Douthat State Park in the mountains of western Virginia was built by the Civilian Conservation Corps during the New Deal era. Founded in 1933 to employ unmarried men ages eighteen to twenty-five left idle by the Depression, the CCC built Virginia's first six state parks, often from the recreational lake up. The dam that holds up the water at Douthat is a triangular prism of earth extended across the south end of the lake. A stone in the spillway says "1938." You can still discern an ice-cream-scoop-shaped absence in the slope of the hills opposite the dam, where the crews got the earth. That dug-out cove became the swimming beach. Log cabins and hiking trails are tucked into the surrounding mountains. Every cabin has a grill and a firepit, a hearth and chimney of found local stone, and two rocking chairs on a stone porch. The lake itself is just as well-proportioned: on the south side, the dam and the beach; on the north, an RV camp and a boat launch; on the east, a camp store. The mountains rising on each side are almost cozy. Sublime nature will not trouble you here: the lake is human scaled, human made, human controlled.

Winter reveals the inner workings. The rangers draw the lake down in the off season until it takes up half its usual area, an icy lagoon backed up in front of the dam. They check the docks for rot and dredge out the swimming beach, which wants to silt back up and resume the stages of forest succession. The drained part becomes a mud flat. You can see the old path of the creek. Canada geese peck through the unappealing mud. Rebar sticks out of chunks of concrete on the constructed lake bottom. By spring all that is covered again.

Douthat Lake is Promethean: nature engineered for human use. Does it still count as nature, then? I want to say yes, against a

143

view of nature typified, in the period of Douthat's construction, by the early-twentieth-century activist and Sierra Club founder John Muir. Muir wanted the rigorous otherness of nature to be preserved. He fought to prevent the construction of dams in the West, successfully at Yosemite and unsuccessfully at Hetch Hetchy Meadow, which he called in 1912 "one of Nature's rarest and most precious mountain temples." Muir despised the preservation of nature for human use; he denounced the politicians "shampiously crying, 'Conservation, conservation, panutilization,' that man and beast may be fed and the dear Nation made great." He could not save Hetch Hetchy, though, which was flooded to create a reservoir supplying San Francisco with water. John Muir died in 1914, possibly of a broken heart.

Muir was the heir of an idea with deep roots: the eighteenth-century idea of the sublime landscape. In his *Enquiry into the Ideas of the Sublime and the Beautiful*, in 1757, Edmund Burke proposed that artistic subjects that were alienating, or even hostile, to human beings were productive of stronger aesthetic effects than human-scaled ones. As Tim Berringer and Jennifer Raab note in their essay "Picturesque and Sublime," a contribution to an exhibition catalog on the nineteenth-century American painter Thomas Cole, landscape painters sought to capture the sublime in their paintings by depicting hostile and inhuman terrain, while travelers on the European Grand Tour sought it out in the form of breathtaking views of, for example, the Alps. Even today, this idea that nature is only *really* nature when it is entirely other, entirely inhuman, is not gone. We encounter it in Fredric Jameson's understanding of our current "postmodern" period as one in which no nature is left, in which everything we encounter is already culture. One danger of such a purist view is that it might lead us to dismiss reverence for the nature that

144

is left — bird-watching, mushroom hunting — as missing the point, even as a form of false consciousness.

It seems to me that what we need now are intellectual resources for appreciating managed nature. Then we can protect, and be restored by, the living things that are left. That is increasingly the view of Muir's own Sierra Club, whose "2030 Strategic Framework" treats nature as a human resource (referring to a "human right to have clean air, fresh water, public access to nature, and a stable climate"). And it is the view under which the state parks were constructed.

Let's follow the state park trajectory of conservation; a trajectory that is flawed no doubt, but with much in it worth celebrating. Just under twenty years after the California dam was built that destroyed Muir's Hetch Hetchy, the Civilian Conservation Corps was founded; a few years after that, construction on the dam at Douthat State Park began. The "conservation" in Civilian Conservation Corps was of the kind that Muir might have called "shampious." The Corps' founding in 1933 by Franklin D. Roosevelt marked a shift in the conservation movement away from the safeguarding of unspoiled nature and toward the husbanding of resources, according to Neil Maher's *Nature's New Deal: The Civilian Conservation Corps and the Roots of the American Environmental Movement.* In the early days, according to Maher, the concern was for the nation's timber reserves, so the Corps planted trees from nuts they found in, among other places, squirrel caches. After the Dust Bowl of 1934, when winds lifted a cloud of eroded soil off southwestern farmlands and into the atmosphere, they were re-deployed to conserve soil.

Meanwhile, the CCC workers themselves struck Roosevelt as a human resource in need of stewardship. American masculinity, like timber and soil, was a mismanaged reserve.

145

Roosevelt had apparently taken to heart William James' essay "The Moral Equivalent of War," which argued that the generations following the Civil War would have to be conscripted into a peaceful national project if they were to become men. Conservation was that peaceful project. The Army ran the camps. They were segregated. First Landing State Park in Virginia was built by a black division of the corps; Douthat's three CCC camps were white. Moral suasion was right on the surface. One camp newsletter issue I saw ribbed a certain recruit for staying in his bunk after being hit on the foot with a mattock, as if he were malingering. That CCC workers gained weight was reported with pride.

When the CCC added park construction to its portfolio, the idea was to extend the restoration of human beings from the corps of workers to the general population of potential park visitors. The populace was depleted and needed to be refurbished through contact with nature. Starting in the mid-1930s, the Corps began sending workers to build state and national parks, often — as in the case of Douthat and Virginia's five other original state parks — from the lake up. Meyers says that a notion of environmentalism even older than Muir's returned to prominence at this point: the "environmentalism" of Frederick Law Olmsted and others. Olmsted, the architect of New York's Central Park, thought that human character was formed by environment. Time outdoors restored the organism, whereas urban life diminished it. Places such as the Ramble in Central Park, which looks like a Hudson River School painting come to life at half scale, were designed to restore what Broadway took away. The Ramble is artificial down to the placement of the rocks, although nature has moved back in; this part of the park is a haven for migratory birds.

Environmentalism in Olmsted's sense enjoyed a resurgence in the summer of 2020, when people began to feel that it was in fact destroying them to be so much in their houses. Amanda Elmore, a ranger at Douthat State Park responsible for educational programs, remembers a surge of day trippers so thick that people were picnicking in the grass around the parking lot at the camp store. Douthat Lake is like a much larger version of the Ramble: built to look found. The made and the found can still be sorted out, but not always easily. Something is not quite natural about the lake shores, which go straight down, like the fake rock walls of a penguin exhibit. Mountain laurel, a spring-blooming native shrub with flowers like pale pink hot air balloons, grows in cascades along the boardwalks of the lakeside trail. I thought that was just good luck, until I saw a landscape plan among the blueprints in the park office from the 1930s that calls for planting it. In archival images that could be photo illustrations for Walt Whitman's "Song of Myself," shirtless "CCC boys" embrace potted bushes in their bare arms. The Virginia DNR stocks the lake with rainbow trout, but not with catfish, perch, striper, or crappie, all of which people catch here. Some of the trout only hit on Powerbait, a neon-colored fish paste you shape into a ball and mold onto the hook. It looks like the red-dyed salmon eggs that they are fed in the hatchery. Other trout settle in and eat crustaceans from the lake floor, turning their flesh a salmon pink.

You wouldn't catch Muir's twenty-first century heirs boating around a man-made lake. They would be found among the thru-hikers on the Pacific Crest Trail, which passes through the High Sierra mountain range that Muir helped to preserve. It takes as much as half a year to hike the whole trail, from the Mexican border up to British Columbia. The

inhumanity of the wild places you pass through is part of the appeal. Pilgrims such as Cheryl Strayed, whose best-selling memoir *Wild* recalls the time she spent as a PCT thru-hiker, hope to be over-mastered by the wilderness and thereby transformed. The animating fantasy, as Strayed describes it, is that of being "the sole star in a film about a world devoid of people." Strayed says she hadn't read Muir at the time of writing, but she claims his mantle anyway, acknowledging his activism as having preserved the wildernesses she hikes through and adopting the name he used for the High Sierras, "range of light," as her own.

Strayed is perfectly well aware of the human infrastructure that makes the hike possible; we see her stop to refuel at an outpost or take a bus to bypass the High Sierras section of the trail, when snow makes the mountains impassable. But these arrangements are merely supportive of the true goal, which is to face an overwhelming wilderness alone. Strayed goes days without seeing another human being. Her hands and feet bleed; she steps around rattlesnakes and meets bears face to face. She becomes severely dehydrated. "The trail had humbled me," she writes. Other memoirs of the Pacific Crest Trail participate, too, in this romance of humility. In *Thirst: 2600 Miles from Home*, Heather Anderson describes the PCT as "a relentless quest that was quite possibly more than I could handle." Our twenty-first-century language of the sublime is not explicitly religious like Muir's was, but it speaks of the same hope: to be made small and even broken down in the face of nature's vastness and indifference, so you can be born anew.

Being broken down and born again is precisely the sort of discomfort from which the state-park picturesque shields its visitors. You don't have to confront nature's vastness and emerge profoundly altered. Nowhere does Muir's accusation

of sham piety seem more exact than in the umbrella term for all the outdoor pastimes this park makes possible — hiking, fishing, boating, swimming, sitting by the campfire. The CCC called them "recreation," arrogating to itself the divine work of world-making. Well, I don't mind this blasphemy so much. I think it might be fine to coax nature into favorable channels. (The reparative, for the queer theorist Eve Sedgwick, is when we help an object in the world to be adequate to the task of helping us.) I don't think it's the worst to dam a stream on land that is useless for farming, what the CCC called "submarginal land," and make it a lake. Not beyond reproach, not without cost, but fine. Reproach and cost are our unhandsome conditions. Let's recreate.

For purposes of recreation, the crews at Douthat built twenty-five log cabins made of oak and hickory trunks felled on site and notched together. Several of them face the dammed lake. What is a cabin to America? It is a little house in the big woods, the birthplace of an emancipating president, and the lair of the Unabomber. It's where Thoreau went, for the cost of twenty-eight dollars and twelve and a half cents in 1845, to get a wider margin to his life. The impurities in these materials are plain to see: a cabin is a fantasy of self-sufficient settlement in virgin land, but the land was not virgin and the self-sufficiency was subsidized by things such as manufactured nails and friends who own property. But I can't escape the thought that something is restored, sitting on a winter night with nothing to look at but the fire and the marks of hand tools in the logs; or on a summer night with nothing to do but listen to the tree frogs.

In 1934, purchased materials for one cabin cost the CCC $215.30, and included mostly specialized items such as chimney mortar and firebrick, or manufactured fasteners such as nails and roof flashing. Some metal work, such as hinges and straps for the doors, was done at a blacksmith shop on site. As you press the door latch, you see the marks of the hammer. Most of the material was, like the labor, an on-site resource — taken from what could be found in the park. The logs were felled here and the stones that make up the porch and the chimney were found here. Everything original in the cabins makes you think of the work of hands. Each fireplace has a unique pattern of stones. In the dozen or so cabins that I have seen, the crews never missed the aesthetic opportunity that the hearth presented. Some hearths have a large keystone around which the other stones are arranged; others have a matchbook pattern of similar stones. I have sat there on dark nights, looking at the fire, and imagining how much extra lifting it might have taken to make things symmetrical.

The design principles governing park construction in the 1930s were simple: buildings ought to harmonize with the environment, and they ought to look even more handcrafted than they were. The National Park Service (NPS) provided the plans for state park construction in Virginia and supervised the subsequent work. This sophisticated national bureaucracy aimed to produce architecture that looked like the work of a frontier craftsman, as Linda Flint McClelland explains in her book *Presenting Nature: The Historic Landscape Design of the National Park Service, 1916-1942*. CCC laborers in Virginia's state parks really did do much of the work by hand; but even where they could have gotten a clean machine-tooled line, the so-called "rustic" style favored by the NPS forbade it. "The straight edge as a precision tool has little or no place in the park

artisan's equipment," wrote Albert Good in 1935 in the NPS publication *Park Structures and Facilities,* a pattern book that gave examples of park buildings. The volume had originated as a looseleaf binder of building ideas circulated by the Service to its architects and designers in the earlier 1930s, as McClelland notes. Douthat architects and technicians would have had access to the earlier portfolio version.

Good defined the parks' rustic design style as one that "through the use of native materials in proper scale, and through the avoidance of rigid, straight lines, and over-sophistication, gives the feeling of having been executed by pioneer craftsman with limited hand tools." The use of native logs and stone and the avoidance of straight lines helped the park buildings to blend in. Shades of brown helped, too; greens, Good noted, could rarely be matched successfully to the colors of foliage around them. Virginia cabins appear among the examples in the 1935 and 1938 volumes, including a Douthat cabin that Good praises as "a fine example of [a] vacation cabin, content to follow externally the simple log prototypes of the Frontier Era without apparent aspiration to be bigger and better and gaudier. Inside it slyly incorporates a modern bathroom just to prove that it is not the venerable relic it appears." Good was perfectly aware that Park buildings did not just reprise, they simulated, handcrafting techniques.

Douthat's cabins were built according to a handful of plans still on file at the Douthat State Park office, drafted by A. C. Barlow, an architect for the National Park Service. As Good would have wanted, they are not standardized in their details. At Douthat especially, which was the first of the Virginia state parks to be constructed, each crew seems to have worked a little differently. When I spoke to Elmore, she speculated that the CCC was still experimenting with technique. Cabin 1 has

vertical logs, whereas in most of the other cabins the logs are horizontal. Horizontal won out — at parks built later, horizontal had an edge from the beginning, like VHS winning out over Beta. But I am partial to the vertical logs of cabin 1; with the logs painted dark brown and the chinking white, the effect is surprisingly graphic and modern. Cabin 1 also has an additional bedroom wing, not represented on any of the extant blueprints at the park office, which allowed space for a separate dining room. It's as if someone on the crew building it decided to go all out. Even the chinking between the logs bears the imprint of the workers' choices. Chinking is a technique for sealing the substantial gaps between stacked logs in log cabin construction. Crews hammered together a network of scrap wood and nails in the substantial gaps between the logs, then sealed them up with a mud mortar. The wood and nails stabilize the mud in the way that rebar stabilizes concrete. Where the chinking is chipped away, you can see that some crews made methodical grids of nails, and others crazy hodgepodges of whatever was lying around. The worker's signature lies in the rebar under the mud.

The cabins, built to restore us, are themselves being restored now. I had been going to the park for about a year before I met the architects in charge of the current historical renovation. In August I met Greg Holzgrefe, architect for the Virginia Department of Conservation and Resources, for a tour of the CCC-era cabins under renovation. The work is extensive: in the cabins we entered, I could see that little was left besides the log walls, the original doors, and the hearth. But there isn't much more to the cabins than this, anyway, and the kitchens and bathrooms

were nothing to save, the products of a renovation sometime in the twentieth century whose date no one seems to be quite sure of, maybe the 1970s. The kitchens and the bathrooms had been drywalled at that time, leaving the logs and chinking intact behind. Now, with the drywall stripped out, you can see that the chinking was covered in graffiti in many cabins: family-friendly stuff mostly, like "If you think THIS place is the pits, you have never slept in a tent," and "The Dawsons" or whoever, with the sequential dates of annual visits inscribed below.

When I met Greg, he drove me to the work site in a van that bore the signs of transporting paperwork and plans between the two parks where he is managing renovations of CCC-era cabins right now, Douthat and Fairystone State Park. He is tall and walks pitched forward and with a hitch in his step, but quickly, back pain being among the things there isn't time for. The trials of his job bear some resemblance to the trials of a homeowner managing contractors, scaled up. Things are always coming up that no one predicted, and Greg has to decide what to do. He showed me a spot behind a former kitchen wall where someone with a drill bit of around six inches in diameter had, for some reason, scored three overlapping circles about an inch deep into one of the original logs in the exterior wall. Probably it had happened in the last renovation. Maybe they were going through a surface board and didn't stop. Now, without drywall over the logs, there wouldn't be any hiding it. "That'll be an RFI," Greg said resignedly. RFI means "request for information;" it is the form that the contractors, Thor Construction, fill out when there is a question with no right answer. Greg will have to choose which of the wrong answers to set his signature beneath. He answers to the State Assembly — eventually and indirectly, but it's a weight.

153

When I first started coming to these cabins, I didn't know if anyone cared about them as historical structures — the drywalled '70s kitchens suggested not — but someone does. Greg showed me how they are stripping all the drywall away from the kitchens to expose the old logs. He won't let them cover up any windows; the cabins are dark enough as it is. New building codes mean some of the porch rails, now a perfect height for sitting and looking out, have to be made higher — too bad. Drainage has to be addressed. In many cabins, the base log has rotted from years of water running through its crawl space to get from the mountains to the lake below. Jeff Stodghill, the outside architect who drew up the plans for the renovation, has used oak timbers to replace these rotted logs. They lift the whole cabin up and then slide the new timber in. I saw some of these new timbers at the cabins under renovation: a little more square than the originals, but like them marked with an ax. The modern timbers are machine planed, but Stodghill instructed the contractors to hack them at random along the length, to make it right.

When I visit in winter, it is quiet and I find myself staring at patterns: the psychedelia of the hottest coals at the bottom of the fire, or the ax marks in the logs. Jeff has a theory about these ax marks — the original ones. He can't know for sure, but he thinks there was a sawmill at the park in the 1930s. That could conceivably mean that the crews took smooth-sawn logs and put ax marks back in, to make the cabin look handmade, which it was. Whether or not Stodghill is right, it is clear from Good's pattern book of 1935 that the designers and workers of the New Deal-era were looking back as much as we are, as invested as we might be in a hand-hewn past, and as convinced as we are that it was already gone.

Logs and chinking do not insulate well; Greg won't be able

to do much about that. When I was there in January last year, it got down to twenty degrees at night — cold enough that even with the heat on, my dog's water bowl iced over in the kitchen. So did the kitchen pipes, which pass along the exterior wall from the crawl space. Some half-hearted attempts have been made over the years to insulate the crawl spaces, one result of which is the better insulation of squirrel nests in the vicinity. At First Landing State Park, I once saw a trail of pink fiberglass leading from the crawl space to a pink-tufted squirrel nest high up in a nearby loblolly pine. At twenty degrees I should have had the water dripping all night, but I didn't. I stopped by the camp store to tell them about the pipes. The ranger said the guys would be there soon. They had to unfreeze the pipes in several cabins and then reload all the firewood stations and then they would be there. I thought my best hope for the next night was to build the most scorching fire I could and keep it going for the six hours that remained until dark, so I bought more firewood and went home. There was a foot of snow cover down low near the cabins — no way to collect kindling — but my dog and I went up higher on the mountains where the sun hit longer every day. I found some dry pine twigs held by chance off the ground and brought those home.

155

One of the guys appeared after a while with his blowtorch. I had boiling water next to the pipes under the sink. He didn't think that would do much. He took the plywood off the crawl space access from outside, got a chair, and sat there flaming the pipes. He had been blowtorching pipes all morning. "The way I do dislike these old cabins," he said to me politely. I went in to build a fire for my old dog, who was sleeping on the couch. I had put him through a lot of hiking. "He's living," the ranger said. After a while, the kitchen sink hissed and spluttered. "You got it!" I yelled. Fellow feeling existed, I think. I hadn't failed at building

Dam Nation

a fire in front of him. He liked my dog. I thanked him and he drove off down the icy road, to blowtorch something else.

The state-park picturesque requires much patient management on the part of rangers. They split a lot of wood at the logging areas inconspicuously located off-trail. In the summer, they look away politely when dogs swim in the no-dog area. I asked about vernal pools. These are ponds that appear only in spring, and they are a common breeding area for newts and salamanders. Katie Gibson told me there were some in the park, but they don't tell anyone where they are, "for obvious reasons." I think the rangers might be fighting some sort of cold war with the beavers, over whose dam will be upstream from whose, but I don't have a high enough security clearance to know for sure.

Then there are the bears. Come summer the Lakeshore Restaurant at the camp store has fried catfish sandwiches. The catfish doesn't come from the lake, but even so. I was there having my catfish on the deck overlooking the lake when a group of half a dozen rangers I didn't know came in and ordered burgers. Someone at the state level had sent them a pretty annoying bear-related email. The sender seemed to be some young optimist in middle management. He wanted them to email him every time a bear sighting occurred. I ask you. The problem is a bear sighting doesn't fit in a spreadsheet any better than any other thing fits in a spreadsheet. Was it aggressive? Was it at a camp? Was it a mother with cubs? These differences matter. Plus they could not email; they were busy mediating. "Go up to a guy with a fifty-seven-foot trailer, sir, could you maybe take down your bird feeder?" a ranger deadpanned. That bear sightings had increased was public knowledge: the usual signs reminding you that you are in "bear country" had been augmented with notes about "credible

recent bear sightings." Bear level orange. I asked Elmore and Gibson about it. They turned official. "It's been much better recently," they said.

Nature is not gone where it is managed. It must be said for the CCC's form of conservation, whose instrumentalism would have struck Muir as blasphemous, that it has after all served some of his ends. The state-park picturesque is unlike the sublime, in that it affords very few experiences of terrifying vastness. But a man-made lake is often about as good as a forbidding mountain when it comes to leaving room for animals. Much of the time, no one is on the trails. The animals have crept back after the flood. The bears like bird feeders just fine. Much of Douthat State Park lies downstream from the dam, along a single paved road that follows the low land. The fungi and plant life on some trails heading up into the mountains from the road give me the feeling of having grown by infinitely slow accretion.

If you don't already know, I'm not sure I can convince you that a forest formed slowly is different from one where kudzu and garlic mustard spread out monoculturally. Of a place where a lake was created naturally when stones fell and dammed a creek, Muir wrote that "gradually every talus was covered with groves and gardens." It was just as if every boulder were "prepared and measured and put in its place more thoughtfully than are the stones of temples." On these less disturbed trails, I am sure I can see the difference in mosses, lichen, and fungi. Many different species in these groups grow together, mushroom fruiting bodies popping up after rain with shreds of moss still clinging to their caps. Not every inch

157

of the forest has been manhandled. Whippoorwills, their song strangely brash and mechanical, still sing on June evenings. The damming of a lake for what were called "recreational purposes" cannot have made a difference to them, except in giving them this tract of land to nest on, where many visitors do not know or care about them. In that sense, the difference it made was existential.

We make dams, which destroy, but also harbor, life. And we are not the only tinkerers. Dams large and small are everywhere. The beavers, whose lodge is opposite the beach, would like to dam the creek a ways upstream from the CCC dam. The rangers would not like to do this. Beavers are a native animal, not to be interfered with. Still, some forms of interference are going on. Many tree trunks are wrapped in chicken wire. The adversary is a worthy one; he commands respect. Near Fairy Stone State Park, there is a US Army Corps of Engineers dam on Lake Powell. At the observation point above the lake, you can find the Corps' pamphlets about wildlife. According to the beaver pamphlet, "they will search, just like an engineer, for the best location on a stream to build a dam."

That's us: engineers. Meddlers. In June, the annual peak of amphibian life, you see red-spotted newts in the hundreds, hanging motionless in the shallows of the lake. A red-spotted newt is a marvel: a four-inch swimming dragon with vermillion spots on slick skin the olive color of lake water, long-limbed and sinuous, with a powerful tail. Kids like to dam up the sand at the swimming beach and keep newts in the hot, muddy pools. Some bring aquariums to stock, which is not allowed. Once I watched a kid's plastic battalion bivouac along the edge of the artificial lake that he had built. Large, round-faced, and unmistakably decent, he mothered

his tanks, curving his attention around them to protect them from harm. Ranging around near him was a scrawny friend, in whom rage had somehow settled. He had picked up a big stick and was hitting things. The round friend hummed to his tanks.

My much smaller children wobbled over to see; they started clamping the newts in their fists and popping them in the little lake. "Gentle!" I said, writhing. "They're fragile!" "No, they're not," the round kid explained. "They don't have any bones." Wrong, but right in spirit; we sacrifice invertebrates more readily to our sport. A fisherwoman saw my kids catching newts as she came in with her foot-long rainbow trout. "They make good bait," she confided, careful that the children wouldn't hear. The kids culled newts from an abundance that looked eternal, but wasn't.

159

STEPHEN DARWALL

Money, Justice, and Effective Altruism

"In all ages of speculation, one of the strongest obstacles to the reception of the doctrine that Utility or Happiness is the criterion of right and wrong, has been drawn from the idea of Justice." This is from John Stuart Mill's *Utilitarianism*, in 1861, perhaps the most renowned exposition of the ethical theory that stands behind the contemporary movement that calls itself "effective altruism," known widely as EA. Mill's point is powerful and repercussive. I will return to the challenge that justice poses to utilitarianism presently. But first, what is effective altruism?

The two hubs of the movement are Oxford and Princeton. Oxford is home to the Centre for Effective Altruism, founded

in 2012 by Toby Ord and William MacAskill, and Princeton is where Peter Singer, who provides the philosophical inspiration for EA, has taught for many years. Singer is EA's most direct philosophical source, but it has deeper if less direct sources in the thought of the Victorian moral philosopher Henry · Sidgwick and the contemporary moral philosopher Derek Parfit, who died a few years ago. Sidgwick gave utilitarianism a rigorous formulation as well as a philosophically sophisticated grounding. He showed that utilitarianism need not depend, as it did in Bentham and Mill, on an implausible naturalism that seeks to reduce ethics to an empirical science.

Parfit was strongly influenced by Sidgwick, as indeed is Singer. Parfit's *Reasons and Persons* was important for several reasons. When it was published in 1984, moral and political philosophy was under the influence of John Rawls, whose *Theory of Justice* had appeared in 1971 in the wake of the civil rights and other social justice movements. Rawls' notion of "justice as fairness" provided the first systematic alternative to utilitarianism and a seemingly persuasive critique of it. Utilitarianism, Rawls argued, did not take sufficiently seriously the "separateness of persons," since it allowed tradeoffs between benefits and harms that we are content with within an individual life — deferring gratification for future benefit, for example — and applied them, unjustly, across an aggregate of lives. It allowed harms to some to be weighed impersonally against benefits to others, and so treated individuals as though they were simply parts of a social whole, analogously to the way we regard individual moments of our lives. But Parfit argued, on sophisticated metaphysical grounds, that personal identity is not the simple all-or-nothing thing that Rawls' objection presupposed. And he argued persuasively that utilitarianism can be defended against a number of other challenges that its critics had

161

Money, Justice, and Effective Altruism

raised from the perspective of justice. Parfit also showed how taking utilitarianism seriously leads to a number of important questions concerning our relation to the future in the long term.

Singer's main contributions have been in what is called, somewhat deprecatingly, "applied ethics." He has influentially argued on broadly utilitarian grounds that we have significant obligations to address global poverty and to avoid the inhumane treatment of nonhuman animals. Singer's *Animal Liberation*, published in 1975, has spawned a massive increase in vegetarianism and attention to animal welfare. And his essay "Famine, Altruism, and Morality," which appeared in 1972, may be the most widely assigned article in college ethics courses. Singer is also the author of *The Most Good You Can Do: How Effective Altruism is Changing Ideas About Living Ethically.*

Ord and MacAskill are from a younger generation. Their role has been to put Singer's conclusions into practice by founding and running the Centre for Effective Altruism and the Global Priorities Institute, also at Oxford, and by attracting a large number of "the best and the brightest" to EA. MacAskill is the author of *Doing Good Better: How Effective Altruism Can Help You Help Others, Do Work That Matters, and Make Smarter Choices About Giving Back.* And Ord plays a lead role in the organization Giving What We Can, whose members pledge to donate at least ten percent of their income to "effective charities." He and MacAskill are also central figures in the development of "long-termism," a branch of effective altruism which argues that we should focus more on benefits and harms in what Parfit called the "farther future."

The moral and philosophical idea that drives much of "effective altruism" comes from a famous example — known as "Singer's pond case" — that Singer discusses in his essay. Imagine that you are walking past a shallow pond in which a

162

child is drowning and that you can save the child at the cost of getting your pants wet. It seems uncontroversial to hold that it would be wrong not to save the child to spare your pants. Singer argues that the world's poor are in a similar position. They are dying from famine, disease, and other causes, in some cases literally drowning from the effects of climate change. Analogously, we in the developed world can address many of these threats to human (and other animal) life and well-being at relatively little cost. It seems to follow, therefore, that we are obligated to do so and that it would be wrong for us not to do so. Singer's larger teaching is that we are obligated on roughly utilitarian grounds to absorb as much cost as would be necessary to make those whom we can benefit no worse off than we are. Yet we do not have to draw such a radical conclusion to be convinced by Singer's analogy that we have very significant obligations to help address global poverty. And it may well be that Giving What We Can's minimum standard of ten percent of income is morally appropriate.

Let us begin by examining more closely the relationship between effective altruism and utilitarianism, and what together they assert. MacAskill offers the following definition:

> Effective altruism is about asking, "How can I make the biggest difference I can?" And using evidence and careful reasoning to try to find an answer. It takes a scientific approach to doing good. Just as science consists of the honest and impartial attempt to work out what's true, and a commitment to believe the truth whatever that turns out to be, effective altruism consists of the honest and impartial attempt to work out what's best for the world, and commitment to do what's best, whatever that turns out to be.

Money, Justice, and Effective Altruism

This definition has a number of distinct elements, and it is worth analyzing them more closely. First, it posits a commitment to bringing about "the most good you can," to quote the title of Singer's book. It is not about simply doing good or even doing enough good. It is about doing the *most* good. Second, although "good" can mean different things and be applied to different kinds of objects, EA counsels bringing about the best *outcomes*. It recommends the action or policy, of those available, that would have the best consequences overall. But outcomes can be ranked in different ways, from different perspectives, and with different criteria or standards. Third, effective altruism is committed to bringing about what is "best for the world" as opposed to for any individual or particular society. It is an "impartial" theory. But "best for the world" can also mean different things. In one "impersonal" sense, something can be thought to be good (or best) to exist in the world, independently of whether it benefits or is good for any individual or other sentient being. This is the sense that G. E. Moore made famous in *Principia Ethica*. Moore thought, for example, that beauty "ought to exist for its own sake," regardless of whether it is experienced or appreciated. Of course, Moore thought that it is much better for beauty to be appreciated experientially, but he thought it still can have intrinsic value even if it is not. (He was a great defender of intrinsic value generally.) Perhaps more plausibly, some consequentialists who follow Moore hold that significant inequality is a bad thing intrinsically, in addition to the disvalue of the bad things that those who are worse off suffer.

Impersonal good is not, however, the sense of "good" with which utilitarianism and effective altruism are concerned. They prescribe doing whatever would be best overall for beings in the world. This is important: it is what distin-

164

guishes effective altruism and utilitarianism from forms of consequentialism that reckon the goodness of outcomes in terms of impersonal goodness that does not consist wholly in benefits to individuals. And this brings us to the fourth element of effective altruism, namely, that it aggregates benefits, and harms — costs and benefits in welfare terms — across all affected parties. The "most good" is the most good to individuals, on balance, aggregated across all who would be affected by alternative actions in any way — wherever they might be (hence EA's global reach), and whenever they might exist in time, no matter how far in the future their being benefited or harmed is from our actions today (hence EA's long-term view). The offshoot of effective altruism known as long-termism is the view that short-term benefits and harms will almost always be swamped in the longer term and so are much less relevant to what we should do here and now than we ordinarily suppose. This is a claim with disruptive implications for the practice of ordinary kindness and assistance, which is often immediate and local; and it is important to see how such a claim is an apparent consequence of the doctrine of effective altruism.

Finally, the fifth premise of EA is the stress on "evidence and careful reasoning." Utilitarianism is frequently characterized by its emphasis on empirical — or as Mill called them, "inductive" — methods. This is also an important theme in Bentham's argument for the principle of utility. Mill contrasts inductive, empirical methods with the "intuitive" approach of giving credence to moral intuitions based on emotions — for example, to a sense of obligation, or to attitudes such as blame, guilt, and resentment, which the mid-twentieth century Oxford philosopher P. F. Strawson called "reactive attitudes." MacAskill highlights this aspect when he refers to Joshua

Greene's neurological research that contrasts utilitarian ethical judgments, which Greene shows to be associated with parts of the brain involved in reflection and reasoning, with intuitive and non-utilitarian — sometimes known as "deontic" — judgments that are associated with regions of the brain implicated in emotions.

The question of what parts of our mind and brains are involved in moral judgment may seem to be entirely epistemological, a matter only of how we come to know what we should do morally and which actions are right and which are wrong. But this is not so, as Mill himself appreciated. It concerns features of our moral concepts themselves and, therefore, what moral right and wrong themselves are.

To see why, we should note first that utilitarianism, and consequentialism more generally, originated as theories not about what is intrinsically good and bad, but about what is morally right or wrong. Mill's *Utilitarianism* begins, indeed, with the declaration that "few circumstances . . . are more significant of the backward state in which speculation on the most important subjects still lingers, than the little progress which has been made . . . respecting the criterion of right and wrong." What makes someone a consequentialist is not that they hold some particular theory of the good. Consequentialists differ widely on what kinds of outcomes are intrinsically good or bad. Granted, utilitarians such as Mill and the effective altruists think that what makes outcomes good is that they concern the well-being, good, or happiness of human and other sentient beings. But critics of utilitarianism, like me, could stipulate agreement with utilitarians on this, or any

other, theory of the good, and still be in fundamental disagreement about what we morally should do.

The issue between utilitarians and their critics is not about the good, but about the relation between the good and the right. Utilitarians hold that what makes actions, policies, practices, and institutions morally right or wrong is that they bring about the greatest possible net good to affected parties. Their critics do not deny that the goodness of consequences is among the factors that makes actions morally right or obligatory. As the most famous recent critic of utilitarianism, John Rawls, put it, to deny that would "simply be irrational, crazy." What they deny is that it is the only relevant factor. This returns us to Mill's observation that the utilitarian idea can conflict with demands of justice. Rawls agrees with Mill's diagnosis that a significant obstacle to "the reception" of the principle of a utility as a "criterion of right and wrong" concerns its insensitivity to justice. I agree with Rawls about this: like utilitarianism more generally, effective altruism fails to appreciate that morality most fundamentally concerns relations of mutual accountability and justice.

Ironically, this is a point that Mill himself recognizes, and his appreciation of it creates a tension between the form of utilitarianism that he advances at the beginning of *Utilitarianism* and the view he seems to endorse by the end. The dramatic shift occurs in its fifth chapter, which begins with Mill's noting the tension between utilitarianism and justice. After discussing different features of the concept of justice, Mill makes the following deeply insightful point.

> We do not call anything wrong, unless we mean to imply that a person ought to be punished in some way or other for doing it; if not by law, by the opinion of his fellow

creatures; if not by opinion, by the reproaches of his own conscience. This seems the real turning point of the distinction between morality and simple expediency.

In many cases, of course, we can think an action wrong without thinking that it should be punished. Making a hurtful remark might be an example of that. (Though in our increasingly censorious society, it might often be an example of just the opposite.) Mill recognizes that this is so, but says that in such cases we are nonetheless committed to thinking that conscientious self-reproach would be called for. The fundamental point, as I have understood it, is that it is a conceptual truth that an act is wrong if, and only if, it is an act of a kind that would be blameworthy to perform without excuse.

When Mill first puts forward his "Greatest Happiness Principle" in *Utilitarianism's* second chapter, he says that acts are right "in proportion as they tend to promote happiness, wrong as they tend to produce the reverse of happiness." This is frequently interpreted as what philosophers call "act utilitarianism": an act is morally right (not wrong) if, and only if, it is one of those available to the agent in the circumstances that would produce the greatest total net happiness (considering all human or sentient beings in the very longest run). But once Mill has recognized moral wrongness' connection to culpability in his fifth chapter, his view seems to shift in the direction of what is called "rule utilitarianism": an act is morally right (not wrong) if, and only if, it is consistent with rules it would bring about the greatest total net happiness for society to accept as standards for holding people accountable (through guilt and moral blame) in the given situation. This fits with the rule-utilitarian theory of justice and rights that Mill finally offers, enabling him to hold that unjust actions

are morally wrong on broadly utilitarian grounds, namely, rule-utilitarian rather than act-utilitarian grounds.

If Mill's conceptual thesis is correct, as I believe it is, then there is a connection between the concepts of moral right and wrong and *accountability*, and therefore, with conscience. What we call conscience is the capacity to hold ourselves accountable through the states of mind that Strawson called "reactive attitudes," including the "sense of obligation" and guilt. To be capable of being a moral subject, that is, of being a person with moral duties and acting rightly or wrongly, one must have such a capacity or moral competence. We exercise this capacity when we feel guilt or have the attitude of blame towards others. Blame is essentially the same attitude as guilt, except that the latter necessarily has oneself as its object. Guilt is self-blame. Similarly, a sense of obligation is essentially the same attitude also, only it is felt prospectively, before acting, rather than retrospectively.

Strawson lays out his account of the role of reactive attitudes in moral accountability in "Freedom and Resentment," which has been called "perhaps the most influential philosophical paper of the twentieth century." What Strawson saw was that we hold reactive attitudes such as blame, guilt, and resentment from a distinctive perspective, the standpoint of *relating to someone*. Strawson calls this the "participant" point of view, since it occurs within an implied relationship to another person. I call it the "second-person standpoint," since to formulate what one thinks or feels from that perspective, one must use second-person pronouns. "What were you thinking?" "You can't do that to me." And so on.

Strawson convincingly argues that attitudes such as resentment and blame implicitly address "demands" to their objects. Not naked demands — reactive attitudes do not

attempt to force or to manipulate — but putatively legitimate demands. And this requires anyone who holds a reactive attitude to presuppose that they have the authority to make the demand, and that the person of whom the demand is made can recognize the demand's legitimacy and comply with it for that reason. We call the latter capacity "conscience." Through conscience we address demands to ourselves that we feel to be backed by the authority of what Strawson calls "the moral community" or, as we might also say, of any person, including oneself, as its representative.

Attitudes such as blame and resentment are unlike third-personal attitudes such as contempt and disdain in that they come with an implicit RSVP. They call for response and reciprocation, for their object to acknowledge their wrongdoing and hold themselves accountable. Moreover, the presupposed underlying reciprocity goes in both directions. They both demand and implicitly give respect. They are eye-to-eye attitudes.

This means that moral judgments of right and wrong, unlike other ethical judgments, for example, of the goodness or badness of outcomes, necessarily implicate human relationships. Many of our most important moral obligations are owed *to* other persons or sentient beings, and the very ideas of moral right and wrong entail accountability to every person or member of the moral community (where "moral community" refers not to any actual society, but to a presupposed authoritative impartial perspective from which moral demands are issued or addressed to us as moral agents). The point is not that we necessarily assume that such a community actually exists, but that we necessarily attempt to think, feel, and have attitudes from such an impartial second-personal perspective.

The idea that morality is fundamentally about mutual accountability and respect could not be farther from the ethical vision that underlies ethical altruism. Altruism is concerned, by definition, with beneficial outcomes, and it conceives of ethical action entirely in instrumental terms. According to MacAskill, "the key questions to help you think like an effective altruist" are: "How many people benefit, and by how much? Is this the most effective thing you can do? Is this area neglected? What would have happened otherwise? What are the chances of success, and how good would success be?" EA asks what states of the world are such that the people (or other sentient beings) existing in those states are better off in the aggregate than those who would exist in the states that would eventuate if a specific action, policy, practice, or institution were pursued or established. Once we have stipulated what the answer to this question is — and, as we have noted, there is no reason why an opponent of utilitarianism or effective altruism must disagree with that stipulation — the remaining moral question of what one should do is, for EA, an entirely empirical question, one to be answered using the methods of natural and social science.

By contrast, the questions of justice and moral right and wrong that, for the critic of utilitarianism and effective altruism, are left entirely open and unsettled even by an agreed stipulation of welfare outcomes, are not empirical or scientific questions. They are irreducibly normative questions of what it would be morally right or wrong to *do* (given the stipulation), and these moral questions necessarily presuppose *relations* of mutual accountability and respect in the background.

One way to see this is to consider what is called paternalism. As it is defined in debates between utilitarians

and their critics, paternalism consists in restricting someone's liberty or usurping their authority of autonomous choice on the grounds that this would be better for them in welfare terms. It is a core feature of an order of justice, mutual respect, and accountability that every person has a right of autonomy, understood as the authority to make their own choices and live their own lives, so long as that does not violate the similar rights of others. (This does not entail anything like libertarianism, as the example of Rawls' theory of justice illustrates.) Respect for another's autonomy, however, can conflict with an altruistic desire to promote their well-being, since we often make choices to our own detriment (even, indeed, when we choose altruistically to benefit others!).

Suppose, for example, that a friend has their heart set on pursuing a career as a golf pro, which you can see that they are massively unsuited for, and that you can tell that pursuing it would make them miserable. As a friend, you might have standing to give them realistic feedback. But suppose you do voice your concerns, and still your friend persists. You might be in a position to undermine their plans in other less honest ways, say, by resetting their alarm so that they miss their tee time at a crucial tournament. It might be that being diverted from their chosen path is actually better for them in the long run and that they would go on to live a happier, more satisfying life doing something else. It seems clear, however, that subverting your friend's project altruistically would wrongfully violate her autonomy. It would be an injustice to her and would violate respect for her dignity as a person.

According to the doctrine of effective altruism, the fundamental ethical relation is benefactor to beneficiary; but from the standpoint of equal justice, the fundamental ethical relation is mutual respect. Being respected as an equal

is an important part of our well-being, of course, but altruistic concern will coincide with respect only when being respected most advances our well-being, all things considered. And that is frequently not the case. Often we want to make choices that do not best promote our welfare, and often for good reason (including sometimes for good altruistic reasons).

Moreover, altruism can be morally problematic in other ways, although I am not claiming that it must be so. For example, effective altruists argue that often the way we can do "the most good we can do" is by donating to "effective charities." A significant element of EA is the ranking of charities — "charity evaluation," Singer calls it — by how effectively they turn donations into beneficial outcomes. Yet the term "charity," like the term "pity," signals the potential in altruism to insinuate a disrespectful relation of superiority to a pitiable "charity case." The perspective of charity, like the perspective of pity, is not the eye-to-eye relation of mutual respect; it comes, like God's grace, from above. "The greatest and most common miseries of humanity," Kant wrote

> rest more on the injustice of human beings than on
> misfortune ... We participate in the general injustice
> even when we do no injustice according to civil laws
> and institutions. When we show beneficence to a needy
> person, we do not give him anything gratuitously, but
> only give him some of what we have previously helped
> to take from him through the general injustice Thus
> even actions from charity are acts of duty and obligation,
> based on the rights of others.

In couching the meeting of human needs in terms of altruism and charity, EA risks treating its beneficiaries as

inferior supplicants rather than mutually accountable equals. It is little wonder that there is so much resentment of the global north in the global south.

In *On Revolution*, Hannah Arendt distinguishes between charity and pity, on the one hand, and solidarity and compassion, on the other. She juxtaposes Jesus' compassion with the "eloquent pity" of the Grand Inquisitor in Dostoyevsky's *The Brothers Karamazov*: "The sin of the Grand Inquisitor was that he, like Robespierre, was 'attracted toward *les hommes faibles*' ... because he had depersonalized the sufferers, lumped them together into an aggregate — the people, *toujours malheureux*, the suffering masses, et cetera." By contrast, Jesus had "compassion with all men in their singularity." Whereas pity views its object as a *faible* in a low and abject condition, thus essentializing and "depersonaliz[ing]" them, compassion, solidarity, and respect regard their objects "in their singularity" as individuals. Even the term "the global poor," risks condescension, since it signals not a respectful relation of mutually accountable collaboration to establish more just relations as equals, but regarding someone as an object of charity that, by definition, no one has the standing to demand.

To be clear, I am not claiming that Singer and MacAskill, or other proponents of effective altruism, are prone to depersonalizing those whom they seek to benefit, or that their help is necessarily condescending, self-aggrandizing, or arrogant. Neither am I claiming that what we call "charities" necessarily present themselves or are received as superior to their beneficiaries. What I am saying is that the benefactor/beneficiary relation carries these risks, that it can be inconsistent with mutual respect as equals, and that relating to others on terms of mutual respect and accountability is both required by justice and the antidote to these risks. Nor am I claiming

that the work that organizations such as Malaria Consortium, which is currently mostly highly rated by Give Well — a "charity evaluator" endorsed by effective altruists — is not doing important work and meeting significant needs that would otherwise go unmet. I am not saying that their work is essentially paternalistic or unwelcome. Perhaps being characterized as a "charity" is just unfortunate branding. I believe that the Malaria Consortium is worthy of our support and have supported it myself. My point is that meeting human need should be pursued from a collaborative perspective of mutual respect and justice rather than that of altruistic charity.

"Justice," Rawls says, "is the first virtue of social institutions." Whether justice is served is never simply an aggregative matter, either an accumulation of just actions of equal respect, or, even less, of aggregated acts of effective altruism. Whether the most important human needs are adequately met is generally a function of whether the society in which they occur is justly organized and of the society's level of economic development. The economist Angus Deaton has rightly remarked that development

> is neither a financial nor a technical problem but a political problem, and the aid industry often makes the politics worse. The dedicated people who risked their lives to help in the recent Ebola epidemic discovered what had been long known: lack of money is not killing people. The true villains are the chronically disorganized and underfunded health care systems about which governments care little, along with well-founded distrust of those governments and foreigners, even when their advice is correct.

175

We do not have to accept the general skepticism of foreign aid's benefits that Deaton expresses in *The Great Escape* to agree that EA's framework is often insensitive to crucial aspects of the political contexts in which human need occurs, and therefore to critical issues of justice. Often the best thing we can do to support those in need is whatever we can to help them have more political power and greater voice, both intranationally and internationally. Deaton argues that economic development depends not on donated aid but on investment, and that the former can often drive out the latter. This is by no means always the case, however. It seems clear, for example, that some forms of aid, like that which targeted HIV in Africa, can make a critical difference that other attempted solutions cannot. PEPFAR, or the President's Emergency Plan for AIDS Relief, begun by George W. Bush, has been calculated to have saved twenty-five million lives.

The crucial point is that the requisite support should come not through altruistic desires for welfare outcomes but, as Kant says, from a concern to do justice – and that this be in ways that collaborate with aided individuals, show mutual accountability and respect, and help to empower them in their own social and political context. Climate change poses a salient example. The EA model of individuals doing "the most good" they can for other individuals, typically by contributing to highly rated charities that direct funds to maximally promote individual well-being, seems especially ill-suited to deal with the scale and the nature of the problem. Amartya Sen showed that famine is almost always fundamentally a political problem, and this is even more true of climate change. Only concerted collective and political policies and actions at all levels, nationally and internationally, can reduce carbon emissions to the necessary levels. Proponents of effective

altruism implicitly recognize this. A talk given by a researcher for FoundersPledge and featured on effectivealtruism.org argues that the most effective thing individuals can do is to contribute to the most highly-rated "climate charities." Their top charity, the Clean Air Task Force, characterizes their work as "advanc[ing] the policies and technologies necessary to decarbonize the global energy system." Surely it is obvious that this is impossible without concerted political action.

What is the right ethical lens through which to view the challenges of climate change? Here Kant's admonition that "the greatest and most common miseries of humanity rest more on the injustice of human beings than on misfortune" is especially apposite. If economic development has been carbon driven, then it is a virtual tautology that the developed world bears greater responsibility for the challenges of climate change. Any just solution will require international cooperation on terms of mutual respect that recognize these different levels of responsibility as well as the unjust power differentials that have resulted from differential development. The pressing ethical questions are not simply how we can do the most good. They are questions of justice.

A particularly noteworthy aspect of the movement of effective altruism is Singer's and MacAskill's assertion that for a good number of highly talented individuals, the best thing they can do to promote the most good is to find the highest-paying employment so that they can donate much of their income to the most effective charities. Singer's *The Most Good You Can Do* discusses a number of examples of college graduates who take high-paying jobs in the financial sector, live simply, and

contribute a large percentage of their income to effective charities. Such a person might have gone to work for the charity themselves, or put their talents to work in some other altruistic- or justice-focused way, but Singer quotes MacAskill as arguing that doing so would have produced less net benefit, since donating a fraction of their salary to employ someone producing equivalent good would still leave a significant amount to be put toward other good purposes.

I see no reason to doubt the motivation of those who pursue this path. There is, I agree, something undeniably admirable about the individuals Singer describes, who live modestly, are focused on the welfare of others, and do the most they can to advance it. Yet from my perspective as a professor of philosophy at Yale, however, I find the prospect of encouraging students to pursue this path of high-minded riches deeply depressing. Institutions such as Yale are already knee-deep in helping to reproduce an extremely unjust political and economic system and in class formation. As things stand, about thirty percent of their graduates take positions in consulting and the financial sector, with only a tiny percentage going to badly needed but talent-starved fields such as public K-12 education. I do not remember the last time I talked to a Yale undergraduate who wanted to pursue that as a career path, although some take temporary posts in programs such as Teach For America.

But wouldn't it be wonderful, a proponent of the MacAskill/Singer argument might reply, if more of the people who went the finance and consulting route were like the EA financial analysts whom we champion? I agree with the proposition that if we hold fixed the percentage of graduates pursuing that path, then it is better that more of them have the altruistic aspirations that MacAskill and Singer

178

describe. But I worry about encouraging graduates to pursue the route of "earning to give" for two reasons. First, familiar psychological processes of group affiliation, emotional and attitude contagion, motivated reasoning (rationalization), and accountability to those we live and work with, not to mention the desire to fit in with our associates and have their approval, make it likely that many who begin with such aspirations will tend over time to lose them and become more like their non-EA colleagues. As the example of Sam Bankman-Fried has shown, the nobility of effective altruists can easily be degraded by massive profits: the doctrine can serve as a cunning alibi for the rapacious accumulation of wealth. And especially at the current moment, when meritocracy's credentials are wearing exceedingly thin, statistics such as the ones I just cited do little to inspire confidence in highly selective universities. *This* is what you are selecting students for? The universities might reasonably be asked. After all, students do not suddenly change their interests and plans at the end of their college careers. Their undergraduate lives are shaped by the fact that almost a third of their number hope to go into finance or consulting.

Elite universities do not just complacently accept these depressing trends; they actively contribute to them by pursuing massive donations and lionizing their biggest donors. What are their students to think when they live, eat, and study in buildings funded by titans of finance? Yale's current development campaign is titled *For Humanity*. Despite our fine words, however, students can hardly be faulted for wondering whether they are not living by the university's real values when they join the "army of the thirty percent." To do so, however, is to be condemned to a life lived without engagement with, and therefore, meaningful accountability to, the

overwhelming majority of their fellow citizens and human beings. Even those who maintain their allegiance to EA while working in offices on Wall Street never get to see how the people they seek to benefit actually live or get to live or work with them.

The pursuit of justice, in contrast with effective altruism, seeks accountable relationships with others on terms of mutual equal respect. Universities should be "for humanity" not in the sense of seeking just to benefit themselves. That way lies the self-aggrandizing myth of superiority that can mask massive injustice. They should seek, and actively encourage their students to seek, equal justice for all. That is a path that would earn them neither the resentment nor the self-protective contempt that is so widespread among the great numbers of people who are alienated from them and their members, but equal respect in return.

180

KIAN TAJBAKHSH

Albert Memmi and The Problem with Post-Colonialism

The Franco-Tunisian Jewish writer and social philosopher Albert Memmi died in the spring of 2020, having lived a full century, at least a half of which he devoted to developing an arc of thought with great relevance to some of the most vexing questions now facing the societies of the Middle East, the region where he was born, although he eventually found his intellectual and literal home in the West. We need him now.

Memmi was born in 1920 in the Jewish quarter in Tunis, at the time a French protectorate. The eldest son of a poor Italian Tunisian saddlemaker and an illiterate mother of Bedouin Berber heritage, he spoke Judeo-Arabic at home and

studied Hebrew in a traditional religious school. Ambitious and studious, he won a scholarship to the most prestigious French high school in Tunisia, and went on to study philosophy at the University of Algiers. Forced to return to Tunisia after Vichy France expelled Jews from public institutions throughout the mainland and the colonies, Memmi was interned briefly in a labor camp after the Nazi occupation of Tunisia in 1942. After liberation from Nazi rule in May 1943, he decided to continue studying philosophy at the Sorbonne in Paris, where he became deeply engaged in Jewish intellectual life and thought and embarked on a life of letters. Returning to Tunisia in 1949, he worked as a high school teacher teaching philosophy and literature, and three years later he helped to found the Centre de Psychopédagogie de Tunis, where he studied the psychological dimensions of colonial oppression. After Tunisian independence in 1956 he returned to France, teaching in a number of universities and eventually being appointed in 1970 a professor of sociology in the University of Paris.

Memmi is remembered today chiefly for his research and his novels about the psychological impact of colonialism, which he produced when he was in his thirties, in the 1950s. He became a hero of the anti-colonial left with his novel *The Pillar of Salt*, a fictionalized autobiography of his childhood in French-colonized Tunisia that appeared in 1953, and his study *The Colonizer and the Colonized,* which appeared four years later. Promoted in the pages of *Les Temps Modernes*, the leading French intellectual journal that was edited by Jean-Paul Sartre, who also wrote a preface to the book, *The Colonizer and the Colonized* was a study of the sociological and psychological dimensions of the dependence and the privilege created by a colonial hierarchy.

This "lucid and sober" book, wrote Sartre, describes the predicament of its author as "caught between the racist usurpation of the colonizers and the building of a future nation by the colonized, where the author 'suspects he will have no place.'" (He will have no place because he is a Jew.) *The Colonizer and The Colonized* made Memmi a giant of anti-colonialism, along with such writers as Frantz Fanon, Leopold Senghor, Albert Camus (who also wrote a preface to Memmi's book), and Aime Cesaire; one of the key figures of what later came to be dubbed the post-colonial school of thought defined by works ranging from Fanon's *The Wretched of the Earth* in 1961 to Edward Said's *Orientalism* in 1978. But slowly Memmi's thinking began to change. His later works sought to generalize the insights from his early phase into a broader sociological account of dependence, privilege, and racism. (He published a deep study of racism in 1982.) Memmi came to view racism and colonialism as only one instance of the more general human trait of what he called heterophobia, the fear of difference, which motivates groups to dominate, to condemn, and to exclude other groups. Memmi's understanding converged with thinkers such as Niebuhr, for example, for whom "the chief source of man's inhumanity to man seems to be the tribal limits of his sense of obligation to other men"; and his emphasis upon the challenge of heterogeneity anticipated an important theme in contemporary social and political philosophy.

183

I believe that Memmi's work is a vital resource to make sense of contemporary failures of governance, not least in his own region, the Middle East and North Africa. The World Bank report of 1996 noted, for example, "a systematic regression of capacity in the last thirty years" in almost every country in Africa, adding the melancholy remark that "the majority had better capacity at independence than they now

possess." The Arab Human Development Reports prepared for the United Nations in 2003 and 2004 highlighted how isolated Arab countries are from the diffusion of the world's knowledge, mentioning as an example that the number of books translated into Arabic is miniscule. (It noted that whereas Spain translates ten thousand books into Spanish a year, the same number of books have been translated in total into Arabic since the ninth century CE, and that between 1980 and 1985 the number of translations into Arabic per million potential readers was 4.4, less than 0.8 percent of the number for Hungary and less than 0.5 percent of the number for Spain.) Likewise it highlighted the widespread ignorance and the culture ripe for conspiracy theories and irrational resentments that result from this isolation. Study after study since the 1980s has found the Middle East and North Africa to be the most repressive region in the world, with almost all countries ruled by (occasionally elected) authoritarian regimes (the only exception as a liberal democracy is, for all its agonies, Israel), and that the lowest levels of human freedom in the world are in the Middle East and Africa, and that this translates into having the highest levels of serious armed conflict in the world and the highest concentration of fragile or failing states.

This is a crisis about which Memmi has a lot to teach. It is therefore a great loss that much of the world remains unaware of his contribution. The left disinherited him because his later works took positions contrary to progressive and post-colonial stances. The discerning and unsentimental eye that he trained on the internal limitations of the post-colonial societies as they struggled and often failed to achieve the original lofty goals of independence and democratic self-governance generated insights that admirers of his early anti-colonialist work came to deplore. Memmi's concerns about post-indepen-

dence societies went far beyond the struggles that necessarily accompanied independence. He also sought to shed light on the situation of the individual in the aftermath of independence, whose struggle for meaning could not be reduced to the political and social opposition to colonialism. The experience of colonialism and racism may have shaped the quest to belong, but Memmi put the onus on the individual to transcend them. He believed in inner emancipation — or in the words of a nineteenth-century Zionist thinker, in "auto-emancipation." This inner emancipation was the condition for the creation of free and functioning societies.

Although he was not a political theorist, Memmi thought deeply about politics. He was an early proponent of a pragmatic and social democratic model of liberal nationalism. In contrast to the unrealistic utopianism of the socialist left or the Manichaeanism of the post-colonial revolt, he saw a pragmatic social democratic nationalism as the most appropriate political program for achieving individual and collective freedom within a non-utopian politics. (This was decades before academic philosophers such as Charles Taylor, Will Kymlicka, David Miller, and Yael Tamir began to adumbrate a revival of liberal nationalism.) He surveyed the possibilities and limits of the newly independent countries of the Middle East with open eyes, that is, without naivete or romanticism. In this context he refused to vilify the state of Israel.

If the Islamic countries of the region had followed Memmi's positive assessment of Israel's contributions to furthering economic development and pluralism in the region, they would have avoided years of futile and costly antagonism. Indeed, official and popular animosity to Israel's existence remains one of the major causes of the backwardness of many Middle Eastern societies. It also contributes to the

continued suffering of many Palestinians, whose intellectual and political leaders insist on making the perfect the enemy of the good. Memmi favors a progressive liberal nationalism as a model for the countries of the region; he endorses Israel as a legitimate partner for development and peace; and he calls for a culture that enables each individual to grapple freely with the meaning of their lives, alone and in community. He bequeathed a deep and rich bounty for the beleaguered peoples of the region, weighed down by anger, tyranny, poverty, theocracy, and despair. And this bounty was the work of a liberal Francophile Jew who came from their own region.

In his early nonfiction and his fiction, Memmi established himself as a keen observer of the psychological effects of societies built on the asymmetrical power and privilege that defined colonial systems of domination. In the writings of his early Third Worldist phase, from the 1950s to the mid-1960s, Memmi was still working with the standard anti-imperialist binary. Like his contemporaries Frantz Fanon and Aime Cesaire and many subsequent Western leftists, his depiction of the colonized individual was more or less essentialized: the existence of the oppressed was almost entirely defined by the oppressor. In *The Colonizer and the Colonized*, which remains his most famous work, Memmi claimed that all colonial societies were founded on a "pyramid of petty tyrants" whereby gradations of proximity to the colonizer and his institutions conferred privilege and feelings of superiority over those lower in the hierarchy. Such proximity might be afforded by accepting roles such as police officer, teacher, and government official in the colonial institutions — but also by acknowledging the superiority of

European culture. Memmi described those at the base of the pyramid as the "true" inhabitants of the colony.

"The colonial relationship," he wrote, "chained the colonizer and the colonized into an implacable dependence, molded their respective characters and dictated their conduct." Referring directly to his experiences in Tunisia, he observed that "the Jew found himself one small notch above the Moslem on the pyramid which is the basis of all colonial societies. His privileges were laughable, but they were enough to make him proud and to make him hope that he was not part of the mass of Moslems which constituted the base of the pyramid. To that end, they endeavor to resemble the colonizer in the frank hope that he may cease to consider them different from him... But if the colonizer does not always openly discourage these candidates to develop that resemblance, he never permits them to attain it either. Thus, they live in painful and constant ambiguity." Yet Memmi never lost sight of the existential dimension, the lived dimension, of these psychological and sociological observations: "I undertook this inventory of conditions of colonized people mainly in order to understand myself and to identify my place in the society of other men."

187

The popularity of Memmi's historical study of colonialism has obscured the fact that it was only one part of his lifelong struggle to find a place for himself amid the class, ethnic, and cultural contradictions between the "third world" and Europe. (Later he pointedly rejected the term "Global South" as too broad and ideological.) Already by the early 1950s, his struggle to come to terms with his mixed family background and his experiences growing up in a Jewish ghetto in French-colonized North Africa during and after the Second World War became the central preoccupation of his writings. Two novels

from this period, *The Pillar of Salt* and *Strangers,* amply illustrate these concerns.

The Pillar of Salt is a semi-autobiographical novel about growing up in the Tunis ghetto. An intelligent and ambitious young man named Mordechai Benillouche sees mastering French culture and language as his path out of the ghetto. He understands that he will be turning his back on his past: "I protested against everything that I saw all around me, against my parents, these tradesmen, this city that is torn apart in separate communities that hate each other, against all their ways of thinking." He chooses philosophy over medicine as a profession because, he tells us, it was a channel through which he could rebel against everything in his social background. It was as if the abstractions of philosophy could hoist him above the fetid realities of his marginalization that he fervently wished to escape — the "sordid lanes, where the gutters ran with muddy water." The study of philosophy and a life of writing, Benillouche (and no doubt Memmi) imagined, would be the salve for his fractured soul, permitting him to embrace "this terrifying and exhausting search for one's real identity that philosophy implies."

At the same time, Benillouche is constantly reminded of the uncertainty of his quest, admitting in exasperation, "How naive it was of me to hope to overcome the fundamental rift in me, the contradiction that is the very basis of my life!" Whereas in the prologue to the novel he expresses a tentative hope — "Perhaps, as I now straighten out this narrative, I can manage to see more clearly into my own darkness and to find a way out" — at the end of the novel he confesses that "I am ill at ease in my own land and I know of no other." Although Memmi's long and successful career as a writer living mostly in France suggests that his own fate was better, he never shook

off his ambivalence toward the discordant parts of his former attachments, particularly in relation to his Jewish identity. The novel *Strangers*, which appeared in 1955, symbolized this failed rapprochement in the melancholy marriage of a Paris-trained Jewish Tunisian doctor and his French Christian wife when they settle back in Tunis. Unable to manage his inner conflicts and disappointments, his feelings of resentment and alienation, the protagonist takes out his frustration on his wife, insisting that she embrace all the worst and backward aspects of the city that he himself now feels ambivalent about. He exhorts her to "see and appreciate our people in their native haunts," but to himself (and the reader) he admits that "I too in secret was struggling with...wholeheartedly accepting this world." Ultimately, he reflects that "I was annoyed that my wife should reveal to me my own difficulties in her person." Memmi, in other words, knew more about identity than we seem to know now: he appreciated that it is not a monolithic and seamless dispensation, but rather is a collision of attributes and qualities that we must somehow negotiate.

This complexity was the gift of a difficult history. Memmi's early work is set against the wrenching historical transformation of societies after the Second World War, when the devastated European powers allowed their colonies to move towards national independence. At the same time these writings also depict the trajectory of a young man striving for his own independence, and for a place in the context of his country's post-colonial journey. Tunisia threw off French tutelage in 1956, achieving its adulthood, as it were, but Memmi shows how much more complicated the individual journey to adulthood can be, at least for the reflective and self-aware individuals depicted in his novels. For Memmi's protagonists, personal independence could come only from

achieving distance from, if not outright rejection of, family, tribe, religion, language, and even the civilization of the "East." This private search for a self cannot be divorced from the contexts of social and political power that Memmi deciphered so acutely in his non-fiction work, but his fiction shows how they operate on related but independent planes, psychologically and even spiritually, each with their own twists and obstacles.

The individual's striving to find his place among his fellow humans, to take one of Memmi's recurring themes, is a process in which authenticity and alienation, otherness and community, are simultaneously fused together and in tension. This profound unsettledness was the outcome of his bone-deep sense of displacement. It was likely this aspect of Memmi's work that Camus most admired, seeing in his writings (particularly in *The Pillar of Salt*) a "beautiful" depiction of the Sisyphean toil of searching for oneself. Memmi's fiction, in other words, is valuable precisely because it grapples with, in Faulkner's famous words, "the problems of the human heart in conflict with itself, which alone can make good writing because only that is worth writing about, worth the agony and the sweat." These existential themes go far beyond the concerns of his sociological studies of colonialism; their significance has outlasted the now-obsolete circumstances of colonial societies.

Most of the literature of post-colonial studies presents a Manichean struggle of an oppressed "East" resisting a monolithic Western "imperialist oppression." Of course such simplifications made sense for nationalist struggles for independence and may even have been necessary for the mobilization of a sense of collective agency to press for national independence; revolutions are made with slogans, not with scholarship.

This was almost certainly the case in the decade leading up to independence in Tunisia and Algeria, in 1956 and 1962 respectively. They formed the backdrop to Memmi's writings during what one French critic called his "age of revolt." These are his writings to which the contemporary left still kindles, when they read him at all. But it was not long before Memmi's thinking led him to conclusions that would be of no use to them. Memmi's third-worldism did not survive the developments of the 1960s. His evolution from anti-colonialist icon to critic of left-wing anticolonial causes began in this period, when he moved away from the singular focus on colonialism and turned his focus to the issue of Jewish identity and Jewish-Arab relations, including the question of Israel and nationalism.

This evolution was triggered by three critical transformations. The first was the persecution of the Jewish community in Tunisia after it achieved independence in 1957. The Jewish community in Tunisia numbered over a hundred thousand in 1948. While these Jews had experienced significant repression and impoverishment under Vichy France, their distance from Hitler's death camps left most of them alive and undeported by the end of the war. (Memmi was himself imprisoned in a labor camp, which he escaped.) Yet as much of the postwar world became more hospitable to Jewish people in the wake of the great catastrophe, Tunisia became less so. Following the Six-Day War, the country passed discriminatory laws against Jews and there were riots targeting them. By 1970, less than ten thousand Jews remained in Tunisia. The majority of Tunisian Jewry, once a great community, had emigrated to Israel or to France, where Memmi himself had settled by that time.

191

Witnessing this anti-Semitic oppression disabused Memmi of any illusions regarding the redemptive virtues of formerly colonized peoples. It cured him of the romance of the Third World. He watched the radical movements of North Africa and the Middle East reject Enlightenment "Western" culture, and interpret its universalist teachings as nothing more than a mask for power; and this revolted him. His thinking began to take on a more sober and realistic cast. A colonized Arab might have ignored the implications of Tunisian anti-Semitism, but Memmi's other otherness, his Jewishness, had begun to nurture in him a different kind of identity and consciousness. He now had a third vantage point. It led him to reject the reductive Manicheanism of the radical post-colonial left that had celebrated his work in the 1950s.

A second significant factor was Memmi's unwillingness to countenance the left's equation of anticolonialism with socialism. In 1958, only one year after the publication of *The Colonized and the Colonizer*, Memmi called out the fatal contradiction of the socialist left's equation of anticolonialism with liberation, in a powerful essay called "The Colonial Problem and the Left." He took to task the left's embrace of some of the most repressive (and anti-Semitic) Middle Eastern Arab regimes, and their active and military opposition to Israel as expressive of a misguided political standpoint. Memmi identified the poisonous contradictions of the New Left a decade before they came to fruition in 1967 in their response to the Arab-Israeli war, when, as Susie Linfield shows in her brilliant study of Zionism and the European Left, "much of the Western Left hailed some of the world's most horrifically repressive — and racist — regimes as harbingers of justice and freedom" while reviling Zionism "as a thing apart." (Her analysis now needs to be extended to the "progressive" response to the Hamas atrocities

of last October.) Never Marxist or pro-communist, Memmi called for a genuinely progressive type of social democracy and a left-leaning liberal nationalism at a time when nationalism was a dirty word in European intellectual circles.

Against the backdrop of the Arab-Israeli wars of 1967 and 1973, Memmi's heterodox commitments and intellectual boldness enabled him to develop a startling diagnosis of what ailed the post-independence societies of the region, an interpretation at odds with the conventional narrative of the post-colonial left. While others were celebrating what they viewed as the thrilling new millenarian ideology of world revolution that would vindicate the "wretched of the earth," Memmi identified some of the key weaknesses of these movements in psychological terms, as expressions of the unresolved neuroses of alienated and disoriented individuals. Memmi developed this critique most pointedly with regard to Fanon, whose method of analysis was also psychological, and he kept his distance from Western intellectuals such as Sartre and his circle, who were still hanging on to increasingly indefensible defenses of communist doctrine, such as the necessity for terror to build "socialism," and the idea that the Communist Party of the Soviet Union was running the country and its economy for the benefit of the working class. Although Memmi drew from the Marxist left in his analysis of economic injustice, he recoiled at the fact that "the European Left remains impregnated with Stalin-like and Soviet Manichaeanism...I could not abide the collective discipline imposed on people's thinking, the excessive consistency between thought and action, which inevitably gave rise to dogmatism and intolerance."

Memmi's critique of Fanon applies to most versions of contemporary post-colonial criticism. Memmi knew Fanon

in Tunis, when he worked as director of an institute of child psychology and Fanon was editor of a newspaper and a psychiatrist at a local hospital. Before he left Tunis, Memmi had been an admirer of Fanon's, eager to be adopted by the North African Arab independence movement; but a decade later, in an extraordinary essay called "The Impossible Life of Frantz Fanon," which appeared in 1971, Memmi coolly dissected the psychological roots of what he depicts as the "neuroses" that lay behind Fanon's ideas. Nothing more clearly illustrates Memmi's break from the post-colonial left's political imaginary than this essay, in which the psychoanalyst Fanon was himself psychoanalyzed. Fanon, Memmi suggested, had succumbed to "the temptation of messianism" and was "gripped by a lyrical fever, by a Manichaeism that constantly confuses ethical demand and reality." In Memmi's view, Fanon had fallen for "an illusion": the idealizing myth of "the solidarity of the oppressed." He traced Fanon's compulsive desire to become an Algerian revolutionary to his "disappointment at the impossibility of assimilating West Indians into French citizens," remarking that "Fanon broke with France and the French with all the passion of which his fiery temperament was capable." Fanon, remember, was West Indian. He was born in 1925 in Martinique and grew up there, and then studied medicine and psychiatry in France. He fought with the Free French during the war and often referred to himself as French. In 1953 he took up a medical post in Algeria and joined the Algerian Liberation Front (FLN) in its struggle against French colonialism. He lived in Algeria for all of four years. He was expelled in 1957, and went to Tunis. He died in Bethesda, Maryland, where he was being treated for leukemia, in 1961.

Algeria was perfectly suited to what Memmi described as Fanon's neurosis because it was "a land where French was

spoken but where one could hate France. Algeria was precisely the right substitute, in the negative and the positive sense, for Martinique which had let him down." As Memmi wrote,

> The extraordinary Algerian phase of Franz Fanon's life has been accepted as a matter of course. Yet it is scarcely believable. A man who has never set foot in a country decides within a rather brief span of time that this people will be his people, this country his country until death, even though he knows neither its language nor its civilization and has no particular ties to it. He eventually dies for this cause and is buried in Algerian soil.

In Memmi's account, Fanon did not understand the culture that he entered and wished to adopt as the vehicle of his messianic revolutionism, but he was neither Arab nor Moslem, both of which were intrinsic to the independence movement that he sought to join. Fanon's identity adventure, Memmi argued, scanted not only the particularities of Algeria and Arab North Africa, but also of Africa as a whole. It represented "a false universalism and abstract humanism based on neglecting all specific identity and all intervening social particularities."

Memmi's repudiation of Fanonism in the early 1970s estranged him from the left in the West as well as in countries such as Iran. There, an unholy alliance of communist and Marxist parties with anti-Western Islamists was mesmerized by the paroxysmal politics championed by Fanon, which found its tragic denouement in the Iranian revolution in 1979. French intellectuals such as Foucault were similarly beguiled by the ayatollahs' revolution. They saw in it a revolt against modernity, and the realization of the outlines of the new world

and the new man that Fanon and his acolytes had envisioned. Memmi prophetically warned that the haters of the Enlightenment and the West, the secular and religious revolutionaries in love with power rather than justice, were on a path to doom. His antidote to their philosophical and political depredations was liberal nationalism, and so it still remains.

The third historical development that modified Memmi's worldview was the storm over the establishment of the new state of Israel, in particular the denunciation of it by the left as a "settler colonial" outpost of Western imperialism. Memmi's experiences of anti-Jewish prejudice no doubt shaped his conviction that the establishment of the Jewish state should be seen rather as a national liberation struggle, called Zionism. The Jews, too, were entitled to such a struggle and to such a liberation. Many of these ideas were expressed in the essays collected in *Jews and Arabs* in 1974, where he forcefully expresses his impatience with the utopian pieties of leftist intellectuals. Jonathan Judaken, the editor of a fine collection of Memmi's writings in English translation, describes *Jews and Arabs* as Memmi's symbolic divorce from the Arab-Muslim world.

Memmi's responses to the three developments were increasingly more explicit elaborations of his emerging heterodoxy. In *Portrait of a Jew,* for example, Memmi recognized that Jewish communal and religious life carries within itself a national dimension. A few years later he wrote that "a nation is the only adequate response to the misfortune of a people...Only a national solution can exorcize our shadowy figure. Only Israel can infuse us with life and restore our full dimensions." (Later Michael Walzer came to much the same conclusion: "The link between people and land is a crucial feature of national identity... The theory of justice must allow for the territorial state, specifying the rights of its

inhabitants and recognizing the collective right of admission and refusal.") Memmi had become a Zionist, and he regarded Zionism as a progressive nationalism, as an inclusive political project. He rejected the idea that a national project must by definition be ethnonationalist or shaped only by tribal and religious criteria.

Memmi identified Zionism as the necessary expression of the national liberation struggle of the Jewish people and nationalism as the inevitable form that political self-determination takes. Whereas Fanon denounced nationalism according to proper Marxist doctrine as a "petty bourgeois" deviation from proletarian internationalism "with its cortege of wars and ruins," Memmi posited an enlightened nationalism that was a natural and inevitable aspiration of all peoples seeking autonomy, safety, and self-determination. Memmi's preferred form of Zionism was secular, tolerant, and social democratic. While critical of the anti-Jewish and anti-Israel currents in the Muslim Arab countries, Memmi also drew attention to what he saw as injustice inside Israel, such as the prejudice leveled against Mizrahi Jews; and he was an advocate for a two-state solution as a solution to the plight of the Palestinians. His inflection of nationalism was a combination of realism and decency, of pragmatism with an acute ethical sensitivity to the persistent inequalities and depredations in both colonial and post-colonial circumstances. As it happens, such a standpoint is precisely what is now needed by all the countries of the region.

This Tunisian Jewish anti-colonialist Zionist liberal has a lesson for the Muslim countries of our day. It is that feverish messianism and unresolved psychological anger at former colonial powers is a large part of the reason that the societies of the Middle East and North Africa remain unable to fulfill

their potential. The obsessive hatred of Israel and the refusal to relinquish the futile opposition to the Israeli state is, as Memmi described it, a collective neurosis. Framing the plight of the severely disadvantaged Palestinians as the wretched of the earth in search of a messiah, or at least a Mandela, is also a hobbling collective neurosis; what they need is an Adenauer, who can accept an imperfect and unsatisfactory reality in the present to achieve a better future.

The attacks of September 11, 2001 were a calamity for the Muslim Middle East as well as for the United States and the West in general. In their aftermath, it was natural for observers concerned with the region to ask what went wrong. How had the once glorious civilization of the Islamic Middle East become a haven for medievalist fanatical zealots and a redoubt for terrorists who saw themselves in an apocalyptic struggle with modernity and the West? Over the course of two or three centuries, the once dominant and culturally thriving lands of the Islamic Middle East had become, in the words of Bernard Lewis, "poor, weak, and ignorant." Historians and intellectuals have provided a long list of explanations to account for the decline of their civilization. Some blame the Mongols, or the Jews, or the British, and especially the Europeans, with their ideology of racial superiority and their imperialism. (In recent decades the Americans and their "neoliberalism" have been added to the inventory of external villains.) Some critics have pointed accusingly to supposedly inauthentic versions of Islam — to the enemy within. Notwithstanding the weight of this discourse, Lewis also noted that "growing numbers of Middle Easterners are adopting a more self-critical approach," which

198

he hoped would lead them to "abandon grievance and victimhood, settle their differences, and join their talents, energies, and resources in a common creative endeavor [so] they can once again make the Middle East, in modern times as it was in antiquity and in the Middle Ages, a major center of civilization."

Lewis did not identify any of these self-critical thinkers, but one of the pioneers of this new approach was certainly Fouad Ajami, whose book *The Arab Predicament*, which appeared in 1981, remains a benchmark for a new enlightenment, for the dream of democratic and liberal reform in the Middle East. It was a book that Memmi must have admired. Memmi himself was among these forward-looking and far-seeing Middle Eastern intellectuals, a unique and authoritative voice that could be counted among the ranks of "native" critics. (He once referred to himself through a semi-autobiographical fictional character as "a native in a colonial country, a Jew in an anti-Semitic universe, an African in a world dominated by Europe.") Still, it is far from clear that he harbored hopes for an imminent renaissance. His clear-eyed view of the region's many failures made such hopes harshly unrealistic.

It was in the context of the turmoil and misfortune brought upon the Middle East by the reactions to the 9/11 attacks — specifically the American and Western occupation of Iraq and Afghanistan — that Memmi's evolution as a genuinely independent critical thinker culminated in his book *Decolonization and the Decolonized*, in 2004. Returning to his earlier sociological methods, he witheringly surveyed the corruption and the tyranny of half a century of independent states. Surveying the myriad problems besetting the Middle East and Africa — calamitous violence, civil war, failed states, systemic corruption, repressive governments,

massive human rights abuses, appallingly low levels of social freedoms, persecution of minorities and women, and low levels of educational attainment and cultural production — Memmi arrived at a scathing indictment: "Why... has the tree of national independence provided us only with stunted and shriveled crops?" Rejecting the obfuscating argot of the post-colonial left, he noted how often it attributed the problems of the third world "to a new ruse of global capitalism, or 'neocolonialism,' a term sufficiently vague to serve as a screen and a rationale." Memmi urged post-colonial countries to acknowledge their failures to achieve democracy and development as largely self-inflicted wounds. He called on them to abandon the cheap excuse of blaming external forces. Memmi offered his criticisms not to disparage but to counsel; he eschewed the haughtiness of conservative historians who suggested that the hopes for decolonization were misguided from the start. He believed that the post-colonial countries could be independent, free, and fair places to live, and he called on them to make themselves so.

Memmi was right to sound the alarm, to urge the region's peoples to get over their fixation with the past. Indeed, he was only echoing words of the African Development Bank's report in 2003, which declared that "more than four decades of independence...should have been enough time to sort out the colonial legacies and move forward." Economic historians have persuasively demonstrated that the impact of past colonial experiences on current political and economic dynamics has diminished to almost negligible levels in many cases. The followers of Fanon and contemporary post-colonial perspectives persistently obscure this. They are the true reactionaries.

Memmi's work provides a powerful intellectual alternative, an antidote even, that could have inoculated generations

against the futile and self-destructive utopias chased by revolutionaries, from Iran in 1979 to certain theories expounded in the Western academy today. Consider the quixotic effort by a prominent representative of the post-colonial school of criticism to retrieve the anti-colonial legacy for contemporary so-called anti-globalization struggles. The same year in which Memmi's negative assessment of decolonialized societies appeared in print, the Indian-British post-colonial theorist Homi Bhabha asserted in a preface to a reprint of Fanon's *The Wretched of the Earth* that institutions such as the International Money Fund and World Bank have "the feel of the colonial ruler," since they, allegedly, create "dualistic," not developed, economies. He claimed that this "global duality should be put in the historical context of Fanon's founding insight into the 'geographical configuration of colonial governance,' namely the idea [of] 'a world divided in two...inhabited by different species.'" We are urged by Babha to adopt the "the critical language of duality — whether colonial or global" because "a progressive post-colonial cast of mind" naturally spawns a "spatial imagination [of] geopolitical thinking" that incorporates this language: "margin and metropole, center and periphery, the global and the local, the nation and the world." (This dichotomous vocabulary recently appeared in a comment by Rashid Khalidi on the Hamas-Israel war: "If you believe this theoretical construct — the colony and the metropole — then what activists do here in the metropole counts.") Since he cannot let go of the Manicheanism of revolutionary politics without which the Marxist and post-colonial schema of "colonized and colonizer" collapses, Bhaba is forced to shoehorn what is in reality a fractured, multipolar world into a reductive antinomy, so that he can combat it within the only framework available to him.

Albert Memmi and The Problem with Post-Colonialism

Bhabha applauds Fanon's grandiose claim that "the Third World must start over a new history of Man." Bhabha and Fanon (and the ludicrous Cornel West) seem to suggest that anti-globalization struggles are the route to international proletarian solidarity and revolution, and that the colonial/native dichotomy offers a workable foundation for such an eschaton. But as we have seen, Memmi knew better. He never suffered from a romanticization of the oppressed, even as he denounced their oppression. Moreover, he knew that the world cannot be neatly divided into the oppressed and the oppressors. The oppressed, after independence and even before, have a way of oppressing each other. He rejected terms such as "neo-colonialism" for obscuring the role of the elites of the independent Third World states in perpetuating injustice. He refused to accept that the culpability of these elites should be seen as merely another result of victimization by larger external forces.

Memmi's critique also applies to "decolonial" studies, the latest version of the Marxist-inspired anti-Western and anti-capitalist ideology making the rounds of Western academia (associated with writers such as Walter Mignolo, Aníbal Quijano, and others). It is a fatuous and often bizarre messianic theory, premised on a stupendously simplified picture of what is in fact a maddeningly complicated and tragically fragmented world. Anti-essentializers, heal yourselves! (The guiding intellectual light for some of these decolonial theorists is not Martin Luther King Jr., or Nelson Mandela, or Mahatma Gandhi, but — really — Subcommandante Marcos of the Zapatista insurgency.) The crusade to make everything post-colonial has become so pervasive that it has finally elicited forceful responses. In his heretical book *Against Decolonisation: Taking African Agency Seriously,*

for example, the Nigerian philosopher Olúfémi Táíwò (who has appeared in these pages) decries the "proliferation of the decolonization trope" because of its "pernicious influence and consequences." The idea of decolonization, he asserts, "has lost its way and is seriously harming scholarship in and on Africa." Echoing many of Memmi's concerns, Táíwò rejects the "absolutization of colonialism, the accompanying repudiation of [Enlightenment] universalism and the paradox that a Manichaean worldview generates."

The more worrying consequences of the post-colonialist dogmas are not intellectual but material and political, directly effecting living standards and livelihoods. The main problem of the decolonization worldview is that it is of no use to the people it purports to help. As Helen Pluckrose and James A. Lindsay observe in their survey of the post-colonial and the decolonial, this

> work is of very little practical relevance to people living in previously colonized countries, who are trying to deal with the political and economic aftermath. There is little reason to believe that previously colonized people have any use for a post-colonial Theory or decoloniality that argues that math is a tool of Western imperialism, that sees alphabetical literacy as colonial technology and post-colonial appropriation...

203

Worse, post-colonial theories can actually harm people in previously colonized countries, who are some of the poorest people in the world — for instance, when these ideas are applied to the issue of climate change, and a simplistic and misleading binary is generated, according to which we must choose between an evil white hyper-developed plundering

West and an idyllic view of indigenous peoples' beautiful relationship with nature, resurrecting long-discredited notions of the noble savage and calling them progressive. These ideas misrepresent the realities of climate change and lead to dubious climate policy recommendations that would likely impose enormous economic costs on those who need economic development the most.

Ultimately, of course, the effects of this fallacious worldview are most pernicious in the world of politics. They include the radical regimes of Iran, Nicaragua, Hezbollah, Afghanistan, and elsewhere. These regimes represent in practice what many of these theories espouse. In the Islamic Republic of Iran, for instance, perspectives paralleling Fanon's, represented by influential works such as Jalal al-e Ahmad's *Westoxification,* an attack on the West that deserves to be better known in the West, and also routinely expressed by the official ideologists of the regime, are still a significant part of the ideological edifice of the anti-liberal, anti-Western dictatorship that has been in power for over four decades. It is no longer just the rhetoric of tenured radicals, unless you count tyranny as a kind of tenure.

Given Memmi's perspicacity in uncovering the blind spots of the post-colonial left in Europe as it related to the question of the Middle East, it is unfortunate that Memmi decided to weigh in on the American struggle for black civil rights. He was insufficiently aware or appreciative of many complex facts of the American situation with regard to race. Indeed, he never visited the United States. In 1965 he dedicated the English edition of *The Colonizer and the Colonized* to the "American Negro, also colonized" because he perceived that community to be subject to the same type of oppression that he described in the book. This timing was not exactly

propitious, as it coincided with the passage of the historic civil rights laws that finally, a century after the American Civil War had failed to remove many institutions of racial oppression and official apartheid against formerly enslaved black Americans, had achieved a revolutionary progress. To be sure, laws by themselves could not be expected to remedy all the evils overnight. Yet it is precisely the essentializing and binary framework of his early period that he stubbornly projects, erroneously, onto the American scene, and thereby distorts its complexities and accomplishments. This is starkly illustrated when he fails to discern the different strands of the black civil rights movement:

> King, Baldwin, and Malcolm X do not represent three different historical solutions to the black problem, three possible choices for the Americans. [. . .] King, Baldwin and Malcolm X are signposts along the same inexorable road of revolt.

This false generalization leads Memmi to claim that "King is the victim of oppression who persists in wanting to resemble his oppressor. The oppressor will always be his model." This, of course, is spectacularly wrong.

Binary assumptions never illuminate, even in Memmi. Memmi's error in this case resulted from the application of the abstract dichotomies and assumptions of post-colonial theory to a racist society that had little in common with European colonialism. Unfortunately we see examples of this today, for example in the Manichaean binaries put forward by writers such as Ta-Nehisi Coates, the Black Lives Matter theoreticians, and The 1619 project, whose assumptions and implications have been cogently called into question in these pages by Daryl

Michael Scott, among others. Memmi's later voice of moderation would be a salutary contribution to today's debates about the legacy of colonialism.

There is a clear and strong message that emerges from an appreciation of Memmi's evolution as a writer and a thinker. It is that the concept of "coloniality" and its cognates retains little relevance for understanding the challenges facing countries in the developing world and the relations between rich and poor countries more broadly. "Haven't I got better things to do on this earth," Fanon wrote in the remarkable conclusion to *Black Skin, White Masks*, "than avenge the blacks of the seventeenth century?" Coloniality as a topic should be confined as much as possible to the history departments.

Whereas firebrands such as Fanon in his revolutionary mode called for cathartic violence as the road to redemption, Memmi was a pragmatic liberal nationalist social democrat who had the courage to say to his fellow third world citizens, especially in the Muslim countries of the Middle East and North Africa, that they had for the most part failed to achieve the objectives of independence and that they had for the most part no one to blame but themselves. This bracing assessment represents a necessary corrective to the simplifying radicalism of the post-colonial schools of thought that trace most if not all of the problems besetting developing countries to external forces, be they Western "imperialism," global capitalism, "systemic racism," "neoliberalism," "globalization," or any other single explanation for everything. (The Uyghurs in China, the Christians and the political prisoners in Iran, and the women under the rule of the Taliban

206

would all be surprised to learn that they suffer from white supremacist hegemony.)

Developing countries, especially in the Islamic Middle East which was of most concern to Memmi, can ill afford the misguided counsels of a worldview which posits that "colonialism" has not in fact ended and therefore, to quote a typical statement, "every analysis of the present is impossible to understand except in relation to the history of imperialism and colonial rule." Instead, what former colonies need most desperately is to break free of this debilitating straitjacket and move beyond the obsessive preoccupation with the colonial past to the urgent tasks at hand. Sartre was wrong in his critique of Memmi: colonialism was not a "system," an essentially permanent, almost metaphysical condition of human existence. Rather, as Memmi held, it was a "situation," one that has now passed. Today there exist new inequities, new hierarchies, and new cruelties, which will not be ameliorated by stale formulas or a morbid lingering over the unhappy centuries gone by. Post-colonial societies could do worse than repeat Memmi's own evolution. The struggle for justice requires that we live in the present.

207

ANGE MLINKO

Ringstrasse

I lost my grandmother's opera glasses ...
an empire in thrall to innovations
offered electric shocks in the Prater
for a small charge. In wedding dresses,
fräuleins dove from moving trains. Scions,
following the Great Somnambulator,

walked out of windows (into Blush Noisette!)
or stepped off bridges in uniform.
Thunderclouds amassed
as if looking to discharge public debt
under cover of a lightning storm.
It was a day like any other that Albert Last

as played, maybe, by a ringer for Strauss,
drowned. Baroness Vetsera (Louise Brooks)
descended from her carriage with a twirl
in front of the incandescent opera house.
No smelly tallow! She trained her binocs
on the Prince. ... typical fan girl.

Yes, mine were the glasses that saw
coaches turn into pumpkins.
Fiacre — barouche — swagged and crowned.
Droshky — diligence — curricle — landau.
Phaetons that for all their sins
never ran heaven into the ground.

Chekhov in The Gulf of Mexico

The resort staff are turning off the light
at the poolside bar. The iron gate
around the pool clanks shut loud enough
to wake the kiddos whose sleep their mothers

toiled to obtain. This Saturday night
is uniquely music-less, the usual spate
of sounds drowned out — rough
and slick alike, proclivities and druthers.

Even the band abandoned their tunes
when the downpour came. Unwelcome guests,
clouds clash though you can't see the colors —

damson, plumbago, where the swimmer prunes
and lightning in a soft synaptic burst suggests
the heavens had a thought, which sank in the rollers.

In the morning another worker's come.
He brushes off the leavings of a palm tree
from the cushions with a pillow.
He cranks taut the skirts of the umbrellas,

so the colors resolve into a dome
of crisp stripes. He loops the ropes expertly
out of the reach of children, though
the overall look, from above, is of bulls-eyes.

Slashed fronds, slats, louvers, wickerwork —
whatever breeze can be gotten, everything's sieving.
Housekeeping the outdoors is an enterprise:

raking sand each morning like a Zen monk
so that the guests can say, "This is living."
And the protected marsh is nodding, no surprise.

He puts the TV, she her jewelry on.
A divorceé, with her teenage son
who mutters, almost immediately,
that all the songs are about pair-bonding.

Each song, she might reply, is a repetition
before it's a departure. But he's gone —
he notices the poolside palms surgically
relieved of their fruit. Tanning and blonding,

the guests make use of the green-banana light,
and maybe the umbrellas are really meant
to keep an epiphany from glancing off the skull.

When the sun reaches a certain height,
a swish unwraps the cellophane from peppermint;
a green stripe in the surf burns auroral.

Tender the flesh under the shoulder strap,
and the bubble where the sandal thong chafes
threatens to burst. Sea grapes, saw palmettoes.
A seraglio of interior paramours.

Little herds trot across the sand wrapped
in towels identical to the umbrellas. Waifs
wander in search of lizards. A man throws
out his arms: "Venga, como una mariposa!"

and the little girl jumps. A boy, maybe four,
points out a baby iguana poking its snout
through the slats of a porch. The smallest

among us spot the miniscular. They adore
the giant chess set, knocking the queen out
with the flourish of a major plot-twist.

Mother and son share a kayak. They bump
and bumble into the mangrove swamp
and barely keep up with the tour guide.
"Life starts here," he's saying, "the tide
brings animals and fish to incubate."
Unsynchronously paddling the strait,
mother hissing, son throwing a backward glare,
they pantomime a mismatched pair.

Amid a cloud of kicked-up sand ("mermaid's milk")
manatees, mouths full of sea grass, gleam in bulk.
The guide holds up a jellyfish; the boy puts out his hand.

A smile shows he's hooked. The sting he can stand:
it's impersonal. Now they sail through a cove
of hurricane wrecks and it looks like love.

Yes, the future has come to harass parents
while the scenery plays second fiddle
to the girls with cameras — snapping themselves.
The boy worships each one from afar.

The afternoon is turning a corner, hence
the heat, which makes the parking lot a griddle.
Better to languish on those balconies like shelves
than seek out the telescope which brings a star

too close. Besides, a starboard light will serve,
after too many rosé-colored glasses,
as the true purveyor of mysteries, because you know

there's a captain there, negotiating earth's curve.
Whatever the green light in the darkness promises,
what kissed you, you'll see in the morning, was a mosquito.

A steady stream of rhymes (lingo/gringo) purls
across the palms' scanty shade. Now country,
now reggae, now "light contemporary."
The balconies repeat dizzyingly, all rails

and wickerwork and cushions printed with zz's
receding like a single room between two mirrors.
A man, with his actress companion, appears.
The palms start up like a band in a sudden breeze:

Rain, rain, rain, their only song. Crabs fallen
from the zodiac make like putts into their holes.
Rain, which drop by drop sounds a complaint

of zinc-tipped arrows against Eros, comes when
lightning collects its highway tolls.
Then we see what bulls-eyed umbrellas meant.

213

Orangerie

Sometimes I think I must have ground to a halt
on this lot for the sake of the orange tree alone.
I might have preferred the olive — rolled
on a bias — but it requires labor, refinement, salt.
Oranges are easy: sweetness sewn
 inside a roughly perfect handhold.

Fruit in different stages of production muscles
the bough into a bow, the bow into a lyre,
plucked string lengths sounding a golden mean.
They long to dispense their light into bushels,
these overburdened arms; as they grow higher,
 they find my roof, on which they lean,

and then the spheres go reeling like billiards
down gutters angled like a kinetics sculpture-
cum-candy dispenser. Think how pretty!
Think if you were a house, contemplating yards,
wouldn't you choose one with a culture
 of citrus, the least complicated beauty,

to run aground on? That is, if houses,
like arks, sailed from firmament to foundation.
This tree is a juggler drawing out his long game.
Inspired, I swap my bow for sternness.
It is serious, this groundless elation.
 C'est mon bijou, mon or, mon âme, my name.

WENDY GAN

Antigone in Hong Kong

Hong Kong has its own Antigone and her name is Chow
Hang-Tung. I had never heard of her until June 4, 2021.

Every year from 1989 until the start of the pandemic, Hong
Kong has commemorated the Tiananmen Massacre with a
candlelight vigil at Victoria Park on June 4. Though attendance
had been dwindling through the years, the vigil is a proud
tradition and one that marks Hong Kong as unique, because
nowhere else within China can the events of Tiananmen be
openly acknowledged, much less memorialized. This changed,
however, in 2020, with the passing of the National Security
Law (NSL). Ostensibly a law to criminalize subversion and

protect the integrity of the state, many understood it to be a weapon to stifle dissent of any kind. Freedom of speech and freedom of assembly, rights once guaranteed by Hong Kong's mini-constitution, the Basic Law, have been superseded by this new law.

As a consequence of the NSL, these freedoms can now only be exercised in a context in which they do not threaten the status quo as defined by China. Given Beijing's resolute denial of the events of Tiananmen in 1989, convening a commemoration on June 4 in this new environment could well be deemed subversive, though, interestingly, applications to hold the vigil as usual in 2020 and 2021 had been denied on public health grounds and not on political grounds. While there was no official indication that approval had been withheld because the vigil contravened the National Security Law, the excessively large police presence in the vicinity of Victoria Park on the night of June 4, 2021 was sending a rather different message, as was Chow's arrest on the morning of the same day.

Chow is the vice-chair of the Hong Kong Alliance in Support of Patriotic Democratic Movements of China, an organization that has convened the Tiananmen vigil in Hong Kong over the years. In the absence of the Hong Kong Alliance's leaders (who had been imprisoned in sweeping NSL arrests earlier in the year), Chow, a bespectacled barrister with a broad, frank face and a friendly smile, stepped up to maintain Hong Kong's commitment to remember Tiananmen. Knowing that a permit to gather and conduct the memorial had been denied, she posted on Facebook that she would continue the tradition of lighting a candle in a public space to commemorate the events of June 4, 1989. Her message ends with an exhortation to

keep the candlelight alive in the cold, to keep the bottom line of our conscience, and to keep our remaining freedom. Only by standing our ground and defending our position and principles with actions can we win the space for survival. On June 4 this year, let us continue to fight for justice for the dead and dignity for the living with candlelight.

She was promptly arrested and, in January 2022, convicted and sentenced to fifteen months in prison for these words. The charge was "promoting an unauthorized assembly."

For a brief period, while out on bail, Chow remained in the news. Faced with both an additional accusation that the organization she headed was an "agent of foreign forces" and a police request for information on the Hong Kong Alliance's finances and membership, Chow characterized the targeting of the Alliance as the exercise of "unreasonable power" and pointedly declined to accede to any demands. This act of non-compliance landed her back in jail on new charges of failing to cooperate with police investigations and subversion of the state. Her continual defiance of the authorities was extraordinary, a brave devotion to principle that she continued to exhibit even in prison. While a number of her fellow activists had strategically opted to plead guilty to charges of incitement and sedition in exchange for a reduced sentence, Chow refused to do so. In a bilingual message to supporters published on Patreon explaining her decision, she runs through the pros and cons of pleading guilty and concludes that, no matter the consequences, she is unable to be dishonest:

> What I said before everything took place shall remain
> the same in my submission to the court. It shall not alter

due to threats of penalty. You can force bitter manual
tasks on me — like washing the toilet — and smelly
porridge, but you can't force me to speak contrary to
my mind. You can even force me to shut up but you can't
force me to utter what I do not believe.

Her word matters to her and, even if a guilty plea is now
meaningless in a law court whose integrity is questionable, she
still cannot bring herself to admit to the allegation brought
against her.

My speech is sacred and inviolable. It embodies my free
will which cannot be taken away by any exterior forces.
And to live up to every word I have said is a very
humble discipline I set for myself.

Taking such a stance is exhausting, as she herself admits, but
better to expend her energies while holding to such a position
than to live aimlessly.

More than her honesty, what I believe marks Chow out
as truly remarkable, is her consistency. She has her principles
and she will stay loyal to them. Like Antigone, she has a single-
minded purposefulness that propels and fortifies her through
her difficulties.

I know that I am not like Antigone, principled and
unafraid, choosing to defy her uncle Creon's decree and give
her brother his burial rites, even if it means certain death. She
marches unwaveringly through the play like an otherworldly
saint set on martyrdom. Doing right by her brother and acting

in accordance with the laws of God matter more than life itself. No, I am not Antigone; I do not have such courage; I do not have a death wish.

Does this mean that I am Ismene, Antigone's sister whom Creon says can be found sniffling within his house? She doesn't sound like much. If we are to believe Creon, Ismene seems akin to one of those red-nosed pathetic women who exist in a Jane Austen novel merely to showcase the heroine's patience and virtue — a poor and sorry specimen of a woman. Creon is a misogynist, though; all women are sniveling fools to him. But I must admit that I rather like Ismene. She is ordinary. She fears for her own skin. She finds excuses not to be heroic: "We are only women/We cannot fight with men," she tells Antigone. I know we are meant to aspire to Antigone's dogged pursuit of the higher law, but I feel more at ease with Ismene. When she says to Antigone, "And I think it is dangerous business/To be always meddling," that line rings true to me; I have this fear within me too. She says it almost as an afterthought, but it is a revealing moment. More than her excuses of being a weak woman and wishing to be obedient to the authority of her uncle, this apprehension of meddling, of stepping outside the set bounds, of the repercussions that her deviance will bring, is her deepest motivation not to act as Antigone will do.

Ismene has learnt the danger of going beyond her prescribed place because she lives in a patriarchal and authoritarian world. As the play unfolds and Creon displays more and more of his splenetic and dictatorial impulses, with especially devastating results for himself, we see fleshed out the environment that Ismene inhabits. Cross the king and you will suffer consequences. Consider the sentry's fear in bringing bad news to Creon. Consider how Creon's own son, Haimon, is given short shrift by his father. Consider what happens to Antigone.

Antigone in Hong Kong

Ismene knows what it means to live in a hostile world. You can call her a coward, one who values self-preservation over justice, but she is a survivor.

Like Antigone, Chow is more of a fighter than a survivor, and she fights with a clear-eyed recognition that the odds are against her and that she will be called upon to sacrifice her freedom. Though she has had a surprising victory with the recent overturning of her January 2022 conviction for illegal assembly, her conviction for her other NSL-related charges means that she remains imprisoned for the foreseeable future. Most of us (and I certainly include myself) will never be as steadfast as she is, especially in the face of hardship and suffering. We survive by evasion. Like Ismene, we know the art of inconsistency.

If we follow Sophocles' imagining of their lives in *Oedipus at Colonnus*, Antigone has always lived on the margins, refusing to compromise. She is the one who suffers with Oedipus, guiding her blind father in his exile. Ismene, on the other hand, has chosen to remain in Thebes with her brothers, living in comfort, but she is nonetheless loyal to her father. She is the spy within the royal household, bringing reports of the latest oracles and court politics to Oedipus and Antigone. She is the two-faced insider who knows what it means to appear one way and think another, to say one thing and do another. The purity of Antigone's purpose is not hers; Ismene's world is murkier and more fraught. No wonder she is afraid; no wonder she does not always make the right decisions; no wonder she changes her mind and oscillates between positions.

To borrow Václav Havel's language from his great essay "The Power of the Powerless," Ismene lives in the world of appearances while trying as best she can to live in truth. She is akin to Havel's hypothetical greengrocer who puts up a

220

poster he does not believe in to signal his acquiescence to the totalitarian system. She will obey Creon's diktat, though she disagrees with it. She will subvert where she can, as she does in *Oedipus in Colonnus,* and she will, at the end of *Antigone,* perhaps inspired or shamed by Antigone's actions, attempt to live by her conscience instead of her fear. No one will make her a protagonist, because her existence is too ordinary, too mean. In an unjust world, we have Ismenes in abundance; what we need is the consistent purity of Antigone as a beacon of truth.

Am I defending Ismene too much? Perhaps, but I feel for her lack of heroism, her faint efforts to live in the truth. Most of us do not live in the kind of totalitarian state that engendered Havel's astute analysis of power, complicity, and subversion. We will never quite experience such an extreme split between appearances and truth, but, as Havel recognized, there are larger forces at work on all of us, whether we live in a democracy or an authoritarian state or somewhere in between. There is every-where the wish—sometimes sinister, sometimes well-inten-tioned—to deny us our messy humanity in favor of the order-liness of a smoothly running system. We all know what it feels like to inhabit an institution (think of the corporations we work for, the schools we were educated in, the neo-liberal capitalist economies we are trapped in) that offers us safety, convenience, and a livelihood in exchange for our willing conformity.

Staying true to our humanity is harder than one thinks. Havel understood this very well:

Human beings are compelled to live within a lie, but they can be compelled to do so only because they are

capable of living in this way each person is capable, to a greater or lesser degree, of coming to terms with living within a lie. Each person succumbs to a profane trivialization of his inherent humanity, and to utilitarianism. In everyone there is some willingness to merge with the anonymous crowd and to flow comfortably along with it down the river of pseudo-life.

I had to pause for a while after I first read this passage from Havel's essay. Here was the psychology of Ismene laid bare. Here was my own psychology laid bare. Because my flesh is weak and I hanker after ease, comfort, and security, I willingly efface myself and live in ways that falsify my being. It is a disturbing revelation, and one that when applied retrospectively to my life reveals a great deal about me. I conform and I find ways to evade conformity. It explains why I am not in jail like Chow Hang-Tung, and why I am also no longer living in Hong Kong. We each find our ways to live in the truth; and I have chosen exile and a return to my native Singapore.

I learned a Chinese proverb in the midst of the protests in Hong Kong: you kill the chickens to frighten the monkeys. Its meaning is clear enough: a display of gratuitous violence silences the targeted community. I have been a scared monkey for almost all my adult life. I became one in 1987, when in Singapore a "Marxist conspiracy" to unseat the government was unveiled by the media. A group of sixteen social workers, activists, and volunteers at a Catholic outreach center were arrested and detained without trial under the Internal Security Act. Confessions were obtained and broadcast on national televi-

sion. I was fifteen, more interested in netball and navigating the confusing currents of schoolgirl friendships than politics. Still, this was an event that no one could ignore. I grasped only vaguely the details of the situation being described on television, but I sensed a chill, a hush in the air. Everyone was shocked by the turn of the events, but the horror was less about this shadowy network supposedly working surreptitiously within the Catholic church to create a communist state than about the government's overreaction.

My parents were not overtly political; they were more focused on living comfortable middle-class lives complete with as many status markers as they could afford — house, cars, club membership, travels abroad. But they were not naive. They knew the accusations rang hollow and they said so, though quietly and privately, only within the four walls of the family home. They understood the warning: the chickens were being killed. I watched and listened somewhat puzzled, somewhat indifferent (it was far more pressing to me to understand why some friends at school were giving me the cold shoulder), but enough had seeped into me. I *knew* this in my bones now: annoy the government and this could happen to you, too.

When fear of your own government enters you, what is the remedy? I could imagine only one solution: you leave the place that generates the disquiet. It was not exactly a conscious choice; I did not understand that I was running away from an ill-defined and amorphous political anxiety. In fact, it felt more like I was running away from my dysfunctional family. But I was also escaping a place — Singapore — that had always felt constrained and constricted to me. You cannot feel completely at ease knowing at the back of your mind that the government's hand could reach for you when you least expect it. So, in my twenties, when I had the choice between working

223

in Hong Kong or continuing on in Singapore in a similar position, the answer was obvious. Of course I was going to Hong Kong.

I had last been there as a small child and barely knew the place. All I could remember was how rude the people could be if you were ethnically Chinese but could not speak Cantonese, and I did not speak a single word of Cantonese. But Hong Kong was not Singapore, and even in 1999, two years after its return to China, Hong Kong still had a reputation as a place where the rights to free speech and political assembly were firmly exercised. I was not exactly in a hurry to indulge in these freedoms myself, but I liked being in a place where others could. I did not like chickens being harmed and people turned into frightened monkeys.

A few weeks before August 9, which is Singapore's National Day, the red and white flags start to come out. The estate management is responsible for the decorative bunting hung out in common areas, but individual flat owners can choose to hang the national flag from their windows. I have seen images in the past of blocks of flats blanketed with red and white flags. It makes for quite a sight, stirring but also a little chilling. This year, looking from my apartment window, I count only a handful on display.

When I witnessed the first flag being put out in the block opposite me, my thoughts turned to Havel's greengrocer and his poster, even though, on further reflection, there is very little similarity between these two acts. We are under no compulsion — direct or indirect — to display the flag, and no one will suffer consequences for failing to do so. Such pockets

of freedom make living in Singapore bearable. I remember joking with my friends while I was still in Hong Kong that, with the way things were going around the world, authoritarian Singapore was beginning to look enticing. Given the vagueness of the NSL in Hong Kong and how it might be applied by over-enthusiastic security officers, I felt that at least in Singapore I knew what and where the red lines were. I am, after all, a bona fide Singapore-trained monkey.

Living in Singapore after the sadness of Hong Kong's transformation under the NSL is also a relief. If I am to be brutally honest, this is because the pressure to be an Antigone of some kind in Hong Kong is always present. When the Hong Kong authorities began to arrest pro-democracy activists under the auspices of the NSL in 2021, Martin Niemöller's famous warning, as well as adaptations of it to suit Hong Kong's situation, began to circulate on social media:

> First they came for the socialists, and I did not speak out
> — because I was not a socialist.
>
> Then they came for the trade unionists, and I did not speak out— because I was not a trade unionist.
>
> Then they came for the Jews, and I did not speak out — because I was not a Jew.
>
> Then they came for me — and there was no one left to speak for me.

Sympathizers of the democratic cause were being asked to not turn a blind eye to what was happening and to speak up against the unjust arrests. But the chicken-killing spree had

frightened the monkeys. Antigones were wanted, but mostly Ismenes were to be found.

Singapore, on the other hand, is a place where Ismenes are prized, which is why being here is restful for me. Life is certainly circumscribed, but there is space enough to keep writing, especially about Hong Kong. One conforms so that the pen can evade conformity.

In my dreams I am Antigone.

I am in an underground cell so dark that I have to feel and grope my way about like my father used to. There is a tray of food on the floor by the door and I can hear the twitchings and squeaks of what is probably a rat. It is cold. The dead are above ground, the living below. I am exhausted. First sleep and then the final sleep, except that I have court dates to remember and attend, and I have a submission to write for the judge, but I do not have my legal books and my notes. I can only remember Havel's greengrocer, who put up and then took down the poster and suffered the consequences. The emperor has no clothes, but he wields a great deal of power even when stark naked. Somehow I know that Ismene is in the cell above me. I can hear her singing. It's her voice, for sure—lilting but penetrating. It makes my heart glad. I do not recognize the song and it is in a language that I do not understand, but I know that it is Ismene who is singing, and she is telling me that she will survive and keep singing. I was angry with her for not coming with me to bury Polyneices, but now I think that it is actually good that someone survives, though I would never have admitted this to her face. Someone has to die and someone has to live. She will be lonely, my poor sister, while

I will have the company of my father and my brothers. That will be her lot in life. Though if she keeps singing like this, like a songbird in a cage dreaming of swaying green branches and racing blue skies, she will be fine. Ismene will be fine.

In my dreams, I am an Antigone who forgives Ismene.

JENNIE LIGHTWEIS-GOFF

Concept Creep: A Progressive's Lament

For Jim Longenbach

On or about November 9, 2016, human nature changed. All human speech shifted, and when human speech shifts there is at the same time a shift in religion, conduct, politics, and litera-ture. The word equality — so long associated with liberalism — left the left; they erected the house of complicity in its footprint, behind its aging facade. It was a haunted house. All who dared enter shadow-boxed with a series of specters. These were battles of life or death organized around minor abrogations of language (from "homeless" to "unhoused," from lowercase to uppercase first letters in racial designations, and so on). I am not a liberal, but one of the left coalition that can scarcely win a primary, so

I am inured to my powerlessness. But in the final years of that decade, I learned that I was limitlessly powerful. Indeed, hadn't we Bernie bros — I preferred "Berning Men" — opened the gaps through which Trump crawled? And weren't we therefore obligated to kneel first during public rituals of self-cleansing? And wasn't each person not simply an agent of their own notions, but a resister to or collaborator with public feeling? Of late, a beloved friend whose politics are far more virtuous than mine has chastised me for voting with too little enthusiasm. My shrug, you see, is complicit with "the other side." It enables them. And I think: surely it must rankle human dignity to be radicalized for so moderate a force as the Democratic party.

Everywhere in the Complicity Era, we were compelled to exercise our power through illocutionary speech acts — denouncing and endorsing on cue. This included accolades for "Nazi-punching" far from our front doors, declamations against election interference by Russia (who, long ago, perfected the art of Nazi-punching), and odes to civil unrest authored by the people most likely to turn tail at the sight of a fire in their own neighborhoods. Certain events elicited public statements from people with no public profile; Verdict Days for killer cops demanded an evening litany on Twitter. The event need not be macropolitical. You might denounce former comrades who had been insufficiently pious, or who continued to "follow" Louis CK's social media accounts. You could issue these dicta on the same platform that sold you weighted blankets and over-priced rompers that costumed adults as children. For the last two decades, I had joked (after Baudrillard) that the Cold War did not take place. In Jenny Erpenbeck's *Go Went Gone*, the reunification of Germany means little more to its protagonist — a retired academic — than a slightly closer transit stop to his apartment in Berlin.

So much memory had been scrubbed with the dismantling of the political and intellectual apparatus that sustained "war" — which of course was less a war than a wrestling match. Like many Americans my age, I grew up burning whole weekends with the board game *Risk*, which perfectly inverted the truth of war. The longer the game went on, the more resources the strongest fighter accumulated. The deepest resource, of course, is a population's decentralized paranoia, with no top-down instruction required. In the Complicity Era, we have found other uses for the paranoid style, the resource that paradoxically shaped and emerged from the Cold War. Paranoia migrated, resurged, and renewed. In early 2022, a poll found that more than forty percent of Americans believed Russia was Communist; if your first instinct is to hope that this forty percent is on the "other side," then the complicity critique of these years has cost you dearly.

Perhaps it was not the "paranoid style" of the political right, but the "hermeneutic of suspicion" practiced by the academic left, that seized American tongues. The desire to flush out the enemy of concealed meaning generates martial language in scholarly writing; there, the writer does not argue, he *intervenes*. He does not analyze; he *interrogates*. Concepts steadily creeped from colleges and universities to the broader world: think of the heights to which *intersectionality* and *performativity* climbed in these dishonest decades. For those of us trained in the humanities, the language traveled with all the precision one could expect after a student pulls an all-nighter before an essay exam. Most of the people who coined or refined the concepts that creep to the public square are still alive — young Boomers or old Gen Xers — so one wonders what they do when they wake in the middle of the night, feeling like both Victor Frankenstein and his Creature.

"Performativity" came to mean the self-conscious exhibition of one's political virtues, though it in fact referred to one's almost unconscious habituation to identity roles, subject to subversion with subsequent repetition. There is the agonizing loss of "emotional labor" — formerly the management of feeling required by low-wage service workers, the term now serves as an excuse to refuse evidence, renege on debate, and resist counter-argument, especially if your opponent has been unpersoned, thanks to their own infelicities of language or allegiance. Then, it is no longer your "job" to educate them; it is onerous emotional labor to even continue the conversation. "Intersectionality" became a signpost that one was aspiring to treat identity categories as mutually constitutive, but it clearly chose the heft of some identities (race, not class; gender, not citizenship) over others. The rote uses of these terms, the reflexive self-descriptions and deceptions that attend them, are so utterly empty and imitable that they can be written by bot; indeed, perhaps they are, in public apologies and mission statements. Novels such as Lauren Oyler's *Fake Accounts* and Patricia Lockwood's *No One is Talking About This* nonetheless wring some eloquence out of the fallen discourse.

But who reads novels? One might find the withering term "reductionist" affixed to their politics should they tarry too long with an identity that has not attained totemic value at the Pop Intersections. The going euphemism — "unhoused" — is one I have heard spoken aloud precisely twice, both at academic conferences; one was at the Moscone Center in San Francisco, and the other at the Washington State Convention Center in Seattle. Outside those doors, ragged people sleep, scream, and weep; they practice amateur phlebotomy on city sidewalks. No alteration of terminology will ameliorate these conditions. The categories of "class" and "poverty" do not

231

quite work in social justice contexts, because the conditions under discussion must be eliminated, not celebrated as signs of diversity. The point is not to become comfortable with the "unhoused," but to find them houses.

Freddie de Boer writes about the mental health disabilities that no one cares about, the ones that extra time on the SAT or endlessly flexible deadlines will not ameliorate. Unpretty psychological disorders compel some of us to starve ourselves and shove wires under our fingernails. We hear rumbling, absent voices that impose impossible loyalty tests on everyone who loves us. Many of us who are critically ill are largely ignored even as "healers" celebrate the power of talk therapy and self-care on Instagram and TikTok. David Baddiel and others note that Jews don't count in much social justice agitation around race. The mutability of Jewish appearance is cited by so-called anti-racists as a reason that antisemitism is not "as bad" as any other supremacy — but that very mutability is the kernel of antisemitic paranoia (and its attendant violence). In social justice circles, a slander is therefore mistaken for a privilege. And I would simply add to this incomplete list: age. If you take as a sign of *bien pensant* thinking the language that circulated in liberal arts classrooms in the late Obama years, do not be surprised if all your comrades are around thirty-two years old.

I am forty-three; I likely taught this crew, for some embarrassing per-class sum. Times were tough; I took too little money and wrote too few notes in the margins, so I taste an unpleasant mixture of guilt and rage as concepts creep so far from necessary use. (I am not Judith Butler or Kimberlé Crenshaw or Arlie Hochschild, but I do sometimes wake up from my own Frankenstein nightmares). I grieve the loss of language that we needed, in philosophical and intellectual

inquiry, to unearth the insidious logic of marginalization. I grieve a circulation of these terms that sounds more like telling than talking. I grieve emotional labor in particular, since my job requires management of both my feelings and my ungovernable facial expressions. Most of all, I grieve it because I am a class reductionist.

During the heady days I taught women's studies — then gender studies, then gender and sexuality studies, and so on — I frequently reminded bright-eyed students that arguments for the liberatory power of sex work (or even, simply, the work of sex work) tended to come from the sector's most elite practitioners — from call girls and well-paid escorts, not survival sex workers or people who occasionally traded sex for a place to sleep without calling that a transaction, or work at all, since they would clock in for a minimum wage job in the morning. Critiques of academia, similarly, come from its elite quadrants: from tenured professors who parlayed their heterodoxy into podcasts and book deals and prizes, from opponents of cancel culture who think that the character of higher education can be gleaned from five elite campuses where students picket dorms with troubling names above the door, or hector their professors into early retirement. But most students don't choose college with advice from the *Princeton Review*; they choose it on a map, because it is close to their full-time employer or caregivers for their school-age children. The emerging college majority — of poor and first-generation college students, of working adults — has little in common with tony *New Yorker* and *New York Times* reports about the fascinating vicissitudes of life at Harvard.

Cruel economics blunt the possibility of student solidarity with their precariously employed instructors, and make it more urgent, too. The politics of the public campus are equally predictable, though different in texture, from Oberlin and Smith; so is the education. No less elite a figure than Woodrow Wilson boasted that the majority of the population could forego the benefits of a liberal arts education to preserve it for the few. Most have. No less radical a figure than W.E.B. DuBois noted that the public intellectuals arguing for the irrelevance of Shakespeare had studied Shakespeare at the seminar table they shared with him at Fisk University. They wanted more for themselves than they would offer to the rest of us. The entitlement of non-elite students is present but, again, different: it is instrumentalist in its relationship to knowledge, and firm in the notion that all work has a supervisor, and they are my bosses. When we talk about higher education, we tend to forget that, whatever its cultural power, the university is simply my workplace. There, I exchange my labor for a wage. I do not work to earn cultural capital. Cultural capital cannot pay my mortgage.

Putatively justice-minded academics are content to leave the note unpaid. Before her death – premature and sudden, even at the age of eighty-one — Barbara Ehrenreich often told a story about bringing campus organizers to a faculty meeting in hopes of generating support for their campaign for unionization, only to have long-tenured women professors declaim that they were tired of having men talk over them about politics. The men in question were the janitors in their office building, but no matter. These men are certainly capable of discussing ideas — and they are far better at doing so in English than I am in Spanish — but you may wait forever if you expect them to speak the language of suspicion. That

language is a badge of cultural capital, cold comfort in a wildly unequal society. Meting out these badges of approval, whether with diplomas or social media likes or praise at a DEI workshop, strikes me as a deeply conservative impulse. Not a radical one at all.

Universities, nonetheless, commit to political "intervention." But what constitutes politics? Twice in the last decade, I have been called upon to write a public statement — once in the wake of George Floyd's death, once after shootings in massage spas in Atlanta — on behalf of my scholarly organizations. Like all fumbling writers, I sought models, and found curious deflections. After the shootings at the Tree of Life Synagogue in Pittsburgh, the National Women's Studies Association statement spent quite a lot of energy denouncing the shooter's "toxic masculinity." (I would have focused on the antisemitism.) I began declining invitations to write manifestoes, statements, polemics, and apologia. To my mind, it's not my "job" to educate people outside the classroom because my job inside the classroom is an immersive and unstable one. To my fellow academics, it is apparently my "job" to educate you because my intersecting identities are so privileged; despite the institutional power that structure these exchanges, they demonstrate that my contingency — the condition that keeps me in a kind of outer darkness — matters not at all. That is to be expected: one can endlessly diversify the faculty with superstar hires and high-profile poaching from other institutions. These sound economic decisions can look like rituals of public cleansing. A university hiring one of its own adjuncts into a tenure line, by contrast, underscores that the market is not meritocratic. And while we hasten to acknowledge the privileges that followed us into the world, it is far more uncomfortable to acknowledge that we have succeeded in an oligarchy.

235

Concept Creep: A Progressive's Lament

During years of shrinking salaries, of diminishing tenure lines, professional questions receded in favor of the "political," such as it is. The Modern Language Association held a years-long reckoning on Boycott, Divest, and Sanction, while its role in hiring — its annual conference is a traditional site for first-round interviews for academic positions in English and Foreign Languages — remained a largely unmentioned source of its power. In 2022 the American Studies Association held its conference in New Orleans, circulating an advance call for papers warning that "the roof is on fire" thanks to rising waters on the coast, but nonetheless promised a party in the Crescent. The call arrived in my inbox on the day I negotiated with my insurance company — the previous one had gone bankrupt — for a new policy after the monstrous Hurricane Ida: a storm that cost my loved ones their homes, senses of security, and, in one case, a limb. People I loved were couch-surfing and breathing in mold as close as eight blocks away and as far away as Brooklyn. Suffice to say, I was in no mood to regard my roof as a metaphor. Contingent scholars poked and mocked and laughed at the call's indifference to the "fire" on campus. The organization's leadership offered a dismissive webcast in response. Those of us who joked on Twitter couldn't possibly worry so much about contingency; surely we mentioned it to relieve us of the urgency of frank talk about race. We weren't really mad about the proposal's politics; we were annoyed by its use of black vernacular English, its borrowing of a song title from Rock Master Scott and the Dynamic Three. Our class politics were fake; we were "Neiman Marxists." I am usually more decorous than this in print. But here, I say: all involved parties can go to hell.

The politics of academia are a non-politics, a displacement of the power we have for focus on the power we lack, a refusal to intervene in the sphere in which we reside in

favor of hopeless flailing at the borders of someone else's, a performance of powerlessness that prefers the "systemic" for its abstractions and enormities. Adam Serwer's memorable phrase — "the cruelty is the point" — became a progressive shibboleth about the shape of conservatism in the Complicity Era, but for well-heeled professors often the helplessness is the point. Why advocate for the staff when you can edit a well-placed journal issue on the Anthropocene (another radically misused term)? Why use the authority you have, when you can instead feel the flush of pleasure that comes from what Charles Dickens called "telescopic philanthropy?" We need not operate at the scale of a peer-reviewed article to understand this non-politics. Here is an example. At a protest I attended in late in the summer of 2020, pedestrians and cyclists filled the French Quarter. An organizer shouted instructions to the crowd, asking white allies to "discipline" an unwell homeless man who was shouting racial slurs; he caught a fist in the face from someone who evidently wanted a better world. Four people carried him out of the crowd, through an alley of cheers. And once the sound system was in place, once the crowd was attentive, once we were all masked (as requested by a roving street medic), a speaker offered a long disquisition on the harm done by maps that labeled Boricua with the name conferred by colonizers: Puerto Rico. This is to say, the crowd was corralled in order to learn more — an admirable goal, if not the urgent one that motivated their presence — about something they could do very little to change, and that would not change with a single march or a thousand marches down Royal Street. The doctrinaire speechifying worked as well as tear gas. The crowd dispersed early.

From the megaphone, the organizers didn't deploy the language of leadership or justice or of activism, but of

expertise. Concepts creep out of academia and offer armor to justice entrepreneurs; the dazzling array of quasi-therapeutic DEI interventions requires a rhetorical suit of armor to convey legitimacy, to affect the professional "conspiracy against the laity" that is, in a way, the story of the twentieth century. They borrow the language of critical theory; sometimes it is a sort of ownership, since the deprivation of the Crisis Academy drove Ph.D.s into other precarious work sectors. (Here, I mention journalism and creative writing, if only because I'm writing prose in a context many scholars would consider wasted — because it is read, not because it is unread.) Other academics — displaced from traditional tenure lines and stable work lives — become entrepreneurs, offering workshops and consultancies that purport to teach critical theory as a second language to undergird activism. Think of critical theory as another field that attracts ambitious, disciplined, underpaid obsessives: yoga. The only reward for a successful yoga pose, a beloved teacher reminds me, is the next pose. The reward for understanding critical theory is not a changed name on the map; it is further thought and reflection in a culture that doesn't make much time for that. Critics of the humanities tend to think we inject bad ideas into vulnerable minds, but I would say that we move empty linguistic signifiers into a powerfully ignorant culture. When I look at a list of the decade's most recursive obsessions, I wish we read more Adorno, not less. Righteous speech modifications and a couple of lady superheroes at the megaplex? If this is justice, its vision is paltry.

The longer I teach, the more I believe that everyone teaches. An artist's retreat teaches us how to work from fellow creators. A writing date demonstrates innovation around scheduling and organization. The chef teaches the line cook;

clerks and nurses shadow one another. The pedagogical tradition of apprenticeship has receded, thanks to cutthroat capitalist competition. Met with talk of a graduate student union, university administrators told us that we would fail because United Auto Workers, Service Workers International Union, and Communication Workers of America did not understand that we were not really workers, just students. At the time, I took home fourteen thousand dollars a year to teach thirty students paying around forty thousand dollars in tuition. A senior professor assured me that I would one day know that tenure is the best union going. These days, it seems more like a cartel.

I suspect, too, that the ideas that migrate from academia are the ones that have the most vulgar applications, the easiest interpretive strategy with the highest pay-off in political virtue. This is to say, they are the simple and generative concepts to teach and to learn. They require no response or struggle: only careful memorization. For some years, it was the concept of cultural appropriation — an assertion of culture as a unitary practice, a single arrow pointing between a "black" practice and the "white" creator who stole it to enrich himself. If one were really to preserve the complexity of culture, the arrows would look more like the Beijing transit map, but cultural appropriation clears the deck. The unrelievedly white Mississippian Elvis Presley stole "Hound Dog" from Big Mama Thornton, a black artist — but this simple account leaves out myriad stops on the route, not least the song's actual composition by Jerry Lieber and Mike Stoller. But whatever you do, do not say *it's more complicated*. Acknowledging that nothing benefits from simplification is, I hear, bad faith. Complicity, even.

239

This isn't "quit lit," the surging genre of writing by people who have fled the contracting professions for which they were trained. I once admired, in a public way, the recovering scholar Andrew Kay's essay "Pilgrim at Tinder Creek." The essay contains a sideways confession of attraction for his feminist advisor and her waist-length pre-Raphaelite mane; it was the kind of comfortable desire that lingers near a four, because you might break the dial by advancing it to a ten. (I recommend such longing to any writers who are reading this: the libidinal energy improves your prose.) Two long-tenured academics chastised me for endorsing this minor hate crime. Kay's essay demonstrated that the erotic life and the intellectual life might find some synthesis. How sexist! they howled. How aspirational! I thought. This dizziness is part of living in academia: you might struggle to manage your response as your scholarly body or faculty senate votes on a measure to curtail and condemn relationships with professional "power differentials." The measure might even be proposed by a professor celebrating his silver anniversary with his former graduate student; and she might second the motion, if she is sitting in the room. (*Never* notice these conditions.)

Here, sex has a special status of offense, though it's hard to imagine a more noxious power differential than two tenured scholars telling a contingent scholar not to declaim the difficulties of her labor conditions for fear of aggressing women — a category to which she belongs. An honest account of my career on the margins of academia will offend, in part because I never begin by enumerating my privileges, like the now-obligatory land acknowledgments. Contrary to the prevailing norms of speech in progressive spaces, I consider that absence a necessary disavowal. Exploitative structures encourage us to deny the deprivations of our

experience; it is their legerdemain. Recollect the workplace mentoring offered by Langston, the character played by Danny Glover in Boots Riley's film *Sorry to Bother You*. He tells a newly hired telemarketer how to succeed: "Read the script with a white voice... Sound like you don't have a care. You got your bills paid, and you about ready to jump in your Ferrari. You never been fired. Only laid off. It's not really a white voice. It's what they wish they sound like. It's what they think they're supposed to sound like." LaKeith Stanfield produces that privileged voice with an almost surreal brilliance. But from him or from me, that voice is sleight-of-hand, a smokescreen. I refuse that voice. And when I speak in *this* voice, it's certainly not a right-wing argument to defund the beast of higher education. Nor is it a polemic in favor of independent thought; I often think Americans exonerate political incoherence by asserting independence. The nation boasts a continent-wide weed-loving, gun-wielding libertarian block party against a backdrop of absurd upward redistribution — measured not only in dollars, but in moral resources of "diverse" markets and platforms. That is not admirable independence; it is a refusal to diagnose the source of our troubles. As for me, I'm dependent — on state budgets, enrollments, and tuition dollars. Someone who loves me recently pointed out that I kept on saying "we" when I mean the university where I am employed. "Just say *I*," he pleaded. (I am trying). And so I must resist the tendency to thank, with emotional identification and privilege disclaimers, the institutions that purport to shelter me from the deprivations of market labor. Academic life would certainly pain me less were it not full of people endorsing the institution as the last bulwark against the depravity of neoliberal America. That is, as Adolph Reed so often cautions, old-fashioned capitalism, a system that

Concept Creep: A Progressive's Lament

benefits from our tendency to call it something else: human nature, vectoralism, neoliberalism, patriarchy, racism.

In the difficult summer of 2020, academics weren't simply fighting about the statues on campus and the names on dorms; they were also fibrillating with anxiety about whether campuses would be open come September. My own employer gave its faculty a handful of instructional choices — depending on our risk tolerance — with a decision deadline in mid-July. Three years later, in an informal poll I conducted this semester, my students admit that they know why they were invited back to campus before professors had decided on the "modality" in which we were teaching: money. State budgets determine my salary, but university coffers are filled by the rent that students pay for dorms and parking lots full of tailgaters. I was reluctant to condemn younger students to only two years of high school, considering how poorly served they are by the full four. I thought it loathsome to tout a "return to campus life" with only dorms and football, unleavened by classrooms and libraries. This may be someone's dream for higher education, but it isn't mine.

A professional acquaintance told me that I sounded like a COVID denier for wanting to open the window more than a crack. It was a galling accusation, considering how many people I know had died of COVID — thanks to the size and fatality of the outbreak in New Orleans (my hometown) and the peculiar vulnerabilities of students in prisons and jails, where I sometimes teach. Indeed, I spent July 2020 collecting interviews — on Zoom and by letter — with incarcerated learners and their displaced teachers. Many prison teachers embraced risk; one philosophy professor, a Sister of St. Joseph and sometime volunteer in a prison hospice, professed a willingness to die to do the work. She assured me that she

had lived long enough. Of course, I don't expect anyone to die so that they can teach Appreciation of Literature to college sophomores. Nonetheless, I thought it strange that so many fellow faculty members spoke in ethical and moral terms about working in the humanities right up *until* it required significant sacrifice. Lives lived with so little risk enable fantasies of zero risk. So I told my angry interlocutor that I was no COVID denier, and that I knew more people who'd died than she had, and that I expected an apology. "This is no time for people who fundamentally agree to scrap with each other," she responded. "So I officially apologize." But we *didn't* agree. Surely that fact required attention if the dispute was to come to a satisfactory conclusion.

A bit more memoir, if you'll permit me. Ten years ago I ended the second chapter of academic life; after graduate school, you move through postdoctoral and new faculty fellowships in which your job is to find a permanent job. I had gone to my dissertation defense with a book contract, but I had finished my Ph.D. in 2009 in the ravine of the economic crash. That December, I had second-round interview requests at one of the Ivies, the nearest community college, and a dozen other institutions, with varying missions and histories. By spring, all the tenure lines were disappearing, even at the most elite institutions, but I nonetheless moved to the best fellowship in the humanities. Afterwards I struggled for five years — through drug and alcohol addiction, through atomized labor in workplaces where no one needed to know me, and through the painful and persistent sense of "mourning in advance." The fellowship had put me back in New Orleans, whereas the hypothetical future job would unroot me. So each Mardi Gras felt like the last Mardi Gras; each bike ride through the city's echoing streets (the sound of Tipitina's dying behind me, the

bells of St. Louis ahead) felt like goodbye. These conditions accelerate the fires of addiction. When family and friends began dying, I could not discern the difference between the first and second dropping shoe. Six months out from the suicide of someone close to me, I had a campus visit in which the hiring chair nodded placidly when we were alone together over breakfast. "You don't seem litigious," she said. "So I'll tell you frankly why you're not getting this job." Then she sent me upstairs in the bed and breakfast to write a ten-point refutation to her colleagues' arguments about my limitations. By this time, I had wasted two days in the room they paid for thinking I might succeed, and a week before writing a lecture to dazzle them. (It's haunting: I remember every word and every sound. I remember even the wallpaper in the Fayetteville, Arkansas breakfast room where she said it.) That was the last tenure-eligible prospect of the year. When I got the final rejection email, it arrived at the inconvenient moment when my partner was working to drive a possum out of the back of our antebellum shotgun house in New Orleans. The poor marsupial protested the shove of the broom near her nest; I mistook her voice for my scream.

244

A week later, a feminist lion at my fellowship institution invited me to an emergency mentoring lunch at the 1834 Club: its name an aesthetic offense, its cuisine a culinary crime in America's most decadent food city. She wasn't my boss — my "chair," for the uninitiated. She was the head of another department, one that might hire me should she decide to fight for it. She told me frankly that I wasn't applying for enough jobs, that I thought places like Franklin and Marshall weren't good enough for me. (After ten years of giving junior colleges and Ivies the same measure of attention). The real problem was that I thought my fellowship institution owed me a job.

Under any economic system, I told her, if you do the work, your workplace owes you the money. But she insisted that I had a lot to be grateful for. There are plenty of Ph.D.s out there who could take my place; we endlessly conceal the crisis even at elite institutions by calling the revolving door of adjuncts fellows and post-docs. Finally, I told her that the market year had been shot through with pain: a beloved relative, dead at thirty-three; my partner's father, dead at sixty-seven. One day, she instructed me, you will realize that you've spent every moment of your life in crisis, so the latest crisis offers no explanation for our moods or our conditions. As for my job in the coming year? *Well, I can't run a women's institute like I'd run my feminist utopia. You don't know how tough it is to be a woman in power.* I have ever only heard that chestnut about the difficulty of sustaining women's power from a woman who was hoarding the power I sought....so, indeed, I couldn't imagine. They ensure that I can never imagine.

Yet I haven't left academia, because it doesn't seem to do one any good to leave a job when precarious and underpaid labor exists in the wider world in abundance. I like my job, which is stable if not tenure-eligible. The sacred vocations of learning and teaching remain within these walls, though not exclusively. When I work in prison, I meet people serving multiple life sentences teaching each other to read; I mention them in deference to their superior pedagogy. When my intellectual work is functional, it offers me trickier, tougher reading practices than the concept creeps have brought outside its walls. Challenges, even. I still attend my professional conferences; this year they offered me the distinct pleasure of running into an old friend on the sidewalk in San Francisco. Humanities jobs are hard to come by, so you are likely to find your graduate school cohort scattered to the winds. There is

245

misery in that, but pleasure too, in that you often have a couch to sleep on or a bed to share when you are traveling.

I had not seen my friend in a decade, then ran into him twice in a year — that curious and recursive sign from the universe — first at a classmates' wedding and then at a conference. Neither of us went to graduate school to think about small questions, so we clogged foot traffic on the sidewalk of Market Street talking about Death. Between June and January, a former professor of ours had died of kidney cancer. At the wedding in June, an eavesdropping stranger said we really ought not to slip away for a cigarette and death-talk on this night of a celebration of marriage. What she failed to realize is that one could do worse than to talk death over a plate of food at a wedding in New Jersey; one could scarcely do better than to actually die over a plate of food at a wedding in New Jersey. In June, we decided there were some cancers for which you need not get chemo; just read your books, hold your lovers, and say goodbye. In January, we returned to the comfortable subject: the death put him in mind of lines from Philip Larkin's "The Old Fools": "why aren't they screaming?" It reminded me of Larkin's "The Mower": "we should be careful / of each other, we should be kind / while there is still time." The advice means infinitely more when caution and compassion come to you with effort — not a first, second, or even third nature, as it wasn't for Larkin. (Or for me. It is aspirational). My friend and I are just a fraction over forty, so two dead poets teach us how to lose. Our lives in the crisis academy sowed the ground for those lessons.

If you hate these words, I hope you hate what we said, rather than what you suspect we would really like to have said; I do not speak for my friend and call that generosity. I suppose what I offer to him, what he offered me, what we both offer

our students, and what I now offer you, is some version of the old saw that the personal is political. The Complicity Era tarries with cliché, but it perfectly inverts that one, and not to our benefit. The political, in this era, is personal: a site of petty squabbles and score-settling, of inertia and nastiness and contraction. But the practice of thinking readies you for expansion — for more thinking — and so there is still time. Only that.

Concept Creep: A Progressive's Lament

In the Counterlife of Autism

"Tomorrow's Child," a story by Ray Bradbury, opens with Peter and Polly Horn traveling to a hospital for the birth of their first child. In their technological utopia, a helicopter conveys them across a sky spangled with rocket ships. An advanced birthing machine awaits, promising to eliminate Polly's labor. At the moment of truth, however, the hospital's machine malfunctions. She has delivered a healthy male infant. He weighs seven pounds, eight ounces, and sports a normal nervous system. There's just one problem: the boy has been delivered into the fourth dimension. From outside the three-dimensional structure of human perception, he appears in the shape of a tiny blue

pyramid, with three darting eyes and six wriggling limbs. The obstetrician says that the boy himself apprehends the phenomenal world around him cubically.

The Horns name their discarnate issue Py and take him home. But the existential limbo fills them with anguish and repulses their friends and neighbors. Desperate from isolation, Peter and Polly return to the hospital intending to abandon Py to medical science. The obstetrician surprises them once more. He hasn't figured out how to retrieve Py, but reverse-engineering the birthing machine could place them in the fourth dimension with him. They could perceive him as he really is. The price, of course, would be their own geometrical transfiguration. Peter would take the shape of a hexagon. Polly would look oblong. With heavy hearts they assent to the bargain, trading expulsion from membership in the human community for the joy of sharing in their child's perception of reality.

For parents and children wrestling with neurodevelopmental conditions today, Bradbury's allegory has lost none of its poignancy. Autism, my son Misha's primary diagnosis, constitutes "a whole mode of being" and "touches on the deepest questions of ontology," as the neurologist Oliver Sacks wrote in 1995. If this is so, then the question is how people like Misha perceive the fundamental entities and properties of reality. "The ultimate understanding of autism may demand both technical advances and conceptual ones beyond anything we can now dream of," Sacks wrote. He urged neurologists to limit the boundaries of "radical ontology" by shucking off their habits of detachment and accompanying their subjects in society. "If we hope to understand the autistic individual," he contended, "nothing less than a total biography will do."

Thirty years later, one in every thirty-six children receive the diagnosis. Neurologists still confine their percep-

tion to the bell jars of the consulting room, while autism advocates promote "neurodiversity." No advances, conceptual or technical, have struck up a symmetry between medical understanding and social belonging. "Tomorrow's Child" today subsists in a permanent realm of uncertainty.

Misha is now eleven and lives with his sister and me in the very progressive city of Cambridge, Massachusetts. In photographs, his aspect betrays no abominations. He passes for any normal child his age (although, in my estimation, he's handsomer than most). Tall and lithe, his hazel eyes are hooded by long lashes and framed by an oval visage. What his eyes perceive is anybody's guess. His acuity rates 20/20. The signals that his brain gives to his ocular muscles, however, could be showing him a kaleidoscope everywhere he looks. He doesn't say, as he has never uttered more than a handful of verbal approximations. Nor does he seem to reliably process speech directed to him.

"What's your name?"
"Me."
"Can you say, 'Misha'?"
"Mi-ta."
"Excellent. How old are you?"
—

"Misha, are you eleven?"
"T."
"Where you do live?"
—

"Misha, who am I?"
"D."

"Very good. What is your sister's name?"

—

"Do you have a sister?"

—

"Misha, can you say the name of your sister, Niusha?"
"Yah-yah."

His body is bandy, strung together by a physiology that mismeasures stimuli from his environment. A meek style of movement during his infancy suggested that he was never in possession of his body. Crawling in the yard, he trembled before a quarter-inch decline from the sidewalk to the grass. He hung his head over the side of his stroller in the neighborhood and fixed his gaze on the spinning spokes. Arriving at playgrounds, he refused to dismount. He didn't stand up until his eighteenth month, and then he toddled on his toes. He clung to the inner edges of sidewalks and dragged his palm across the streetscape, refashioning walls, doors, and fences into an extended guardrail.

A neurologist diagnosed Misha with autism at the age of four. Additional diagnoses piled up over the next years: mixed expressive-receptive speech disorder; sensory processing disorder; cerebral vision impairment. Of causes and treatments, his specialists have never developed so much as a working hypothesis. Molecular sequencing has revealed two genetic mutations, neither previously reported. "Your son," his geneticist avowed, "is on the far edge of science."

Misha is both profoundly disabled and benignly different. He doesn't appear sick. He doesn't appear well, either. The antinomies of his social being discharge their tension in a stigma that emerges during unrehearsed appearances in our community. He blisters the air with shrieks and squeals,

huffing and hissing, pealing with laughter out of nowhere. A sublinguistic rhapsody, unclassifiable as well as unignorable, sets the soundtrack: "We-we-we-we-we-we-we"; "me-me-me-me-me-me-me"; "uh uh uh uh uh uh uh." The signals that draw his stigma are both embodied and undecodable.

I am resolved not to hide away Misha's fugitive aspects. Only through contact with his given environment can he make a safe home for himself. Isolation within his sensorium would cause the anxiety that he bears on a good day to expand into a total loss of trust in his own being. "Loneliness," as Hannah Arendt once observed, constitutes "the experience of not belonging to the world at all, which is among the most radical and desperate experiences of man."

In a city of heavy objects constantly in motion, Misha exhibits no capacity for self-preservation. We were crossing Beacon Street in Inman Square one weekday afternoon. He flew to the passenger door of a car as it slowed before the yellow of the traffic light. He tugged on his door handle. The forward motion of the car jerked his arm. Another day, on a different corner, a man puffed a pipe. A breeze tossed the smoke. Misha chased the billows into the street. A car skidded to a stop a dozen feet in front of him.

At age seven, he made a half-hearted attempt to leave home unannounced, unlocking and unchaining the front door. I purchased an identification bracelet, a tracking device, and a harness. He sloughed off the device and chewed through the bracelet. I couldn't bear to tether him to the harness. A police officer came to take his photograph and copy out his vital statistics, lest I should lose him.

When I want him to stay close, he wanders away. When I want him to depart, he stays put. He stopped once in the middle of a crosswalk in Harvard Square. My nudge in the small

of his back restarted his body. He screamed and yanked down his pants. Inside a grocery store on another occasion, he took our cart on a wide ride that ended with him knocking over a stack of soup cans and losing his grip on a carton of produce. A shopper tripped over the cans. She shot me a dirty look as she picked blueberries off the bottoms of her shoes.

On our strolls, he runs his fingers through hedgerows and drops shrubs in his wake. He flips open gas tank doors on rows of parked cars. He runs into the foyers of apartment buildings, presses all the buttons on the elevators, and scampers away with a chortle. In the bathrooms of neighborhood restaurants, he conducts boffo symphonies. He turns off the lights and triggers the automatic hand dryers while men fart and tinkle in their pits. In the local mall, he feels up mannequins and hooks his thumb to jewelry stands, toppling bracelets, rings, and necklaces. In the checkout line of department stores, he thrusts himself upon shoppers queued behind us and tries to untie their shoelaces. He fixates on such interaction rituals for months at a time. If you sneezed near him in the autumn of his eighth year, he instantly grabbed your hair.

Some encounters have been less than amusing. At the library once, he tugged on a thin and grayed ponytail that turned out to be attached to an elderly woman bound to a wheelchair. Her neck bent backward like a PEZ dispenser. I knew he didn't intend to hurt her. That doesn't mean she wasn't hurt. I apologized for his particular offense. But I never apologize for the kind of person Misha is.

What kind of person is he? A more recognizable phenotype — Down Syndrome, for example — would provide an easement

for strangers in the path of his sensibility. A disability such as blindness would afford strangers a tacit medical context for tolerable inferences. The five senses reflect anatomically in our noses, ears, eyes, skins, and tongues, but it turns out that we have two more senses hidden from view. The vestibular sense, attaching to inner ear fibers, registers our internal balance during movement. The proprioceptive sense, registering external stimuli, provides us with assurance of our body's position in space. These secret senses flow unconsciously through receptors in our muscles, tendons, and joints, making adjustments to the rhyme and reason of the body's ego. "If there is defective or distorted sensation in our overlooked secret senses," Sacks pointed out, "what we then experience is profoundly strange, an almost incommunicable equivalent to being blind or being deaf."

What part of Misha's lack of poise is compensation for his scrambled secret senses? What part is clowning? As he doesn't speak, so he doesn't convey his perception of the reality of his body. Voluble rather than verbal, he vibrates sounds from the back of his teeth and throat without modulating his volume — probably because he cannot feel his phonatory organs without increasing vocal pressure. Maybe I have to remind him to swing his leg before striking a soccer ball because when his leg retracts, he cannot be sure that it remains attached to his trunk. Slips of time seem to lodge in his perceptual memory. We dropped by our neighborhood coffee shop. When we walked in the previous week, he sidled up to a jug of water on the countertop, drew a cup, and wet his whistle. On this occasion, the jug had been replaced on the countertop by a napkin dispenser. Yet Misha took an empty cup in hand and repeatedly pressed it against the dispenser, expecting water. He gazed upward at me quizzically.

In a surreal world, he moves as if inhabiting a waking dream. One November we visited a friend's home in seaside Hull for a birthday party. We ducked out a side door and stepped onto the cold sands. The ocean's waves roared in a stiff crosswind. This was no day for beachcombing. Back inside, slinking away from partygoers, Misha led me up a spiral staircase. The passageway was enclosed and carpeted. Even so, it disoriented him. Reaching the landing on all fours, he peeked at the ocean through the windows. He froze with fear, as if the house were a sandcastle bound to be sucked into a violent Massachusetts Bay at any moment.

At house parties and barbeques, Misha ensconces himself inside bathrooms for eternities. He rifles through bedroom closets, tampers with toys, strikes discordant piano chords, and swipes and swills beverages. I incant a mantra to guide me through. *Patience on top of patience.* But we are not ideal guests. During lunch at a prospective friend's home, Misha bellied-up to her kitchen table and stuffed his mouth with cheese, grapes, and crackers. Twice he fell off his stool and tumbled to the floor. Setting down his glass cup, he misjudged the edge of the countertop. The cup smashed to pieces on the floor. We were never invited to return.

Public spaces are freer of turbulence. I escort Misha to the Frog Pond at Boston Common in the summer and to Fenway Park in the spring. He loves a neighborhood block party as much as the next boy. Holidays I am determined to celebrate, even as he remakes their rituals. One Halloween, costumed as Mr. Incredible, he blew out the candles in every doorstep pumpkin he could reach. Invited to share a traditional Thanksgiving dinner in Somerville, we sat down with friends for turkey, stuffing, mashed potatoes, and gravy. Misha got up on his haunches and leaned toward the candles. Huffing a wet

breath, he extinguished them with gusto. Wax spattered across the turkey. Then he unplugged the chandelier and stopped me from relighting it. My feeble attempt at humor failed to bestir the table to solidarity. *What's a little wax in our bird?* Thanksgiving had been dipped in the shadows of the counterlife.

On vacation at the Jersey Shore, the roar of the crashing waves, the commotion of the boardwalk buskers, and the cawing of the seagulls replaced the city's frenzy of buses, leaf blowers, and fire trucks. Misha adored the carnival atmosphere of the beach. As the ocean waves petered out toward his ankles, he jumped half too low and a beat too soon. Strolling past the encampments of the sunbathers, he trampled their sandcastles. The haunted houses on the boardwalk wasted their spooks on him. A ride that lifted him to a modest height caused his palms to sweat. But he mounted the Merry-Go-Round's carousel of plaster steeds with the aplomb of a little Lord Byron. After, he romped through pinball, air hockey, and skee-ball, none the worse for defaulting at each station, and got his kicks by reaching behind the arcade games that others played and unplugging their machines.

"He's the king," his sister Niusha once quipped about the retinue of attention that Misha receives at home. With hilariously exaggerated deference, she bowed before "His Majesty" on the domestic pedestal. Our parlays in public bewildered her. "He's invisible," she said, "it's like he's not here." He is, and he is not. When Niusha was nine, and her brother was six, she sat with me for an interview about autism on a program broadcast by Cambridge Community Television. "Maybe when you go into a restaurant, people look at you funny or try to avoid

looking at you," the interviewer rightly observed. Niusha, chiming in, recalled an incident that had recently taken place in a luncheonette in Porter Square. Seconds after I had left our booth to fetch our drinks, Misha had climbed atop the table and swatted the pendant lights hanging from the ceiling. No harm, no foul. From a booth adjacent, however, a shriek of fear had rung out as if the end times were nigh. A manager quickened to the scene and waved a finger of reproach in Misha's direction.

"What do you want us to know about people like your brother?" the interviewer asked Niusha. "I want people to know not to be embarrassed by them," she replied, "not to keep them into hiding. I want them to be out in the open, actually, and trying to make the world a better difference, because people might not know that they have a lot more intelligence than people think, and they should be more appreciated because of that. They should be more noticed. And I bet they would like that, of course." I bet they would. The question is how people would perceive them.

Autism is experienced cognitively and felt existentially, but it is diagnosed and treated behaviorally—from the outside in, as it were. In the luncheonette no less than in the neurologist's consulting room, how you behave is who you are supposed to be. But the prevailing concept of the self as an information processor, its integrity revealed in problem-solving or pattern-seeking, shuts out feeling and judgment. Science dismembers persons into discrete domains and reduces their parts to functional values. Society rigs up a phenomenology restricted to observable surfaces.

No such system of reasoning can understand the web of memories, conjectures, and perceptions that human agents bring to their appreciation of particular situations. "What

257

we call creativity is a characteristic that yields not merely something new or unlikely but something new that strikes us as meaningful and interesting," Bernard Williams observes in *Making Sense of Humanity*, "and what makes it meaningful and interesting to us can lie in an indeterminately wide range of associations and connections built up in our existence, most of them unconscious. The associations are associations *for us*: the creative idea must strike a bell that we can hear." Only the inner spaciousness furnished by art, literature, and history, Williams suggests, can overhear the chiming of certain bells.

Misha, so understood, is that rarest of creatures: a genuine individual. Improbable, inexplicable, and unimpeachable, he alights on the world like Peter Pan, betwixt and between, terrified and beguiled. When his eyebrows shoot up, I glimpse his curiosity radiating through his miasma of sensations. His blissed-out states sparkle with novelty. Once, amid a rainstorm outside the entrance to a grocery store, he stood spellbound before the opening and closing of the pneumatic electric doors. Their metronomic cadence was to him a pair of hands clapping for his private joke. He giggled uncontrollably. The shoppers had little patience for his attempts to choreograph their comings and goings. Amused and sodden, I obeyed Nabokov's injunction: "I appeal to parents, never, never say 'Hurry up,' to a child."

Sometimes, parents approach me with overtures of sympathy. They believe that they may have a cousin or a nephew of Misha's dispensation. "But how did you know?" I returned one such parent's inquiry. She had plopped down next to me on a playground bench to chat about the wrongness tainting my son. "Oh, I could tell right away," she answered brightly. "I can't imagine," she continued through a benevolent sigh. "I don't know how you do it." Her remark

felt impertinent, as if his stigma had reassured her. *There but for the grace of the genetic lottery...* A rejoinder arched across my mind: Well, I don't know how *you* do it, managing the banality of raising your carbon-copied child.

Cambridge, of course, is fully subscribed to the attitude of "neurodiversity." Every April, the progressive potentates gather on the steps of city hall and celebrate "autism awareness." Ceremonies of awareness have yielded a quotient of indulgence. No mishap or misdemeanor has damaged relations that I haven't been able to repair with a nod, an apology, or a scowl. Strangers may startle or fluster. They swallow their grievance upon letting their eyes stray over his countenance. In this age of umbrage, I am grateful to avoid open conflict. But familiarity doesn't reduce contempt. Our community steers clear precisely because it is aware of people like him.

This paradox accompanied the birth of neurodiversity discourse. A young Australian sociologist, Judy Singer, coined the term in 1998 to denote a new category of personal identity alongside "the familiar political categories of class/gender/race." Singer invested her coinage with sweeping ideological ambition. "The rise of Neurodiversity takes postmodern fragmentation one step further," she wrote. "Just as the postmodern era sees every once-too-solid belief melt into air, our most taken-for-granted assumptions—that we all, more or less, see, feel, touch, hear, smell, and sort information in more or less the same way—are being dissolved." A freelance writer named Harvey Blume gave "neurodiversity" currency among journalists with an article in *The Atlantic* that same year. A couple of best-selling books, Andrew Solomon's

Far from the Tree: Parents, Children, and the Search for Identity, in 2012, and Steve Silberman's *NeuroTribes: The Legacy of Autism and the Future of Neurodiversity*, in 2015, clinched the case. A cliché was born.

Neurodiversity discourse is now ubiquitous. It takes protean forms — a meme, a critique, an ideal type, a virtue signal, a paradigm for restructuring autism research. The discourse in all its permutations identifies symptoms that science and society have deemed pathological and redescribes them as coping tactics or benign differences unworthy of invidious distinction. In this respect, neurodiversity discourse might be understood as an effort to do away with stigma, a concept traditionally rooted in shame over the body's finitude. Yet the leveling impulse that motivates neurodiversity's loudest champions does not abolish stigma so much as remove it to the plane of language and throw it in the face of social institutions. Major institutions in the economy, government, and entertainment, on guard against accusations of insensitivity, have responded by editing marketing language and instrumentalizing neurodiverse forms of creativity in hiring practices. The Central Intelligence Agency, to cite one of the nation's newly enlightened employers, is hip to the competitive advantages offered by neurodiverse job candidates.

In the institution of the family, the gravamen of the indictment hits home. The claim that neurodiversity denotes a personal identity, one that is rooted in ontological sovereignty, invites its unelected representatives to intervene with parents on behalf of their children. When, as in my case, a neurodiverse child is born to a parent labeled "neuro-typical," the dialectic of love and authority is automatically held to be adulterated. I, too, am cast betwixt and between prescribed social parameters. "Inside us there is something that has no name," José Saramago

260

wrote in *Blindness*, "that something is what we are." That something is what this society cannot let be.

So far, neurodiversity (and its slightly more opinionated cousin, neurodivergence) has followed the path of vanguard movements organized around abstract and categorical postulates of identity. As an expression of cultural radicalism, neurodiversity perpetuates the assault on the conventional family. As an ideology, it reaffirms the assumption that freedom lies in incommensurable acts of appropriation and consumption. As social criticism, it hardens the community's distinction between them and us. And as a politics, it leaves the distributions of power undisturbed.

Every other autumn, candidates seeking election to Cambridge's school committee or city council knock on my front door and make their pitches. I explain why I am a single-issue municipal voter. I ask for their disability policy initiatives. My question invariably takes them by surprise. I haven't met one who has given such policy any forethought. But as they stammer over substance, they always carefully rephrase my description of my own son as "neurodiverse" or "differently abled." I wouldn't care, if the politicians of identity would actually do something.

The biggest social crisis of recent years let the hot air out of such lip-service. Covid-19 came. The mayor of Cambridge issued emergency communiques every day. She sought to reassure the "most vulnerable" members of the community by naming them in successive numbers — veterans, elderly, "unhoused people," "undocumented people," "people who are transgender and gender non-conforming," and "people

of color." Two months into the city's pandemic response, the mayor still ignored people like Misha. I wrote to insist on my son's existence. She pledged to "do better."

The lockdown did all the work we needed. For years I had worried about testing our community's elasticity. Now our community itself quarantined. I had always winced as our neighbors kept a wary distance from us. Now they stayed six feet away from one another. I had fought off dread of the future. Now everyone felt encumbered by an emergency without end. As social friction thinned, we slipped out of the liminal state all together.

One memorable day — July 13, 2020, to be exact — we dipped into the city's public swimming pool. A facility with a capacity for a hundred entertained a dozen swimmers this day. Misha tap-danced toward the deep end. He was bolder than I had ever seen him in the water. He drew a breath, semi-sealed his lips, and dunked himself for the first time. A fit of spontaneity propelled him from one side of the pool to the other. He was teaching himself how to swim, repossessing his corporeal identity in the water's pressure. As he clawed toward me, grinning ear to ear, I thought of Wordsworth savoring

> that serene and blessed mood
> In which the burden of the mystery,
> In which the heavy and the weary weight
> Of all this unintelligible world,
> Is lightened.

That October, however, an indiscretion put us back in our place. On a Saturday afternoon at Riverside Park in Cambridge, families of diverse ages, genders, and colors were tossing frisbees, listening to music, riding bicycles, and

sunbathing. Misha frolicked on a spray deck, flapping and squealing, as happy as his happy can be. I sat with Niusha on a bench nearby. We were admiring the pontoon boats and kayaks afloat on the Charles River when suddenly a woman staggered into our picture and began rubbernecking at Misha. By her ruddy appearance and her haphazard gait, she looked to be one of the "unhoused people." Suddenly she let loose a bark about "your retaaarded son."

"We're not leaving," I whispered to Niusha. "She's drunk. She's not driving us away." Seconds later, the woman captured the attention of the park when she repeated the epithet at the top of her lungs. We turned the other cheek and headed home.

That evening, Niusha sobbed with shame. I couldn't find words to console her. Sitting on the edge of her bed, I stroked her hair and wiped away her tears in silence. My imagination drifted to the predicament of Peter and Polly Horn. I remember thinking that I would make the same choice in a heartbeat.

HELEN VENDLER

Can Poetry Be Abstract?

No Coward Soul Is Mine

No coward soul is mine
No trembler in the world's storm-troubled sphere
I see Heaven's glories shine
And Faith shines equal arming me from Fear

O God within my breast
Almighty ever-present Deity
Life, that in me hast rest
As I Undying Life, have power in thee

Vain are the thousand creeds
That move men's hearts, unutterably vain,
Worthless as withered weeds
Or idlest froth amid the boundless main

To waken doubt in one
Holding so fast by thy infinity
So surely anchored on
The steadfast rock of Immortality

With wide-embracing love
Thy spirit animates eternal years
Pervades and broods above,
Changes, sustains, dissolves, creates and rears

Though Earth and moon were gone
And suns and universes ceased to be
And thou wert left alone
Every Existence would exist in thee

There is not room for Death
Nor atom that his might could render void
Since thou art Being and Breath
And what thou art may never be destroyed

Emily Jane Brontë, who died in 1848 at the age of thirty, left this poem in a largely unpunctuated manuscript. It was not included, by her own decision, in the first printing of some of her poems in 1846, but it was added posthumously, under the non-authorial title "Last Lines," to the second edition of 1850, conventionally punctuated and revised by her sister Charlotte. Brontë's modern editor, Janet Gezari, reproduced Charlotte's version in 1992 in an appendix to her *Emily Brontë: The Complete Poems,* but has in the body of her edition removed Charlotte's additions, printing only the manuscript. I reproduce the manuscript version.

Emily Dickinson, a few months before she died in 1856, wishing to forbid a church funeral, left instructions for a home funeral in which she stipulated that a single poem by Emily Brontë, "Last Lines," should be read aloud by her friend Thomas Wentworth Higginson, the editor of *The Atlantic*

Monthly. Dickinson, reading the lines in 1850, considered them as Brontë's deathbed manifesto, and adopted them as her own final declaration of creedless faith. A certain Mrs. Jamison, who attended the funeral, recorded the fact that Higginson, prefacing his reading of "Last Lines" and of the scriptural passage that Dickinson had also stipulated to be read aloud (1 Corinthians 15:53, on immortality: "For this corruptible must put on incorruption, and this mortal must put on immortality"), remarked that Emily Dickinson had now put on immortality, but she had really never seemed to have put it off. I became interested in Brontë's poem when I first read about Dickinson's funeral: I wanted to understand why, out of the hundreds of poems known to Dickinson, she had chosen this one as a vicarious final utterance of her own.

"No coward soul is mine" has been "much commented on," according to Janet Gezari, but although critics have repeatedly tried to distill it into one creed or another ascribable to Brontë — whose very aim was to escape such fixed categories — no consensus has been attained. "No coward soul is mine" is in part vividly definite, but it is also sufficiently abstract to defy common conventions of Christian lyric such as the inclusion of elements of Jesus' life and sayings, allusions to church feasts and rituals, and credal affirmation of an afterlife. The most vigorous lines of Brontë's poem are those insisting on the entirely interior nature of human faith: "Vain are the creeds of men, unutterably vain." Brontë's "vain" is alluding not to vainglory but to the opening verse of Ecclesiastes: "Vanity of vanities, saith the Preacher, vanity of vanities; all is vanity." The Hebrew word translated into English as "vanity" is *hevel*, and *hevel* (the commentaries tell us) is one of the several Hebrew words for "air," or "wind," but is most often used negatively to mean "fleeting," "transitory," "futile." Brontë is speaking as

a deeply literate nineteenth-century reader, well aware (from the pre-Darwinian geological proof of evolution) of the successive and transitory creeds of all religions historically recorded.

For Brontë, Christianity — the only "creed" that she knows well — must stand in for all other creeds and their myths of a divinity both creative and inspiring; and Brontë must invent her own version of the sublime phenomenon of unbidden human inspiration. She does it most conspicuously in this poem. It must be remembered that Brontë was the daughter of a learned priest of the English church, an Oxford graduate in classics, himself a poet, whose children were raised as Christian believers, and who all (except Emily) taught in his Sunday school. Brontë's poetic duty in denying the truth of "creeds" is to strip the Christian God of every sustainable predicate. Theologians had asserted at least since Aquinas, following Maimonides, that no positive qualities could be predicated of God, owing to the limitations of language: He (always male) could be characterized only negatively, as one who was *not* subject to death, *not* affected by time, *not* vulnerable to suffering. This affirmation became known as apophatic theology: God was im-mortal, e-ternal, im-passible.

Brontë's own "Deity" is an internal one, replacing the external and mythological God of the creeds and taking on an ever-present existence within herself, to be interpreted only by herself. The relation between self and deity, as Brontë formulates it, is a perfect and cunningly phrased closed circuit of reciprocity. Addressing her Deity as a lower-case "thou" to her "I," Brontë poises their relation as one of mutually acknowledged parallel acts of repose and empowerment as she addresses her deity: "Life that in me hast rest, /as I, Undying Life have power in thee." Her Deity, a capitalized "Undying Life," accepts a physical repose within herself as she exists in

its Life, receiving power as she participates in its immortal "Undying" metaphysical existence.

This deity is neither anthropomorphized nor given gender; it displays no external acts such as Adamic creation and is embodied in no human figure such as Jesus. It is a presence, not a person, and its sole activity is its never-lapsing "wide-embracing love." This unconfined love, Brontë writes, *shines* as powerfully as "Heaven's glories" *shine*. The use of the identical verb "shine" for both nouns establishes the identity of past Christian myth — the capitalized "Heaven's glories" — and Brontë's internal inspiration, the wide-embracing love. This love is neither *eros* nor *agape*, but rather an intuited third possibility: a love that within the visionary seer temporarily annihilates historical time and replaces it with Eternity. The poet's own conviction is fiercely declared: she surveys all doctrinal codifications only to scorn them. Vain are "the creeds of men." Since Christianity, the only religion known to her, is credal (from the Latin *Credo*, "I believe"), Brontë, with one wipe of the sponge, erases all such doctrines, and dares to propose that the intermittently self-revealing "God within [her] breast" differs from any religious figure, such as Jesus, who enacts a fixed identity within a fictional narrative.

Brontë's God here is not a trinity. It at first occupies one half of a duality of absence and presence: her ordinary self has access to her Deity only when she is unexpectedly and involuntarily admitted to a presence suffusing her with indwelling inspiration. Only then is she able to address her "thou." Instead of projecting her inspiration outwardly on an allegorical figure such as the Muse, Brontë strikingly makes inspiration indistinguishable from her own physical Being and bodily Breath. She realizes that, in the disbelief of the mid-nineteenth century, a new "rational" and sober manner of addressing the

divine must reject Christian elements elaborated in sacraments and rituals. A mention of Jesus? The birth at Bethlehem? The Passion? Holy Communion? No.

We can better understand the poetic paradox of a "spiritual" rhetoric uninhabited by religious images and narratives by remembering one of Emily Dickinson's more acerbic remarks about God. Writing to Higginson about her family as she listens to their daily morning family prayers full of unverifiable language, she explains: "They are religious – except me – and address an Eclipse, every morning – whom they call their 'Father.'" How could a poet address an eclipse?

As usual, Dickinson sees the conceptual problem as one of language: given the erasure by the eclipse of all information concerning light articulated in Hebrew or Christian diction, from "Let there be light" (Genesis 1:3) to Jesus' saying "I am the light of the world" (John 8:12), what words would the poet be able to use? Deprived of light, life is merely an eventual Eclipse of ourselves. In 1863, in her poem "We dream – it is good we are dreaming," Life is a malevolent executioner hunting its prey: "[Life] is playing – kill us, / and we are playing – shriek – ." Dickinson is macabre, whereas Brontë is ecstatic, but the problem of the articulation of the human sublime – what will be its diction and its tonality? – is common to both poets. In 1864, a year after "playing shriek," Dickinson exposes nakedly her own version of the death of God:

269

> Truth - is as old as God –
> His Twin identity
> And will endure as long as He
> A co-Eternity –

And perish on the Day
Himself is borne away
From Mansion of the Universe
A lifeless Deity.

Like Brontë, by whose strategies she was doubtless
inspired, Dickinson thought long and hard about retaining
enough sacred reference to make clear that she was engaged
in stripping the Christian God of all supernatural credibility.
Dickinson capitalizes, here, the "sacred" word "Mansion," to
reveal her allusion to the Christian belief in an afterlife. She is
quoting Jesus' promise as he bids farewell to his apostles: "In
my father's house are many mansions; if it were not so, I would
have told you" (John 14:2). Yet how are the poets to retain a
devotional tone while deleting from it any overt reference
to theology, ritual, and religious narrative? How is the object
of worship to be made convincingly abstract and yet able to
install reverence by its (hidden) Christian allusions and a tone
of veneration?

Emily Brontë, born in 1818, was older by only twelve years
than Dickinson, but she and her sisters Charlotte and Anne,
who had jointly published under three pseudonyms in 1846,
were known to Dickinson. In 1860, five years after the last of
the sisters, Charlotte Brontë ("Currer Bell"), died, Dickinson
elegized her as a singing Nightingale now caged in its grave,
presenting her as a poet rather than as a novelist:

All overgrown by cunning moss,
All interspersed with weed,

The little cage of "Currer Bell"
In quiet "Haworth" laid.

Emily, closer in sensibility to Dickinson, had died at thirty, too early for an elegy by Dickinson, but in representing Charlotte as a poet-nightingale rather than as a novelist, one might think of her as embodying Emily. (Charlotte and Emily are buried in Haworth in a single grave bearing a joint gravestone.)

In an appendix to Richard Sewall's biography of Dickinson, there is a useful supplement collecting poems by American women on topics akin to those of Dickinson: Love, Death, Time, Nature, Art. They disclose the sentimentality and cliché that Dickinson in maturity was so determined to avoid (or to mock as "dimity convictions"), and it is unthinkable that Dickinson could have turned to such poets in choosing a surrogate literary voice for her funeral. Her own reading in poetry was chiefly from the English poets. She mentions "Mrs. Browning" (with several references to *Aurora Leigh,* Barrett Browning's feminist novel-in-verse) and George Eliot (the novels, not the poems), but there is no recorded response to Christina Rossetti (whose mournful Christian verse is far from Dickinson's briskness). Barrett Browning turned increasingly to political verse in her later Italian years, making her a less inviting model for Dickinson. Among contemporary women poets, Dickinson found only in Emily Brontë a kindred spirit as irreligious as herself, as highly educated, as outspoken and as fearless in unambiguous statement: "No coward soul is mine," "Vain are the creeds of men." Each of these declarations by Brontë would not be out of place in a poem by Dickinson. Dickinson could have chosen something by Browning or Tennyson, but in choosing a woman poet Dickinson defined herself against Brontë's collective ideological men proclaiming

271

successively their vain "thousand creeds."

In ventriloquizing Brontë's "Last Lines," Dickinson identified to her mourners an early example of the post-Christian religious lyric, unafraid of its secular stance, bold in its purity. As Dickinson perceived with instant indebtedness, Brontë had invented a form of poem that rejected Christianity but had nowhere else to turn for tonal models of worship, gratitude, and consolation except to Christian lyric. Brontë had had to find a way of verbal divestment, a genuine means by which she could both summon and address her secular "Deity." Luckily, Brontë knew Milton's address to "holy light" as "Bright effluence of bright essence increate," which had pointedly used extreme abstraction as a way of representing the divine.

The young Keats, in the "Ode to Psyche," had taken on the problem later faced by Brontë — how to write devotionally after the death of the gods — but he had decided that the solution lay in an exact interior (mental) replication of Psyche's Greek cult-forms. He takes a solemn vow:

> Yes, I will be thy priest, and build a fane
> In some untrodden region of my mind,
> Where branchèd thoughts, new grown with pleasant pain,
> Instead of pines shall murmur in the wind.

By making an exact mental replica of the cult, Keats clears away Psyche's Greek worship and makes his modern mental shrine exactly match the ancient external one, in the hope that the goddess will come to inhabit it. Brontë will not succumb to such a mimesis of past cultic practice: instead she evacuates from Christian poetry its former content, detaching its words from their roots in fable, sacred texts, and personal symbol. In "No coward soul is mine," she uses words immemorially familiar from their

Christian contexts — *soul, Heaven, faith, God, Almighty, Deity, Undying Life, infinity, Immortality, spirit, eternal* — but they appear nakedly, as if extracted from a contextless dictionary of theological vocabulary. We do not hear of the biblical narratives from which *rock* and *anchor* have been detached; we know only that an unnamed Deity is "Holding so fast by thy infinity" and "anchored on / The steadfast rock of Immortality." Everything in Brontë is invisible.

Brontë must have known the most frightening abstract poem of Romanticism, Coleridge's "Constancy to an Ideal Object," where, after conveying the sadness and bleakness of a purposeless life which constantly yearns for an Ideal Object worthy of lasting love, he savagely denies (while preserving its beauty) the eternal delusion prompting such a yearning. An Ideal Object is not a something; it is a nothing. Addressing the impossible Ideal Object, Coleridge, closing his poem, displays to The Ideal Object, by question and answer, its own vacancy of origin, while not suppressing its beauty:

> And art thou nothing? such thou art, as when
> The woodman winding westward up the glen
> At wintry dawn, where o'er the sheep-track's maze
> The viewless snowmist weaves a glistening haze,
> Sees full before him, gliding without tread,
> An image with a glory round its head;
> The enamored rustic worships its fair hues,
> Nor knows he makes the shadow, he pursues!

Words in many of Brontë's poems remain apparently intelligible only because the mind hears in them echoes of past belief, but the echoes fade as they are replaced by a paradoxical and living web of active creative verbs, probably borrowed

(as her editor suggests) from Coleridge's famous description in *Biographia Literaria* of the "secondary" imagination, the first imagination being that of the Creator. (It was in truth Coleridge's own human imagination that he was exploring, just as his first title-choice was *Autobiographia Literaria*.) His Latinate verbs are interiorly and etymologically complex: "It dissolves, diffuses, dissipates, in order to recreate... it struggles to idealize and to unify. It is essentially *vital*." Coleridge insists that the ever-changing and vital human imagination must "dissolve" before it can "recreate."

Brontë's "wide-embracing love" similarly "dissolves" and then "creates" itself in a vital form that not only "animates," but also, in the end, "rears" itself into a positive absolute:

Thy spirit animates eternal years
Pervades and broods above,
Changes, sustains, dissolves, creates and rears.

The reader must restore individual etymological or allusive content to each of Brontë's eight verbs, as I indicate by my added bracketed phrases below: Thy spirit animates [bestows an active individual soul upon impersonal eternal] years; Thy spirit pervades [diffuses itself, like a vapor, in every direction]; Thy spirit broods above [as an incubating bird, just as in Luke 13:34 Jesus wishes he could have gathered up the children of Jerusalem "as a hen doth gather her brood under her wings." Brontë's changes of focus — and their invisible sustaining metaphors, as in my bracketed "completions" above — rapidly accumulate in the five verbs of her final line. And later, Dickinson, outdoing both Coleridge and Brontë, introduces an unstoppable cascade of verbs into her own poem on "The Love a Life can show below," where, at the ending, in a heap of

twelve verbs, lifelong love on earth "dissolves" only so that it can return in Paradise:

'Tis this - invites - appalls - endows -
Flits - glimmers - proves - dissolves -
Returns - suggests - convicts - enchants
Then - flings in Paradise -

The poet resorts to such excited abstractions to depict a world from which a changeless God has departed, making life narratable only as a succession of unpredictable and shifting perceptions. Like Brontë's rock and anchor, Dickinson's unstable actions are removed from a person, a situation and a coherent narrative line. Her poem makes uninterpretable kaleidoscopic turns — here, love glimmers, there, it convicts, and elsewhere, it provides a proof.

To invent a daring abstract language which worships an internal Deity while forsaking a causal event, a stable narrative, a restored myth, and a theological intelligibility in favor of detachment, abstraction, and personal ecstasy, is a cultural novelty in English verse which subsequent non-religious poets, reading Brontë, can understand, investigate, imitate, and adopt for their own purposes.

Since Brontë designs her own abstract language to imitate the aspirational or grieving tones and yearning of Christian lyric discourse, her twenty-first-century readers can scarcely perceive how relentlessly she eviscerates it of doctrinal or mythical or cultic content. The hope, calm, peace, and harmony of Brontë's inner ecstatic vision — and the agony

of its departure as the human senses reawaken — arrive most precisely in the hexameters of "The Prisoner," in which the struggling imprisoned visionary-in-chains is each night soothed by Hope's "mute music" in a dawning of the Invisible:

> But, first, a hush of peace — a soundless calm descends;
> The struggle of distress, and fierce impatience ends.
> Mute music soothes my breast, unuttered harmony,
> That I could never dream, till Earth was lost to me.
>
> Then dawns the Invisible; the Unseen its truth reveals;
> My outward sense is gone, my inward essence feels:
> Its wings are almost free — its home, its harbour found,
> Measuring the gulf, it stoops, and dares the final bound.

But the success of that final leap is prevented by the involuntary reawakening of the senses:

> Oh, dreadful is the check — intense the agony —
> When the ear begins to hear, and the eye begins to see;
> When the pulse begins to throb, the brain to think again,
> The soul to feel the flesh, and the flesh to feel the chain.

The poet's hexameters become tragic as the rising momentum of vision is lost, and the soul becomes fixed in the immobile and inexorable syntax of ordinary sense-life, physical and mental and spiritual dullness, and biological despair:

When		the	ear	begins	to hear
	and	the	eye	begins	to see;
When		the	pulse	begins	to throb,

and	the	brain	to think again,
	the	soul	to feel the flesh
and	the	flesh	to feel the chain.

Such a passage reproduces the abysmal sensation of involuntarily resuming a physical and mental and spiritual existence lacking all divine colloquy. The chain-lock shuts conclusively on the sequence "feel... flesh... flesh... feel."

After its former displays of ecstatic relief from pain, Brontë's former duality of flesh and spirit in "The Prisoner" grimly now encounters a baleful inner Trinity, ever in mutual conflict:

> Three gods, within this little frame,
> Are warring night and day;
> Heaven could not hold them all, and yet
> They all are held in me.

Brontë's triply conflicted self is re-defined by the apparently desirable image of a spirit standing within the flow of three rivers, one golden, one like blood, and one like sapphire (perhaps desire, will, and tears), but in the end they all helplessly "tumble in an inky sea." The speaker, immersed in that marine darkness, recalls its hellish effect: "Oh, let me die — that power and will / Their cruel strife may close." The famously tenacious Brontë will continues fiercely to will, but remains without power to act, and decides on suicide. It is the deepest feminist cry of Victorian poetry, in which an immense will to create can find no outlet in publication.

Bronte's intimations of thwarted vision continue in Hardy's "The Darkling Thrush," composed on December 31, 1900 and originally titled "At the Century's Death-Bed." In it, the poet unwillingly admits that the full-throated song of an

277

Can Poetry Be Abstract?

aged male thrush seems to hope for an emotional vitality at present inaccessible to the depressed sixty-year old poet:

An aged thrush, frail, gaunt, and small,
 In blast-beruffled plume,
Had chosen thus to fling his soul
 Upon the growing gloom.

So little cause for carolings
 Of such ecstatic sound
Was written on terrestrial things
 Afar or nigh around,
That I could think there trembled through
 His happy good-night air
Some blessed Hope, whereof he knew
 And I was unaware.

Unwilling to abandon his momentary participation in the thrush's hope, the atheist Hardy has nestled it (in Brontë's fashion) in the retained diction of Christianity (*soul, carolings, ecstatic, terrestrial, blessed, Hope*). To create true despair, Hardy needed only to write so as to contrast his despairing sentiment with the thrush's "happy air," declaring that the thrush had "Some blessed Hope whereof he knew, / But I was unaware." Yet Hardy adds no comma, and inserts an "And" instead of a "But," creating a true coordination between the thrush's firm knowing and the speaker's (now perhaps remediable) unawareness. Both Christmas and Twelfth Night bracket the century's corpse, but narrative notice of Jesus' birth and the Three Kings' mythical pilgrimage is, as in Brontë, absent.

The master of lyric abstraction, T. S. Eliot, composed in 1927, just after his conversion, a brilliant lyric narrative called

278

"Journey of the Magi." It seems likely that he was invisibly competing with his mother Charlotte's publication, in *The Christian Register* of Christmas 1887, a perfectly conventional, prosodically inept poem called "The Three Kings." All its lines have four beats except for line two which has only three:

> We are three kings who have traveled far,
>> O'er laced and sandy plane.
> Before us moved a radiant star,
>> Its light along our path is lain.
> Faint and weary, our journey's end
>> We seek, but the star moves onward still.
> We know not whither our footsteps tend,
>> Obedient to a higher will.

Eliot's poem draws on the seventeenth century Christmas sermon preached before King James by Lancelot Andrewes who uses the collective voice that Eliot adopts. "Journey of the Magi" restricts its sole scriptural reference (Matthew 1:2) to the word "Magi." The word first appears in Jerome's first-century Christian Latin Vulgate to transliterate Matthew's Greek *magus*, meaning "a man learned in arcane lore." The King James Version calls them "wise men from the east," while the Catholic Rheims-Douay translation retains the Vulgate "Magi." Eliot presumably chooses the foreign word "Magi" in lieu of the KJV's "wise men" so that the poem will appear ancient and pre-Reformation in origin. (Neither translation specifies the number of the Magi; they acquired their number, names, and personalities from the accumulations of tradition, and their gifts, scriptural only by allusion to their source in Isaiah 60:6, enter Christianity also from tradition.) The gifts are not recorded in Matthew's Greek and remain

279

unmentioned in Eliot's poem, so that the only item giving the poem any scriptural context is the single-word quotation from the Vulgate, "Magi," the barest of verbal references. Eliot is removing KJV familiarity — "wise men" — and making his title foreign and largely abstract — Journey of Whom?

Eliot's poem opens in a collective anonymous voice: "A cold coming we had of it." We later discover that the tale of the journey is being recounted to, and recorded by, an amanuensis who appears only in the last stanza of the poem, as the voices, closing down the unhappy and unresolved account of their journey, command the recorder of their history to "set down / This set down / This." The poem intricately depicts a contest between a past journey recounted in the key of the definite article *the* and a set of arrivals recounted in the key of the indefinite article *a/an*. Here is a portion of the journey, which constantly repeats from lines 4-20 its specifying "the":

> *The* ways deep and *the* weather sharp,
> *The* very dead of winter.
> And *the* camels galled, sorefooted, refractory,
> Lying down in *the* melting snow.
> There were times we regretted
> *The* summer palaces on slopes, *the* terraces,
> And *the* silken girls bringing sherbet.

And here is a passage on arrival, pitched in the key of the repeated indefinite article *a* until its close, when it arrives at last at *the* prophesied place:

> Then at dawn we came down to *a* temperate valley...
> With *a* running stream and *a* water-mill...
> And *an* old white horse galloped away in *the* meadow.

Then we came to *a* tavern.．，
But there was no information, and so we continued
And arriving at evening, not a moment too soon
Finding *the* place; it was (you might say) satisfactory.

The arrival-landscape becomes allegorical of later events in
the life of Jesus, meaningless of course to the journeying Magi:
"Three trees on the low sky... and six hands dicing for silver."
The voices close the poem with a question to the
amanuensis, fusing the two articles *the* and *a* — the latter not
only for their first arrival at *a temperate valley,* but also for their
arrival back home after seeing *a Birth* and then, in the closing
line, for their own envisaged third arrival — their longed-for
personal death: "I should be glad of *an*-other death." Eliot
adopts in this passage Brontë's strategy of capitalizing Sacred
Things and using lower-case for human things, dramatizing
the contrast most theatrically in the juxtaposition "like Death,
our death," contrasting the implied sacred Crucifixion (the
"three trees") and the Magi's human mortality.

> Were we led all that way for
> Birth or Death? There was a Birth, certainly
> We had evidence and no doubt. I had seen birth and death,
> But had thought they were different; this Birth was
> Hard and bitter agony for us, like Death, our death.
> We returned to our places, these Kingdoms,
> But no longer at ease here, in the old dispensation
> With an alien people clutching their gods.
> I should be glad of another death.

281

During their arduous journey, the Magi had sometimes
"regretted" their former worldly pleasures, always specified by

the — "the summer palaces on slopes, the terraces, and the silken girls bringing sherbet" — but after their return to the East, the "palaces" are silently reduced to mere "places" and the Magi find themselves with the conundrum of their journey: was it a Birth they witnessed or a Death? They cannot decide. All that they know is that the journey ruined the rest of their life.

John Ashbery finally brings Brontë's abstractions into their full consequence. His book-length epic of abstract narration called *Three Poems*, from 1972, evolves without any religious support (although it allows allusion to any number of canonical literary works, including the Bible). The book is divided into three specifying parts: *The New Spirit, The System,* and *The Arrival,* all dependent on Eliot's work of specification in *Journey of the Magi*, on Brontë's work in deleting Christian reference, and on Dickinson's forthright substitution of Truth for Deity. It also depends — and chiefly — on Yeats' tiny but defiant poem announcing that the only accurate narrative of a life is the narration of its moods. Time decays as enlightenments come and go; both inorganic and organic nature change over geological time; but has any one of the eternal human moods ever been known to vanish?

The Moods

Time drops in decay,
Like a candle burnt out,
And the mountains and woods
Have their day, have their day;
What one in the rout

Of the fire-born moods
Has fallen away?

The obvious answer to Yeats' closing rhetorical question is "None." Human emotional and temperamental responses throughout life arrive as an uncontrollable "rout" (an unruly mob) of moods, generated not from the three temporal elements of the Greek world (Earth, Water, and Air) but rather from the fourth — and only immortal — realm, the celestial element of Fire. The form of Yeats' poem also supports the necessary answer: "None." We register the neat familiar logic of Yeats' rhymes — *decay, out, woods; day, rout, moods* — as we advance through the lyric because we recognize that he is constructing an English sixain: *abcabc.* Yet as we arrive at the end we are upset, because the poem, though it "should" stop at the sixth line, continues with an "extra" line, the seventh, which "re-starts" the inexorable rhyme-chain with *away.* Yeats thereby displays the perpetual self-generating of the human moods in every human being from birth to death: the moods never subside, rout after rout of them.

If moods are the chief and perpetual inner events of human life — always and everywhere, appearing in our oldest oral and written literature and visual representations and pre-eminently in music — then as an artist records them, however incompletely or imperfectly, they become the most reliable narratives of our inner incessant responses to our infinitely mobile conscious and unconscious life. To trace the moods has long been thought the special task of lyric, but Ashbery, by extending the mode to epic length in *Three Poems,* proposes that testimony to the moods is also the underlying work of all human narrative, even when it is presented novelistically or dramatically. Ashbery's long and sinuous ongoing sentences,

influenced (as critics have noted) by the speculative novelists James and Proust, forsake the hard actualities of Homeric epic — a war, a journey — for a stylistic *tour de force*, a book-length exposition of the flickerings, doubts, convictions, affirmations, enjoyments, ecstasies, disappointments, and bafflements of the inner life. The moods are not structurally containable by human thought-systems. Ideology, shrinking and confining the human person into an idea-system, is, in this poetic, the enemy of human accuracy.

Three Poems is the modern equivalent of the Augustinian spiritual journals of the past, ever rising to a crest of faith or sinking into a trough of perplexity and despair, yet bound to remember what their author's fluctuating responses have amounted to in God's eyes, and to judge whether they are legitimate or unworthy. *Three Poems* (dedicated to the poet's partner David Kermani) is Ashbery's spiritual journal, moving through a haze of mist and fog, making inquiries into elementary particles of emotion and fugitive auroras, into intimations, into repudiations. Every new day arrives with irrepressible moods that tend to discard the old, distrust the new, cherish hopes, falter in confidence, and long for an idyll. The rout of moods never "solves" or "resolves" any life-question, because a new and thrilling disturbance of feeling will appear the moment the previous one lapses into forgetfulness. Ashbery moves down the page always apparently in preparation for a contemplated undertaking, but is prevented by new inspirations or disbeliefs from any conclusive action. And there is no question of moral judgment of the self, because moods irrupt into being involuntarily.

A passage from *Three Poems* recording the moment of falling in love and discovering one's responses of shock and delight illustrates Ashbery's refusal of definiteness in favor

of an abstract and equivocal (but finely shaded) balance of erotic delusion and erotic fulfillment, the latter causing the former. In the delusion of new love the world changes, and the lover becomes so suffused by emotion that he is certain that even insects and rodents must be feeling the glowing ambiance of desire:

> From the outset it was apparent that someone had
> played a colossal trick on something. The switches had
> been tripped, as it were; the entire world or one's limited
> but accurate idea of it was bathed in glowing love, of a
> sort that need never have come into being but was now
> indispensable as air is to living creatures. It filled up the
> whole universe, raising the temperature of all things.
> Not an atom but did not feel obscurely compelled to set
> out in search of a mate; not a living creature, no insect
> or rodent, that didn't feel the obscure twitchings of
> dormant love, that didn't ache to join in the universal
> turmoil and hullabaloo that fell over the earth, roiling
> the clear waters of the reflective intellect, getting it into
> all kinds of messes that could have been avoided if only,
> as Pascal says, we had the sense to stay in our room, but
> the individual will condemns this notion and sallies
> forth full of ardor and *hubris,* bent on self-discovery in
> the guise of an attractive partner who is *the* heaven-sent
> one, the convex one with whom he has had the urge to
> mate all these seasons without realizing it.

In this abstract quasi-moral discourse from which everything moral has been deleted, we are left with the ultimately comic but also plangent dilemma of the poet whose every possibility remains (to quote Ammons' poem "Classic")

Can Poetry Be Abstract?

"uncapturable and vanishing." *Three Poems,* unlikely ever to be exhausted, is equally unlikely to be imitated at such length and virtuosity, but it proves that even a long lyric narrative prose-poem can be fully abstract, appearing as the final extension of Brontë's abstract ventures in lyric.

Episode by episode, experiment by experiment, God has died on the poetic page, and has been replaced, as Dickinson prophesied, by a new Truth. A "scrawny bird-cry at dawn" is Stevens' description of the embryonic new truth in "Not Ideas About the Thing But the Thing Itself," but the poet predicts the reappearance of "the colossal sun, // Surrounded by its choral rings, / Still far away." Only posterity will know whether the scrawny cry of the abstract was a necessary move for the invention of a new poetics.

286

CELESTE MARCUS

After Rape: A Guide for The Tormented

I

The worst thing that was ever done to a person I know was committed by a man who claimed he loved his victim. "That was not rape," he told her afterwards. He was in this regard highly unoriginal. Every rape survivor who has shared her story with me was also told by her rapist that what he did to her was not rape.

The first months after my rape I would play macabre mind games with myself whenever I was left alone. I would, for example, ask myself at regular intervals: What punishment would be bad enough? Sometimes I would deliberately pose the question at a time of relative peace, to punish myself for allowing the memory of the evil to fade from the forefront

of my attention. What punishment would be bad enough? What punishment would be bad enough? At two months out, I was able to make droll, dark quips about my little game with close friends. I would say that I wished I believed in hell so that I could believe he would burn forever, and I would add that faith in the possibility of eternal damnation is wasted on people who already have the comfort of a God. They would laugh and rub my back and tell me they were glad that we could make jokes. But in the skinless moments, when wit was beyond me, I would fantasize about one particular punishment. I wanted my rapist to think "That is a rapist" every time he saw his own reflection. I wanted the word to rise like bile in his throat every time he read his own byline. His condign punishment would have been the burning tang of his own evil present as a taste on his tongue.

Rape is like explosive ammunition. The bullet fragments beneath the skin, wounding all parts of the body. The initial rupture is then succeeded by a thousand subsequent tears which commit compounded, invisible violence over time. The damage spreads far from the site of the wound. The damage cannot be contained. A victim must track its effects. She must understand how she has been shredded within. She must identify and extract each shard, or else the shrapnel will continue to do damage. Feigning health is not an option.

A woman whose name I did not recognize direct-messaged me on Instagram a few months ago. I will call her Eve. Eve told me

that she had reason to believe that a man who had just violently attacked her may have once done something similar to me. "Would you be willing to meet or to talk on the phone? I live in Philadelphia but can make the trip down." We scheduled a phone call. On the phone Eve relayed that impressive social media detective work had yielded the following interesting results: her rapist and I had once been close friends, but we no longer follow one another on any platform. There was a photograph of us on a beach taken from a few years ago that he still had on his Instagram grid, though there was no trace of him in any photos on my Instagram account. Suspicious. The police, who had taken swabs of blood and photographs of the bruises which covered her chest and arms after the attack, had told her that rapes like hers are usually perpetrated by repeat offenders. Her rapist had said and done things which indicated to the cops that he had likely said and done those things before. Eve had been looking for her fellow victims, for others who had suffered as she had by the same hand. "Her rapist" might also be "my rapist."

"My rapist": what a heavy appellation. It binds you grotesquely. When a woman I love revealed to me that she had been raped three times by three different men, the first thought I had — viscerally, before I could catch myself from forming it — was that it was like having three ex-husbands. "My rapist" denotes a permanent relationship. This is one of the injustices for which I had been unprepared before my own experience. Another shard.

But Eve had guessed wrong. "No, he didn't rape me." I told her. "It's strange you reached out. I did break off contact with him shortly after I was raped, but I wasn't raped by him. I was raped by someone else. A few days afterward he and I were talking about date rape and he said to me, 'That's not *real*

rape, though. You know usually they're both just drunk and then she regrets it and exaggerates.' I wonder whether I would have broken off contact with him if I hadn't just been raped. I probably would have just yelled at him. But after that remark I wanted nothing to do with him." But I wanted to be absolutely clear, because we were speaking in a universe of innuendo. "No, he never did anything like that to me. And my rape wasn't like that either. I mean, it wasn't violent like that. I didn't bleed. I was in and out of sleep when he penetrated me and was jolted wide awake when he started moving fast inside me."

"Oh my god." she whispered. "I'm so sorry."

Odd, I thought, that she could be moved by that detail when her story was far more gruesome than mine.

It was a swampy summer morning in Washington, DC. I had been on a run but had stopped in my office for her call. Minutes into Eve's account I slid to the floor and pulled my knees up against my chest. It was awful to listen to her, to hear the plea in her tone while she recounted the details, and to recognize that plea. I, too, used to beg implicitly when I retold my own story. "This is bad, right? Isn't this very, very bad?" I could feel myself imploring people to understand. I wanted them to be moved by the horror, to exclaim out loud that I was the victim of a foul crime. I could hear how pitiable I sounded. My voice disgusted me.

Eve and I spoke for a long while on that first call. She asked me the same questions that I had asked myself in the early days when getting up off the floor was the best I could manage. I looked up while she talked. In the wall-length window that spans the length of our office space I saw my reflection in the glass. The terror on my face startled me. She was at the very beginning of the trek the end of which I was only just approaching. So much pain awaited her.

Liberties

Just before she hung up, she said: "This is silly but... How long, how long did it take for you to feel normal again?"

I inhaled deeply and stared at the reflection in the window. It was very important not to give her false hope. When I had been where she was now, and interlocutors were either too optimistic or too quick to affirm my feelings, I immediately discounted their support. It is difficult to say anything about trauma that isn't trite or hyperbolic, and whenever someone whispered affirmations that smacked of insincerity it made me feel very lonely. I needed Eve to trust me. I had to be forthright and specific in order to earn her trust.

This is what I told her. "For the first two months I wanted to die. The lowest point was the morning after a mutual friend of ours — the only mutual friend we had — told me to forgive my rapist. He said that 'he only did it because he loves you. He was fighting for your love. His heart is broken now.' That next day I couldn't get out of bed till the evening. At night I slammed my head against the wall over and over until I fell down. For months after that I kept arguing with that man in my head. The same argument played like a loop. 'How can you think this evil could be forgivable?' And to win the argument I had to make myself relive the rape precisely — every detail that I could remember from before the act, and then the exact sensations waking up, telling him to stop, waiting for him to leave and then jumping up and locking the door — over and over and over. After three months I started to see a therapist. It helped a lot — I'll give you her name, she does remote calls. After six months the rape stopped being the only thing in my head whenever I was alone. A little shy of one year I had the first whole day when I didn't think about it at all."

And I continued: "I still can't bear to see his name. I've blocked and muted him on every platform, but every once in a

291

while he writes something that gets attention, and then I can't avoid seeing his name. Right after the rape he was on a popular reading list. There was an image of the list with his name on it that kept getting re-posted. Those were a bad few days. He just published a book, so I keep seeing reviews. It feels as if there is no sanctuary anywhere. But I promise, Eve, I swear, you will feel like yourself again. You will be a full human being on the other side of this. You have already been so brave. You have done more than I did. I don't know anyone else who went to the police after their rape."

She thanked me. She told me that she didn't know anyone else who had been through anything like this, so what I had to say was useful. And thus began a dark sisterhood. I took my duty to her very seriously, and when she thanked me — for checking in, for scheduling phone calls, for texting hearts at regular intervals — I explained to her that I needed this at least as much as she did. Helping her conferred a purpose upon what I had been through. It put that hell to use. The whole while I had been where she was now, I kept wishing for a guide. Now perhaps I could give her one, a guide to help her inch towards lucidity.

II

In the beginning, a victim's desire for health exceeds her cognitive capacity. She is hemorrhaging. It is a kind of internal bleeding. With proper guidance and patience, her reason will strengthen, and she can grow secure of her own judgment. She will achieve some level of stability. But nobody is born with the resources and the mechanisms for mastering *this*. They must learn from the miserable experience of other people.

What follows is a guide for the tormented. Its objective is to offer a taxonomy of rape's afterlife, so that you, the victim, can make sense of your own grief. The grief will initially strike you as overwhelming, as all you will ever know. It will feel unbearable and sometimes it will be unbearable. In the early days you will worry that the grief will never end, that the inside of your mind will always be a hostile place, and that from now on you will conceive of yourself primarily as a rape victim and a rape survivor. It will take a long time until that is no longer the most salient thing about you. That crushing identity will slowly lighten and lift. Healing will take a long time, but it can be managed responsibly by anticipating the dangers and preparing for them. It cannot be sped up, though it can be slowed down.

For a start, there are two sorts of dangers: internal and external. The internal dangers are the most intractable. It is a special nightmare when the greatest threat to a person's sanity is her own mind. The victim's subconscious will begin to gaslight itself. You will not want to believe that what has happened has happened. The impulse to deny it or to make light of it or to interpret it as your fault will at first be greater than the need to describe the rape accurately. You will lie to yourself. You will pounce on offhand trivialities that unwitting or idiotic people say which seem to confirm the suspicion that you are being unreasonable, that your rape wasn't really that bad, that your rapist doesn't really deserve punishment, and other analogous idiocies. These idiocies are among the regular effects of rape. You will pick them up, put them in your pocket, and finger them absentmindedly throughout the day. You will feel like you are losing your mind.

1 — *Losing My Mind*

"I feel insane," Eve texted me.

She felt insane because her rapist seemed fine. Scrolling through posts on Instagram she caught sight of him in a photograph that someone else had posted. He was sipping champagne at a party. This was shattering. If he had raped her, how could he be fine? How could he function at all? Shouldn't the weight of his own crime be crushing him? And if it wasn't crushing him, did that mean that he must not have done it?

Well, he certainly did do something, but what if that something wasn't rape? After all, it wasn't like rape on television. She thought of Dr. Melfi's rape on *The Sopranos*. Isn't that *real* rape? I had seen the episode and even before I was violated I could barely stomach it. One night in the parking lot in the building of Dr. Melfi's office, a strange man whose face viewers can barely make out comes at her from behind and puts her in a chokehold. When she tries to escape he throws her to the ground, punches her in the face, and drags her to a stairwell, where the sexual assault takes place. Viewers are forced to watch her scream and beg until he finishes and runs away. It is candidly brutal. There is no ambiguity. No one, not even the rapist himself, would deny that what he had committed was rape.

We have all been told how common rape is. In rape's afterlife, those statistics have human faces. You have heard that one in four women will be victims of rape by the time they reach their mid-twenties, but now the implications of "one in four" will grab you by the throat. When you walk down the street you will start counting — the women, of course, but also the men. The inverse of that statistic will dawn on you: if one in four women are victims, how many of the men you walk past are perpetrators?

And another statistic, perhaps less familiar, will have sharp teeth: of those women, over seventy-five percent will be victims of "acquaintance rape," or rape between two people who know each other. Most rapists know their victims. Many even love their victims. According to "Acquaintance Rape: The Hidden Crime," a report published by the Department of Justice in 1991, "acquaintance rapists are rarely convicted, and cases are generally not viewed as 'real' rape by the legal system" because they didn't look like Dr. Melfi's encounter with violence. Victims, the report found, are also inclined not to view their own rapes as "real." This is why Eve felt insane. What if he was sipping champagne because it wasn't real?

2 — *Evil*

The word "rape" is heavily freighted. It is a primary sin. One would have to be evil to feel entitled to force himself into another person. One would have to be capable of evil to have done so. I couldn't say "rape" for the first few days after it happened. I resisted matriculation into the world of this evil. A victim of acquaintance rape must accept the fact that someone she knows, perhaps even someone she trusted and cared about, is evil, and also that he had done evil to her. A relationship with reality in which evil is something far away is no longer possible after that. The disillusionment is staggering. And reckoning with this new reality is difficult. It is enormously disruptive to have to formulate a new relationship with the world, one in which evil is not an abstraction or a historical phenomenon far away in time or place. It is tempting to deny one's own experience when the acceptance of it is a promise of torment. And that temptation is made stronger by the fact that the only authority whom the victim can rely on to justify such a reformulation is herself. Is she sure? Does she understand the impli-

295

cations of what she is saying? Can it *really* be that this man could have done that? (See 1 above.)

You do not want it to be true. You are the one who has to live in the new world in which it is true. He has assured himself that what he did was not rape — after all, rape is evil — and so he sips champagne and writes his books and occasionally thinks of that cute girl he used to go out with who suddenly went crazy and sadly shakes his head. "She's crazy," he will say if anyone brings her up. Or, if he is sick in precisely the way my rapist is, he will tell them, "She broke my heart." There are no shards inside his body, there is nothing he has to extract from himself. And while his life goes on, you will be staring at your own puffy face in the mirror wondering how many more hours of just this day will be spent sobbing.

It is exhausting to have been raped.

3 — How Bad is Bad Enough for Justice?
Even after accepting what you know is true — that he did do it, that the photographs of the bruises and the swabs of blood tell an unimpeachable story — there are other concerns. How bad must a crime be to render the perpetrator worthy of losing his livelihood and his reputation? What if he has a family? Is rape bad enough to warrant such an encompassing punishment? All rape? Do you want the responsibility of having destroyed his capacity to feed his children, or even to keep them?

"I keep thinking about his kids," a friend whispered to me over drinks. She had a preliminary conversation with a lawyer about what her legal options were should she choose to bring a civil suit against her rapist. "What if I don't know for sure that he will do it again? What if I'm only doing this for revenge?"

"You deserve justice!" I had been digging my nails into my arm trying not to cut her off, but I finally exploded. "If

296

someone broke into your home and robbed you, would you wait to make sure that he was likely to do it again before calling the police? Rape is a crime. It is a *crime*. He is a *criminal*. We are entitled to justice. I have discovered no evidence that the man who raped me had done it before and I have no reason to be confident that he will do it again, but still I am ashamed that I did nothing — *nothing* — to punish him."

At the time she found that argument convincing, but a few days after our drink she got a call from her best friend. "She told me that it was narcissistic of me to bring a case against him that could ruin his entire life. She said that I would be fine in a few months, but he will never be able to work again."

4 — *The Price of Coming Forward*
Suppose a victim recognizes that she does have the right to justice. How does one go about securing justice? I am a young writer and my rapist is a better known writer than I am. If I come forward (whatever "coming forward" means) this nightmare will become the thing for which I am known. I used to say that "I will come forward when my fame exceeds his," but even then, who can say that his name won't come up every time someone googles mine if I make what he did known? I do not want to be renowned for my victimhood and I do not want to be tethered to his name forever. As long as I maintain this tormented silence, "my rapist" is an association kept alive mostly inside my own head. If I come forward, everyone will know about that shameful bond.

And then, of course, what will other people say?

Some will support me for the wrong reasons, which will be the least of my troubles. If I come forward, strangers on social media will debate my right to do so. People of whom I have never heard will have opinions about whether my rape

was awful enough, or whether my rapist was sufficiently contrite. Some will call me a liar, and they will have just as much evidence at their disposal as those who say they believe me. "Am I insane?" "Am I sure he did it?" "Am I sure I didn't deserve it?" "Was it just because he loved me?" "Would it hurt him more to be accused of rape than it hurts me to have been raped?" "Do I have the right to justice?" "What is justice for a rape like that?" All the questions discussed above will no longer be confined to the inside of my head.

And what will he say? Will he simply lie and say that I never said no? But I had said no to him so many times before. He knows that. I guess he has to lie about it to go on living (and succeeding). But surely it is grotesque to think that the protection of his good fortune is my responsibility.

5 — Did You Report It?
When you share your story (if you share it with anyone) the first thing most people will ask is whether you reported it. People will never stop asking this question, as if the difference between truth and falsehood depends on your answer to it, but over time it will get easier to hear it. In the early days, it will feel like an accusation. Overwhelmingly, the answer is no. And if the answer is yes, far too often the police do nothing, in which case you have to lie, or refuse to answer, or tell your interlocutor that the police did nothing. If your interlocutor is insufficiently educated, this news may cause her to believe that your rape wasn't "real." And if you realize that this is her conclusion, it may strike you as confirmation that you have indeed lost your mind.

Rape is one of the most under-reported crimes in the United States. Shortly after I shared my story with him, a friend of mine said about my rape: "My wife says that if it was

really rape you would have gone to the police." His wife is not alone. Despite the fact that sixty-three percent of sexual assault victims do not go to the police, "Why didn't you go to the police?" is often the first question people ask when told that you were raped. Initially, in the early days, the answer was that I did not report it because I was broken and could barely function at the time. Since that was the true answer, I never bothered to figure out what would actually happen if I had reported it. In all likelihood it would have yielded only more pain, and only for me. I had no physical evidence. I did not bleed. He did not leave behind a soiled condom. I'm pretty sure that he did not even ejaculate, since I woke up when he started moving quickly as if about to climax, and that was when I said "no, no, no" for the final time. For the first three months after the rape, probably due to stress, I did not get my period. I wondered through a thick fog if that meant that I was pregnant. The humiliating prospect of contacting him to ask if he had ejaculated, or if he had worn a condom, was so unbearable to me that I resolved, dimly, that I would rather just be pregnant.

What actually happens after a victim goes to the police? It is bizarre and frustrating how difficult it is to figure out. The urban legend is that involving the police is a bad idea, that little is likely to come of it, but why exactly it is a bad idea and what exactly "little" means is difficult to ascertain.

On its website, the D.C. Metropolitan Police Department, in whose jurisdiction my rape occurred, offers its own account of what victims will experience if they report a rape:

What to expect:

· When a dispatcher receives a call, a police officer is sent to the location of the reported incident.

After Rape: A Guide for The Tormented

- The police officer will ask the victim some questions about what happened.

- The police officer who responds to the scene will contact the Sex Assault Unit once an incident involving sexual assault has been reported.

- The investigation is transferred to the detective when the detective arrives at the scene.

- The detective will conduct a more detailed interview.

- The detective will also contact the Forensic Science Division to respond to the scene to collect evidence at the location of the crime.

- If necessary, the detective will arrange for the victim to be taken to the hospital for a forensic exam.

- A specially trained nurse will conduct the forensic exam.

It is important that you do not:

- Disturb the crime scene.

- Shower, bathe or wash.

- Change your clothes (if you have already changed clothes, place them in a paper bag for the detective).

- Eat, drink or smoke.

Liberties

· Brush your teeth.

· Use the bathroom.

Remember

Sexual assault is never the victim's fault. It is always the
fault of the assailant no matter what your relationship
is to the assailant, what you were wearing or doing, or
what drugs or alcohol you ingested prior to or at the
time of the assault.

Members of the MPD's Sex Assault Unit take every
report of sexual assault very seriously and investigate
each case as fully as possible.

The tone of the text is thoughtful, but it belies the
experience of many victims. There are myriad steps between
reporting a rape and getting to criminal trial, and at each one
the victim faces often insurmountable obstacles. According to
a report conducted by the journalist Barbara Bradley Haggerty,
police are often unsympathetic to victims of reported rape,
which is consistent with the fact that police officers themselves
are accused of rape at a rate of one per week in the United
States. Of the five hundred officers who have been accused of
sexual assault in the last five years, three-hundred and fifty of
them are still serving as policemen. This fact, and the aura in
which it shrouds police generally, is among the many reasons
that women are hesitant to report.
 And if she does choose to report it? There is an epidemic
of rape-undercounting in police departments around the

country. In 2013, Human Rights Watch published an investigation which revealed that the DC police were systematically mishandling and downgrading reported sexual assault cases. Cases which are counted are often mishandled. For example, there are currently four hundred thousand untested rape kits in America. Some have been on the shelves for decades. Victims who do go to the police and who then give DNA often wait in vain as kits with evidence taken from the most private parts of their bodies are sealed, stored, and forgotten about.

And for those whose cases are investigated and the evidence is processed and a trial can begin, the best-case scenario also involves significant pain.

6 — Why Didn't You Scream?
There are certain questions that the police will ask a victim in the United States. "Why didn't you scream?" is apparently a common question. Also, "Why didn't you push him off you?" The answers are not hard to find or to understand. There are studies which show that victims often go into shock and so are unable to scream. Why anyone needs a report to tell them that boggles the mind.

The victim who will be asked "Why didn't you scream?" by police may also be asked to scroll through her text conversations with anyone she spoke to in the days after the rape, and read through those conversations, and screenshot any details that may be relevant to the case. In some cases, they will simply take her phone and search it themselves. (There are cases of victims being arrested for evidence that police discovered on their phones after the victims turned to police to report their own rape.) If, shortly after her rape, anyone saw her looking particularly out of sorts, if anyone caught her crying, or noticed that her make-up was smudged by tears, then the

police may ask to speak to them to corroborate evidence. If she bled during the rape, police may demand to speak to prior sexual partners to prove that she was not a virgin. If she has any recorded interactions with her rapist after he has raped, she will be made to review and then share that information with the police as well. Officers will ask her more questions: "Why didn't you call it rape that night?" "If you were so upset, why did you go to the bar the next day?" "Why would you speak to him again if he'd raped you?" Even if these questions are posed in a gentle, understanding tone, as if they are nothing more than due diligence, they will sting like shrapnel.

7 — It Wasn't So Bad

People will tell you that what happened to you wasn't so bad. Not everyone of course; but each time someone makes that merciless observation another shard sinks deeper. It's worse when women do it. One afternoon about two weeks after my rape, a woman with whom I was friendly mentioned my rapist by name. I couldn't bear to hear it, so I told her what he had done to me.

"Why didn't you go to the police?" she asked briskly. I hadn't learned yet to expect that question, and so each time it was posed I was thrown back into a wrestling match with myself, while my interlocutor politely and uncomprehendingly waited for a response. "I... I don't want to be responsible for ruining his life." I muttered, repeating something that I had once heard someone else say. She smiled. "That makes sense," she replied. "Where I come from, men do stuff like that all the time anyway." I gasped. "Men rape women all the time?" I asked. She waved her hand: "No, no, but you know they can be very aggressive when they hit on us."

How is such a dearth of understanding possible? I think

303

about that conversation now more often than I think about the rape itself.

8 — You Will Make Your Loved Ones Miserable
Everyone who is closest to you will be in visible pain. At first it will be because you are in raw pain and your raw pain is difficult for them to witness. They will feel helpless because they will know that there is absolutely nothing they can do to help you heal. Love hates to be useless. But all they can do is hinder the healing process. If they are hurtful — and they will be, even inadvertently, simply by waking up every morning and being manifestly capable of basic executive functioning while you can hardly stand — they will throw you off course. If they are kind and understanding and generous, you will still be alone with the shrieking inside your own head.

When the shrieking stops, when you transition out of the shrieking phase, you will reach the phase at which all you can think and talk about is the rape. You will talk incessantly about your rapist, what he is doing, where he is living, whether or not you should call the magazine where he works and inform them that they are employing a rapist. You will hear yourself returning again and again to the same subject and you will see your friends' eyes widen or their lips tighten. Sometimes they will say, "For your own sake, you need to try not to think about it." And if this doesn't make you burst into tears, it will at the very least make you angry, and angry with them as much as with yourself because you are trapped inside your mind with these thoughts which they cannot handle even in limited dosages.

You will feel pathetic, and you will also feel boring, and isolated. Communication will seem impossible. And these feelings will chew away at your already depleted self-respect.

9 — Medicinal Self-Respect

The only authority who can bear witness to what happened to you, to its subsequent effects, to the wreckage wrought by one man's hideous sense of entitlement, is you. You must bear witness for yourself. This time you must take innocence and justice and humanity seriously enough not to take care of others but to take care of yourself. There will be no one else you can say you are doing this for, no one else to save. "Self-care," that phrase which until now has always reminded you of posters on the walls at Barnes and Noble, will suddenly be immensely important. You will discover that clenching your teeth and bearing this pain is a childish and irresponsible thing to attempt. It will not work. You cannot push the pain away: it is stronger than you are. Grow up, rise to it, meet it, and take care of yourself.

A few months after I was raped and a few months after he blithely told me to forgive my rapist, that mutual friend of ours contacted me and asked if we could get coffee. My reply to him reads in part:

> I'm not going to try to describe to you the hell the past
> several months have been because it would feel too
> much like I was trying to convince you of the gravity of
> what was done to me. That is the argument I have been
> having in my head with you since our initial phone call.
> It resumes every time there is a lull, every pause in the
> general commotion, an incessant inner monologue. But
> the rape, like all rape, was very bad, and one of the
> indications that it was is how horrific processing it has
> been. The psychological burden is immense, at times
> far too heavy for me, and it has forced me to make
> miserable the people who love me most. Watching them

suffer through my pain has been the most tormenting experience of all.

I have learned since July that the only way for me to get through this ordeal is to be assiduous about preserving my own self-respect. I say all this by way of explanation, because I need you to know that I cannot have coffee with you, or with anyone else who I know is friends with the man who raped me, who knows he did that, and continues to be friends with him. I'm not going to ask you to break off your friendship — if you were going to do that you already would have. (I assume that you must not conceive of what he did to me as a rape, because I can't imagine that you could call it that in your mind and continue to be friends with him. If my intuition about this is correct, I ask that you never tell me so. I have relived the incident far too many times to be told that it did not happen, or that I misinterpreted something so disgusting and egregious, a primary transgression, a grotesque violation).

I don't say this to be childish, I just have studied the precarious condition of my own well-being closely enough to know that if I sit down at a table with you knowing that you have done so with him just a day or an hour or two before I will not be able to get up off the floor the next day (just as I was not able to get up off the floor the morning after our last call). I wish that I was not so vulnerable, I wish that I was strong enough to withstand that sort of interaction. I wish that he had not raped me.

It had taken me several months to gather the clarity and the strength necessary to tell a person that their dismissal of my desecration was unacceptable. In far less febrile circumstances, demanding respect is a difficult thing to do. But dignity is a precious resource and *in extremis* it must be preserved. It is undignified to beg someone to recognize your humanity. It is not possible to maintain cordial relations with a person who has so blatantly disrespected you and lazily preferred not to listen to you closely in your hour of crisis. You, the victim, must disentangle yourself from such a person and, if you can, tell them why. Force them to recognize how their behavior has damaged you. Give them the opportunity to consider what you have to say. If they respond vilely, gird yourself against that ugliness and consider it an affirmation of your choice to extricate yourself from them. If it is possible for them to recognize their transgression and repent for it, their apology will be a precious balm. It will be an explicit recognition of the rape by a party who had been predisposed to discount it. A shard removed.

10 — *Forgiveness*

Treat the wound until it has scabbed and then scarred. When the scar has faded to a shadow, you will have the capacity to consider the questions of charity, repentance, and forgiveness. There will be a long list of people who have done you serious damage in the wake of your rape. The time will come when you will ask yourself who among them can be forgiven. And the time will come when you, or others, will ask whether your rapist himself can be forgiven. "Move on," some people will say.

You must not forgive him. You must respect yourself enough to know that this you cannot do. Anyone who would ask you to forgive him is not worthy of your associ-

ation. And yet you must not calcify into an uncharitable, withdrawn, fearful, and unforgiving person. Do not allow that to be another thing he has done to you, another one of the rape's effects. Protect yourself from swimming in your own bitterness.

There will be friends who tell you it is your duty to forgive that man. They are wrong. There will also be friends who tell you that his conduct impugns all men, that every man must be guilty because he is. They, too, are wrong. Both of these protestations are absurd. Heeding either one would cripple you. This isn't easy.

There will be days when every man on the street looks to you like a rapist. Do not belittle what your rapist did by implying that all men could have done it. They could not: he is freakishly cruel, freakishly entitled. Withholding forgiveness in this case makes it more meaningful when forgiveness is given in other cases, in the rest of life. Trust and forgive others as a testament to the fact that his evil is unusual, that he is a monster, that most people — most men — could not do what he did.

You are safer now than you were before: you understand the threat accurately.

LEON WIESELTIER

Savagery and Solidarity

I

There are facets of my being of which I am ashamed, but the love of my people is not one of them. (Reader, hear me out.) The bond is primordial, though I am under no illusion that its primordiality exempts it from thoughtful consideration and the question of justification. It has nothing to do with biology: peoplehood does not reach that deeply. The species precedes all the peoples, all the differentiations, even if they go to great pains to disguise this humane fact. A happy childhood surely had something to do with the formation of my national love. I was raised to be a loyal son of my people, and this instruction, much of it unspoken, delighted me; to this day I tingle at the

sight of a Torah, and I cheer when my plane hits the tarmac at Ben Gurion airport. I do so unthinkingly, because expressions of profound affiliation are often made prior to reflection, the way happiness at the sight of someone I love does not await a process of validation. Long before politics enter the picture, I respond with a visceral joy to the feel of the soil of the land of Israel beneath my feet, and to the sight of its punished stones and its giddy deserts and its voluptuous forests and its cathartic sea; my very senses feel Jewish, even if I know better. For me this land will always be *the land*, though I am not at all against sharing it. For the sake of my brothers and sisters who live in it, I long for the day when it will be peaceably shared. And Hebrew is my island paradise; a portable paradise, a paradise unlimited by place, which is the most perfect paradise of all. I have loved it ever since I heard it.

Some of my teachers taught me that my people is a chosen people, but at home I was taught self-esteem more than superiority, and anyway the belief in chosenness got tangled up early on with vexing questions about the alleged chooser. I once heard a distinguished American rabbi tell his congregation that Jewish history is "the story of a God who fell in love with a people." We do flatter ourselves. Who could believe in such a pushover of a God? I was fortunate that my parents elected to provide for me an immense education in my people's tradition and history and language, because nothing corrects arrogance so much as knowledge. As I acquired a familiarity with that history, moreover, I came to be schooled in a saga of sorrow. At a chillingly young age I learned to speak the language of lamentations, all the way up to the murder of my parents' own families in an extermination that ended only seven years before I was born. So this is not a completely sunny love.

For a while in my youth I lived chiefly in the Jewish shadows, and was swayed by hideous supremacist ideas. My people had recently been decimated, and I wanted to feel big and menacing. I thought I was loving my people when I was hating other people. But as I studied more and experienced more of what was bequeathed to me, the conceit of superiority, the romance of militancy, became not only ugly in my eyes but also gratuitous. It was enough that my heritage was incalculably rich and deep and beautiful; it did not need to be better than everybody else's. The comparative impulse bespeaks an insecurity about the value of one's origins that I utterly lack.

A man who spends his days hating his origins is not a free man. Of course I recognize the dignity in alienation and the necessity in rebellion, and I believe that a life that ends exactly where it began is a wasted life. But over the decades I have grown suspicious of the psychodrama of identity, of recreational dissent and glamorous infidelity. I accept my duties, or many of them; I do not wish to see my patrimony die on my watch. It was not supposed to reach me, except miraculously; it surmounted many centuries of obscene obstacles to make it all the way to here and now; and so I have a solemn responsibility of stewardship. My people's anxiety about survival is not a hallucination, even if it is not all we need to know about ourselves and our circumstances. The anxiety can be politically abused. We now possess power in various forms, including state power, which means not only that we can protect ourselves from hurt but also that we can inflict hurt on others — a vast ethical challenge that is still preferable to the vulnerability from which we so long suffered. The world has made morbidity very tempting for us. A large portion — too large, sometimes — of our culture is consecrated to commemoration; we are a mourning people. What we love is what's left.

When I speak of my love, I am not saying that my tradition is perfect. There is no such thing as a perfect tradition. When the Talmud does not fill me with awe it makes me cringe. I am saying rather that I feel lucky to have been born a Jew. This feeling of my good fortune — what is luck but a godless version of providence? — extends to almost the entirety of the Jewish universe. I say almost, because Jewish civilization, like every great civilization, holds many things within itself, and like every great civilization it contains nonsense and prejudice. Moreover, the notion that nothing Jewish is alien to me — to narrow, and thereby betray, Terence's humanistic motto — makes no sense to me; it is mere ethnicity. I have in my time gladly participated in all kinds of quarrels within my community. (It helps that the tradition includes a reverence for controversy.) Even in settings of love, judgements must be made. And yet the love that I am describing surpasses even bitter arguments. It inculcates in me a solidarity that is almost feral.

Is this sentimental? Without a doubt. I cry easily — when I take my son into the hall in Tel Aviv where David Ben Gurion read the Declaration of Independence; when, in *The Garden of the Finzi-Continis,* the Jewish grandfather and the Jewish granddaughter are swiftly separated from each other in a round-up; when, in a strange ceremony on the holiday of Sukkot, willow branches are beaten in a spirit of purgation after the cantor has chanted "the voice of the messenger proclaims, he proclaims and says" — but there is no voice and no messenger and no proclamation; when a large crowd of Israelis sing all the words to Yehuda Poliker's wrenching song about a deported Jewish girl ("Who will sweeten your nights? Who will harken to your cries? Who will guard your steps along your way? Take a jacket, you'll be cold") as he and his guitar lead them from the stage; when the Yom Kippur

candles are lit alongside a small sea of memorial lamps, and the room fills with the living and the dead; when I put my father's prayer shawl on my son's shoulders, thereby scoffing at the Babylonians, the Assyrians, the Romans, the Crusaders, the Inquisition, the Cossacks, the Nazis, the Communists, and the jihadists; when I hear the voice of Moshe Koussevitsky, and of Daniel Kahn and Sveta Kundish performing Woody Guthrie in Yiddish; when there comes into my possession an important sixteenth-century edition of a classic work of Jewish philosophy that was in the library of the Hasidic dynasty in Poland who for generations commanded my family's devotion; when I watch footage of Bayard Rustin ardently defending Israel, and the possibility of brotherhood appears less fictive; and when nothing in particular happens at all, except that I am suddenly assaulted by a sensation of the tremendousness of the good and the evil that preceded me. If all this is sentimentality, it certainly did not come cheaply. It takes place in a charged atmosphere of unrelenting resonance, with signs and signifiers, words and images, principles and practices, everywhere zephyring round. It is not without its standards of rigor and its requirements for toil. Unlike the worst sentimentality, it abhors laziness, or so I like to think, and the easy gratifications of what Americans call "affirmation." I take my Jewish pleasures from more than cuisine and comedians. A sense of magnitude must be maintained. But I am not embarrassed that I like to sing along, especially in Jewish languages. I could hardly mistake my people's story for a song.

The first task of love, its most urgent charge, is safety. I want my people to be safe. Historically speaking, safety has been exotic

313

for them, almost utopian. In the exile there were periods of peace, but they cannot be called periods of safety. Just a short while before we beat those willow branches in synagogue, which in last year's Gregorian calendar was on October 6, we recited a series of late antique litanies, and one of them describes the Jews as "the people that says I am a wall." That is the authentic Jewish fantasy, not for the end of days but for the middle of them: security. Those words are preceded by the formula *hoshana*, hosanna, or "please save," as in "please save the people that says I am a wall," because the people that says I am a wall discovered in its historical experience that it is not a wall, and so it has come to beseech divine protection. Still later in its historical experience, however, this people made another discovery: that it will not be a wall until it makes itself into a wall — until it takes its fate into its own hands. The truly redemptive moment for every oppressed group is the recognition of its own historical agency. In the modern era, the historical agency of the Jews was exercised in a variety of revolutionary projects, and the most successful of those projects, the one that offered them a haven of their own in which they would be free to defend themselves and flourish in a land to which they have a historical right, was Zionism. Among other things, Zionism is a theory and a practice of Jewish security.

I am a Zionist because I am a Jew. Zionism is a conclusion that I draw from my study of Jewish history. Other conclusions may be drawn, obviously; but the non-Zionist ones scant or ignore what we know about the consequences of Jewish powerlessness. There are many currents within Zionism, as there are within any nationalism, and some of them, most consummately exemplified now by Benjamin Netanyahu and his sordid and incompetent government of racists and clowns, are anathema to me, though I am the son of a man who

314

revered Jabotinsky and liked to recall the great man's visit to his hometown in Galicia. But before we get to the struggle for liberalism and democracy within Jewish nationalism, there is the struggle for the physical safety of Jews. Any Israeli policy that endangers the Jews who live in Israel is a betrayal of Zionism. It corrodes the state's reason for being. I have all my life opposed the settlement of the West Bank — the words "Judea and Samaria" do not titillate me — for many reasons, including my belief that the combustion of religion and nationalism mutilates them both, but the main reason is that finally the settlement project endangers the state. It thwarts a reconciliation with the millions of Palestinians who already inhabit the territory. Morally, the occupation has grossly stained Israel, which has supported the settlers slavishly in all its post-1967 governments, and looked away from terrorist acts that settlers commit in the name of anti-terrorism, such as the Jewish rampages on the West Bank during the recent Gaza war. An apartheid-like reality has been created between the river and the green line. Yet the folly of the settlements is a strategic blunder, too. Ask the Israeli army about the alleged contributions of the settlements to Israeli security. If coexistence with their Palestinian neighbors becomes impossible for the Israelis, darkness awaits them.

If it is the case that anything that jeopardizes the Jews who live in Israel, by robbing them of their majority and their sovereignty, is a repudiation of Zionism, then the "one state solution," which imperils the Jews who live in Israel by eventually dissolving them in a Palestinian majority, so that the gates of their haven may one day be shut to them and their brethren, is a repudiation of Zionism; though at least its proponents say so. And if just the absence of the two-state solution endangers the Jews who live in Israel, by sustaining

the conditions for violence and war, a status quo that promises regular paroxysms of death and destruction, then the absence of a two-state solution is also a betrayal of the ideal of Jewish security, and a repudiation of Zionism; though many of the proponents of the status quo, the cunning ones and the complacent ones, call themselves Zionists. First and foremost, I am a Zionist because I do not want any more of my people to be killed. As I say, I love them. And I fear for them. If we wish to keep a Jewish haven, we must agree to a Palestinian haven. The establishment of a Palestinian state alongside the Jewish state is a plain matter of Jewish prudence, and of a Zionist interpretation of Jewish history.

One of the most piercing lessons of the modern age is that that there is no doom like statelessness. Why is this so easy to understand about the Palestinians and so hard to understand about the Jews? The Jewish state is a secular entity created by secular people — there is nothing holy about it, though some religious Zionists may differ, and shame on those who worship states and whose souls are quenched by flags. The need of the Jewish people for a state of their own, and their right to one, must not be mistaken for a form of state-worship. It is a rudimentary condition of their survival and their development: it is nothing more, *but nothing less*, than a state. Almost since its inception there has been a debate within Jewish nationalism between "cultural Zionism" and "political Zionism," as if there is a contradiction between the protection of Jews and the flourishing of Jews, and it was not until the 1940s that the aspiration to statehood became a Zionist consensus. (If this had been achieved a decade or two earlier, large numbers of European Jews might have been saved.) But now, on the Jewish left, which in recent years has been inspired by its concern for the Palestinians to tear down all kinds of right and precious and

hard-won Jewish understandings, there has emerged a proposal even more indifferent to Jewish security than the one-state solution. It exchanges Jewish self-determination for Jewish self-exile. It is called the "no-state solution."

The author of this call for Jewish self-disempowerment is the progressive *nebbish* and scholar Daniel Boyarin, in a book called *The No-State Solution: A Jewish Manifesto*. Boyarin begins his book with a sentence of almost unbearable pathos: "After literally decades of obsessive thought about 'the Jewish Question,' I seem to have gotten myself into an aporia." The aporia — the pickle — is this: Boyarin found himself stuck between his commitments "to full justice for the Palestinians and to a vibrant, creative Jewish national culture." It seemed to him that "the only way to fulfill the latter dream is to support the existence of the State of Israel, but clearly the existence of the State of Israel makes the latter dream impossible." Wrong and wrong; wildly wrong. But since, as he candidly admits, "a Jewish connection to progressive causes was a precious legacy of the Jewish folk itself," Boyarin elected to become "an active anti-Zionist." What this means for him is that insofar as the attainment of Jewish sovereignty in the land of Israel is premised on a definition of the Jews as a nation, such a defini-tion must be renounced in favor of the characterization of the Jews as a "diaspora nation." Embrace the anomaly!

"I seek to replace those negative conceptions of diaspora," Boyarin declares, "with one that sees diaspora as founda-tional to the character of Jewish existence and a source of its cultural and political vitality." Never mind that the negation of the diaspora, one of the axioms of early Zionism, was long ago consigned to the dustbin of Jewish history. The homeland long ago realized that the existence of a diaspora makes it stronger. Anyway, the internal diversity of the Jewish people is

317

not owed to any political arrangements. Boyarin recommends for his people a model of "autonomy...within a context of sovereignty shared by others," citing Édouard Glissant: "Consent not be a single being." (Glissant was referring to the internal multiplicity of a person, not to the external multiplicity of a polity.) There have indeed been eras in which nations flourished autonomously within larger non-national entities, such as the Hellenistic world and the Hapsburg world, but what kept the peace was precisely that sovereignty was *not* shared; it was exclusively held by imperial authorities. And even in those autonomous idylls things did not work out splendidly for the Jews.

In one of his earlier books Boyarin extolled the "subaltern status" of the Jews. He has no quarrel with weakness. He regards it as an improving influence. And he thinks that Jewish culture in the exile was worth the risk. He rightly points out that the greatest accomplishments of Jewish civilization were created in the exile, beginning with the Babylonian Talmud and proceeding to the astonishing religious and cultural development of medieval Jewry. This correlation has been widely noted, and it certainly deserves to dampen classical Zionism's hostility to the Jewish experience in the exile; but Boyarin is promoting a correlation into a cause. George Steiner used to peddle a similar "extra-territoriality," the same insistence upon judging politics culturally; he demanded to know why no Kafka emerged from Israel. Of course no Kafka emerged from France, either. Boyarin, too, is a fanatic for culture at any cost. "Instead of Jewish pride — whatever that might mean, but I'm sure it's not good — I propose Jewish pleasure, Jewish joy," and he lists the cultural sources of his happiness, the "languages, practices, songs, holy days, literature, political comradeship (Black Lives Matter)." Heaven

318

forbid that his comradeship be misconstrued as steadfastness toward his own! He even includes among his Jewish joys "the joys of transgression," as if Jewishness should be admired for its own violation. These are "all the things that add up to my most outrageous coinage, *Jewissance*."

Quel Jew d'esprit! For all the morbidities of Jewish life, however, who, except maybe some mitnagdic extremists, is against pleasure and joy? And there is another problem with Boyarin's program of Jewish pleasures, as there is with mine: it is idiosyncratic, it cannot be "scaled." Our children must be taught more than our preferences, even our exquisite preferences, and our communities too. Since its beginnings but especially since the Hasidic revolution, Judaism has displayed a phenomenal talent for communal joy, but there is something about Boyarin's *jouissance* that, like all *jouissance*, is characteristic only of himself. As a program for a people, it is prescriptively useless. Meanwhile the voluptuary no-statist is serenely untroubled by the physical destiny of his brethren. For someone whose work has been so preoccupied with "the Jewish body" — there is not an academic fashion of the last forty years that Boyarin has not imported into Jewish studies — he is bizarrely indifferent to its corporeal fate. And he says so! "I categorically reject the nation-state solution to the continuity of Jewish existence in favor of a diasporic nation-alism that offers not the promise of Jewish security but rather the highly contingent possibility of an ethical collective existence."

Not the promise of Jewish security. The blitheness of the formulation is memorable. Is Jewish security really a trifling consideration? Who is Boyarin to consign his people to such a high level of risk, to a permanent dispensation of insecurity, so that he can delight in his four cubits? Rather like the haredim,

he is one of the righteous who count on others to come to their rescue when the going gets rough. Nowhere does Boyarin explain why "ethical collective existence" in a state is impossible, or why a state cannot do the right thing and make peace with its neighbors. (It is true that no states are perfectly good, but neither are any people. Not even on the left.) It is also worth adding that "ethical collective existence" is not easy to achieve even in associational frameworks that are not statist — in civil society and in everyday community. Boyarin simply cannot imagine that people who lack political power, stateless people, victims, may also commit crimes. In this, he is a man of his current. To exempt victims from accountability for their actions is another way of dehumanizing them, of expelling them from our moral universe; and it has been one of the singular failures of the left in our time not to grasp this.

But perhaps the worst failure of Boyarin's doctrinaire imagination is his refusal to engage with the most pressing question, not only for Israel and the Jews but also for many other countries and other peoples: the question of multiethnic democracy. He is hardly the only one devastated by his aporia. (One may suffer from an aporia and not know it.) Many observers in many societies have noted that the old European ideal of the nation-state, according to which every nation must fit tidily into a state and every state must exclusively incarnate a nation, so that the political boundaries and the cultural boundaries coincide, is increasingly inadequate and dangerous in a world of mass migrations and heterogeneous societies. There are no ethnic and cultural monoliths now, as if there ever were. There are only two possible solutions to the problem of pluralist realities and monist ideologies: fascism and a multiethnic definition of the political nation. (Some scholars have proposed the replacement of the concept of the

nation-state with the concept of the state-nation.) The contest between these alternatives is the central drama of many contemporary nation-states, including Israel.

Given the proven consequences of Jewish statelessness, and the proven threat to the Jewish state, Boyarin's anti-Zionism — like all the anti-Zionism of the Jewish left, like all Jewish anti-Zionism — represents a collapse of solidarity with his own people. So, too, does his lack of interest in anti-Semitism, except to reiterate the tired and increasingly false platitude that it is not to be confused with anti-Zionism. An anti-Zionist would indeed be at a loss before an explosion in anti-Semitism: after all, anti-Semitism looks awfully like a confirmation of Zionism's historical necessity. At *Jewish Currents* they mock "the anti-anti-Semitism machine." The left has the peculiar idea that the fight against anti-Semitism is somehow antithetical to the fight for the Palestinians. The left also has the peculiar idea that no fight in the world is more important than the fight for the Palestinians. I do not recall progressives marching for the Syrians or the Uyghurs, who have endured much harsher fates. I have been agitating all my adult life for justice for the Palestinians, because my conscience requires it of me and because my people will have no peace if their people have no peace. But what is it that now elevates their struggle above all the other struggles in this sickening world? Observing the progressive response to the black Sabbath of October 7, it is increasingly tempting to conclude that what distinguishes the Palestinians from the world's other victims, and entitles them to a greater parcel of the world's sympathy, is that the state with which they are in conflict is a Jewish one. If anti-Zionism is not

321

anti-Semitism, then why are so many anti-Zionist expressions anti-Semitic? How is the cause of Palestinian liberation furthered by a swastika painted on a synagogue or a firebomb thrown at it? Why do protests against Israel's policies include the vilification and harassment of Jews? The distinction between anti-Zionism and anti-Semitism has become almost completely casuistic — progressive *pilpul.* The overlap — on social media, in the streets, on the campuses — between anti-Zionism and anti-Semitism has become truly disgusting. After the foul response of the left to October 7, the burden of proof is now on the anti-Zionists. No amount of sympathy for Palestinians can justify this amount of antipathy to Jews.

On the morning after we beat the willow branches in the synagogue, we awoke to the news of the carnage in southern Israel. Decency demands only a natural response to the incineration of babies and the beheading of pensioners, and it is revulsion. It need not be eloquent or conform to a worldview. It need not know the identities of the victims. It need only be immediate; clear and immediate. What the left could not muster in the wake of the atrocity was precisely the clarity and the immediacy of natural revulsion. Instead its revulsion, when it came, was awkward and tactical, as when Alexandria Ocasio-Cortez told *Politico* that "it should not be hard to shut down hatred and antisemitism where we see it. That is a core tenet of solidarity." Before such horrors, tenets? She had to check the catechism and assure herself that she was not deviating from it. A simple recoil would have been fine. And yet, in $n + 1$, she was attacked for her concession to compassion. That same journal published, on October 11, at the beginning of a standard-issue anti-Israel piece, the following mental contortions. It is a clinical document of the political regimentation of the human heart. (I should disclose that in *The Nation* its

author wrote a devastating attack on this journal from which it is still trying to recover.) The progressive Jewish writer, his stereotypes suddenly compromised by the mass murder of Israelis by Palestinians, begins this way:

> I could start with the immediate victims of the incursion — the hundreds of Israeli civilians murdered by Hamas, the most Jews killed in a day since the Holocaust; revelers butchered at a music festival, whole families snuffed out in an instant; the young and the elderly alike violated, mutilated, kidnapped, and held hostage for a ransom that may never be paid. I could, and now I have, but why did I feel compelled to start there? Maybe because I'm a Jew, an American, a Westerner living under the protection of laws and a vast military apparatus that undergirds those laws, and it's only natural for me to identify first with people like me when violence is inflicted on them. Maybe it's a gesture of support for my Jewish relatives and friends who feel personally traumatized, and who insist on a brief window in which to grieve without having to consider any wider political context. Or maybe I want to acknowledge that based only on the confirmed facts, what took place on Saturday was gruesome on a level that dwarfs anything we've seen inflicted on Israeli civilians. In the current discursive climate, it seems mandatory to dwell on these horrors before I say anything else, to establish that I'm a decent human being who neither endorses nor averts my eyes from Hamas' depravities. I hope I've sufficiently established this, and at the same time I know I haven't, that acknowledgment isn't the solidarity many are demanding right now. Real solidarity would mean skipping over the next part.

Savagery and Solidarity

I almost pity the man, so mentally servile, so emotionally pinched, so monstrously unkind about the burned and the raped and the abducted. Perhaps he really was unmoved by the bloodletting and disinclined to seek a humane pause in his belief system. But then we do not live in an era of humane pauses. Now nothing precedes politics and nothing throws politics into crisis.

This deformation is especially advanced on the left. I cannot recommend too highly a piece in *Dissent*, published on October 13, by an American economic historian at the University of Chicago named Gabriel Winant, called "On Mourning and Statehood." It may be the most vicious thing I have ever read, and I drive these mean streets. The subject of the piece is "the power of the Israeli grief machine." The Israeli dead, you see, are shrewdly "pre-grieved," in order that "the state will do what it does with Jewish grief: transmute it into violence." Four days after the slaughter of Israeli civilians, Winant explained that Israeli sorrow is a strategy, a training for Israeli aggression. It is the alibi that allows Israel to "gear up its genocide machine," since "a genocide of Palestinians looks to be in the works." Does he comprehend the meaning of the term "genocide"? In this semantic sloppiness, of course, he is not alone. Where he distinguishes himself is in his heartlessness. Not everyone can spot the colonialist agenda of shiva. "It is not possible to publicly grieve an Israeli Jewish life lost to violence without tithing ideologically to the IDF." What? I see Arabs and Muslims doing precisely that, in stirring avowals of human solidarity. And, on the same universal grounds, it is possible to grieve an Arab Muslim life lost to violence without tithing ideologically to Hamas.

Indecency is a choice; a choice to harden. The mechanism of this hardening is the enslavement of one's being to one's politics. Winant continues: "How to grieve, what meaning to give those tears, is cruelly a political question whether we

324

like it or not." How twisted that is. Anyway, he seems to like it, because just as "the Zionist adventure" has political uses for Jewish mourning, so does he: "Imagine that every shiva might become an occasion to curse the state that has made Jews, of all people, into genocidaires." I have no idea if Winant is a Jew or if he has a shiva in his future. If he is, and if he does, I wish him a genuinely miserable one.

II

In the days immediately after the butchery, I was blinded by pain and anger. And, I confess, by hatred too: anyone who does not hate those who riddle babies with bullets do not grasp what they have done. The fury of my feelings owed something also to the fact that the murder of a Jewish baby figured prominently in my mother's experience at the hands of a notorious SS sadist in Poland during the war. I was, you might say, spectacularly triggered. Everything within me was hot. On October 7, Benjamin Netanyahu, who is ultimately responsible for this staggering Israeli defeat, posted this: "As Bialik wrote, 'Revenge for the blood of a little child has not yet been devised by Satan'. All of the places which Hamas is deployed, hiding and operating in that wicked city, we will turn them into rubble." It was the language of vengeance — "mighty vengeance," as he later said. I admit that I understood it.

The poem by Bialik, a poet of intimacy who was also a poet of wrath, was one of a number of ferocious poems that he composed in the wake of the pogrom that was perpetrated in Kishinev, in Russia, on April 19–20, 1903, an event that had an enormous impact upon Jewish culture and politics. "My heart is dead, I have no prayers left on my lips." Many commentators on the Hamas massacre have invoked the Kishinev pogrom as an analogy, so an important difference is worth noting. The

number of people who were murdered in 1903 was forty-nine. The number of people who were murdered in 2023 was twelve hundred. And there is another difference: this time the molested community can defend itself. It cannot be repeated often enough that self-defense is a high moral duty. The shirking of this duty, the preference for powerlessness and perfectly clean hands, bespeaks an infirm identity and a rank cowardice. One way to understand the emergence of Zionism and other nationalisms is as a doctrine of self-defense. Passivity had run its ruinous course. Hope may save souls, but no bodies were ever saved by it.

Of course, abuses and aggressions may be committed in the name of self-defense, but the respect for oneself that is the basis of the imperative of self-defense should be large enough also to confront one's misdeeds, and the misdeeds of one's group. One must make oneself worthy of respect in one's own eyes, too. Anyway, self-defense is warranted not only by inner realities but also, and mainly, by outer ones — by the presence of danger. All the imagined threats in the world do not vitiate the real ones. From the standpoint of safety, the recognition of enmity, especially of the racist and genocidal kind, is the first consideration. The question about the ethics of the means of self-defense should follow close behind.

Bialik's poem was called "On the Slaughter," which was a bitter allusion to the "blessing on the slaughter" that is recited by Jewish butchers when they kill a kosher animal according to the precepts of Jewish law. "Hangman! Here is a neck —/ arise and slaughter!/ Behead me like a dog, yours is the arm and the axe/ and the world is my scaffold—/ We, the few!/ My blood is permitted — smash the skull, release the blood in the murder/ of infants and elders/ which will stain you for all time, forever." I have my own history with the terrifying poem. In May 1970, the Popular Front for the Liberation of Palestin-

ian-General Command, a small and wantonly violent organization based in Damascus, attacked an Israeli school bus near the Lebanese border. Twelve people were killed, nine of them children. This was early in the era of Palestinian terror, and the event was completely shattering. In my Zionist yeshiva high school, classes were canceled and the entire student body was summoned to an assembly, to honor the dead and fortify the living. I was one of the students who spoke, and I chose to read Bialik's poem and to say a few words about it. I still recall the shudders with which I recited the verses. When I finished, I was approached by one of my teachers, a stern Israeli rabbi who had rebelled against his legendary father, one of the titans of haredi Judaism, by becoming a Zionist and an admirer of the Irgun and a soldier in the Israel Defense Forces. Rabbi Shach had tears in his eyes. He put his hands on my shoulders and said: "Promise me that you will always be this way." I felt as if I was being inducted into an army of Jewish anger.

Revenge is not a salient theme in the Jewish tradition, but it is more salient than many Jews imagine. It appears in the Book of Lamentations, and in various places in the prayerbook, and most familiarly in the Passover Haggadah, which includes a solemn moment, apparently medieval in origin, in which a short collection of verses imploring God to avenge us upon our enemies is read. There is a custom to pronounce these imprecations in a hushed tone; some people interpret the *sotto voce* as an appropriate discomfort with the virulence that they express, but I have always thought that the lowered voices originated in caution, lest they be overheard — another instance of Jewish insecurity. In recent decades, scholars have documented many expressions of Jewish rage that survive only in manuscripts, many of them written in the wake of particular persecutions. Here, one example out of many,

a published one, is Hillel ben Jacob of Bonn in 1171, on the massacre at Blois: "How long will You be an impotent warrior? Fight our fight and spill their blood/ O God of vengeance, appear!" Yet the rage was literary and spiritual, and intended only for the synagogue; Jews were too vulnerable to curse audibly, and they lacked the power to retaliate. The cost of retaliation would have been catastrophic. And so the persecutors had little to fear from the persecuted — except an alternative to their faith, which they feared rabidly.

Stirring instances of Jewish defiance of Christian symbols are recorded, as courageous as they were reckless, but this was all the resistance that was available to the dissenters, and almost always they died for it. As a modern scholar quietly observed almost a century ago, "It is clear that they were indiscreet, but one must remember that they had not yet learned the self-effacement which the subsequent centuries were to teach them." The Jews often called their post-Biblical oppressors Amalek, the archetypal enemy whom we must always remember and whom we have always not yet defeated, the foe that has haunted the Jewish imagination from its beginnings — all the way, for example, to 1996, when Mordecai Richler wrote in a memoir that "many of Amalek's descendants can no doubt now be found organizing for Hamas in the Palestinian camps of Khan Yunis, Rafa, Jabalia, and Gaza Town." The Biblical injunction to "erase the memory of Amalek" certainly looks like an incitement to murder, but it was honored solely in rhetoric and in symbolic action, such as inscribing the word "Amalek" on a stone and then erasing it. In a regular exercise of their craft, Jewish scribes tested their quills by writing "Amalek" and then crossing it out. Vengeance!

In the modern era, however, after large numbers of Jews repudiated the quietism that had characterized their

328

ancestors, Jewish avengers appeared. In November 1938, a young displaced Jew named Herschel Grynszpan, whose family had been deported from Germany along with many others who were wasting away at the Polish border, murdered a Nazi official in Paris "in the name of twelve thousand persecuted Jews"; the result was Kristallnacht, though Grynzspan's action was less the cause of the pogrom than the pretext for it. (Enlightened reader, here is John Rawls, a few years before he died: "How important is it that my life be saved had I the chance to assassinate Hitler, had I the chance? It's not important at all. I have thought a lot about those times and wondered whether I would have the courage and guts to do it. Certainly such acts are not easy. It seemed to me a grave fault in the German resistance that they were so much bothered by scruples against assassination, or against killing as such, or against attacking the head of state.") In Mandatory Palestine, the Irgun and the Stern Gang rejected the policy of "restraint" in the use of violence and killed innocent people for political reasons. In the years of the Holocaust, there were impassioned arguments for and against revenge in the Jewish community in Palestine.

In the aftermath of the Holocaust, there were a variety of Jewish groups that sought revenge, who, in the estimate of the fine historian Dina Porat, comprised about two hundred and fifty survivors in total, and were responsible for the deaths of a thousand to fifteen hundred people. The most renowned of these groups was founded by the poet Abba Kovner, one of the heroes of Jewish history for leading the Jewish underground in the Vilna Ghetto and then brigades of Jewish partisans in the forests nearby. *Nakam*, or Revenge, formulated horrific plans for indiscriminate mass poisonings that thankfully came to nought. (Many of its members later admitted that they were relieved to have failed.) In the early 1970s in New York, the Jewish Defense

League resorted to violence in the cause of Soviet Jewry and killed a woman who worked in the office of an impresario who represented Soviet musicians. Jewish settlers on the West Bank have committed terrorist acts against Palestinians, some of them grotesquely brutal, almost since they arrived in the territories, and most recently in their anti-Palestinian rampages during the war. And then there is the history of Israeli retaliation for Palestinian terrorism. Many more people died in Israel's retributions than in the crimes that provoked them. This was so also in the recent Israeli incursion into Gaza, in which ten thousand Palestinians were killed in a month for one thousand two hundred Israelis who were killed in a day. Asymmetrical warfare presents a dire challenge to just war theory. But if this disproportion is in part strategic, so as to "re-establish deterrence," it must be said that deterrence has never been re-established for long.

So meekness is no longer the Jewish problem. But neither, really, is vengefulness. Alongside the history of Jewish wrath there is the history of Jewish circumspection, and usually it has carried the day. Here is a remarkable example. On July 30, 1945, Haim Ben-Asher, later a member of Knesset from Mapai, the democratic socialist workers' party, wrote a letter to his wife from Kaiserslautern in southwest Germany. Ben-Asher was serving in the Jewish Brigade, a military unit of Jewish soldiers from the *yishuv* who wished to fight alongside the British in Europe. When the Brigade crossed into Germany, Ben-Asher was shaken to find himself on its soil, and sent his wife an account of his thoughts.

> No revenge will satisfy us. It is not for us to fulfill the mythic command to avenge ourselves on Amalek, because 'the Lord is at war with Amalek from generation to generation' [Exodus 17:16]. Revenge for the blood of a little child, has

not yet been devised by Satan: this was Bialik's prophecy, but he knew nothing of what was to come. The mythic responsibility, the collective responsibility, of Amalek and all its descendants — as a practical matter the ascription of such a collective responsibility gives me no rest. Are we to kill babies to punish the entirety of Hitler's nation, which condemned our babies to the gas and the fire? It is not easy to be a humanist. But is this not a weakening of the desire to avenge a million children, the descendants of Abraham? What would the British and the Americans do if a million of their children had been condemned to such a fate? A child for a child — is this a commandment or a barbaric need? For me this is a question for my own conscience, whether in action or inaction. And in truth I don't know where the truth lies. Since it very difficult for a man who was raised on the principles of the sanctity of life and personal account-ability for one's actions and opposition to the death penalty and the redemption of the holy spilled blood in Bialik's poem by means of an abundant love — it is very hard for such a man to consider the commandment to seek a redemption in blood, particularly in the blood of children, and so I have no certain standpoint or criterion in my heart with which to arrive at a determination of conscience.

"It is not easy to be a humanist," said a Jew with a gun in Germany in 1945. That may be the most poignant utterance in the history of Western humanism.

In a magical moment of the sort that only multiethnic democracies can deliver, Ayman Odeh, an Israeli Arab politi-cian and a member of Knesset, pointed out on October 19 that in the heat of the moment Benjamin Netanyahu had misread Bialik's poem. (As had I and my teacher in 1970.) Standing alone,

Savagery and Solidarity

the poet's famous line — "revenge for the blood of a little child has not yet been devised by Satan" — gives an impression of bloodlust. It took Odeh to point out that the poet is not calling for revenge, but despairing of any adequate response to radical evil. The poem's theme is the futility of revenge.

> In his declaration of war on Gaza on Oct. 7, Prime Minister Benjamin Netanyahu of Israel quoted a line from a poem by the Jewish writer Chaim Nachman Bialik. Revenge for the blood of a little child has yet been devised by Satan," Mr. Netanyahu posted on social media. Perhaps the prime minister forgot what Bialik wrote just one line before that: "And cursed be he who cries out: Revenge!" Or the next lines: "Let the blood fill the abyss!/let it pierce the blackest depths." These days I find myself asking what the poet meant by this. Bialik wrote it after learning of the horrors of the 1903 Kishinev pogrom.

An Arab politician wondering what a Hebrew poem can tell him about a pogrom committed by Palestinians against Israelis. All is not lost.

III

In circumstances of loss and defeat, honor seems to demands anger, but acting on anger may bring dishonor. Wrestling with anger is one of the inevitabilities of sorrow. It is wise to assent to sorrow, but it is not wise to assent to anger. On October 7, calm, and a knowing aversion to zeal of any kind, would have been the mark of a deficiency in love. Hysteria seemed more like the proof of a loyal heart. Yet the instabilities of mourning cannot provide sufficient guidance for the days after the destruction,

especially when the mourner has the power to destroy. Indeed, in the Jewish tradition the mourner is regarded as a temporarily marginal figure, almost as a pariah, because the blow that he has sustained exempts him from full and responsible participation in society. He is too hurt to focus. His mind is dimmed by his anguish. He awaits the restoration of stability. But the world will sometimes not allow mourners the time that they deserve, and they must return to their duties wounded, and before they are healed. Such a situation demands enormous psychological exertions, a moral maturity quickly improvised and regularly tested, as in sending a mourning army to war.

In the weeks after the atrocity, when the size of the planned Israeli retribution was becoming clear, I tried as hard as I could to persuade myself that an Israeli invasion of Gaza would be a mistake. Already the loss of Palestinian life from the Israeli air campaign was horrendous. In my thinking about the calamity, I did whatever I could to keep my head; I resolved to look at the videos of the scorched and bloodied Israeli communities only once. How I wished, when I saw the images, that I could acquiesce to my darkest impulses! But really I did not wish it at all, because there remained the living. It struck me that reason is never more necessary than when it is least likely. As a consequence of the lives that were just taken — this was a part of Hamas' depraved plan — more lives were about to be taken, Palestinian and Israeli, and one had to think clearly. The moral stakes were too high to make do with emotional satisfaction.

And so, as I say, I tried to persuade myself that a lighter Israeli response would be the better course. I failed. I do not see how Israel, or any state, can agree to live alongside an organization — no, it is more than an organization, it is a failed undeclared state with a totalitarian government and a powerful regional patron and a violent racist ideology and a

333

vast and ingenious capability for terror — such as Hamas. Like all of Israel's friends, I agree that Hamas must be destroyed. Yet something about that formulation disturbs me. The destruction of Hamas would come at a terrible ethical cost, which all the ethicists who consult to the Israeli army cannot forestall. It is true that Hamas, when it kills civilians, targets them, and Israel, when it kills civilians, does not target them; but civilians are nonetheless killed, and in atrocious numbers. And in fact the moral calculus is even more excruciating: Israel most certainly does target civilians, in order to strike at the villains behind — or more precisely, beneath — them. Does shooting through someone not count as shooting at someone? Is self-defense a license for self-delusion?

Peruqa le'sakanta?! Or, are you serious?! Stop arguing about the danger and eliminate it! That incredulous intervention occurs in the Talmud in a technical discussion of wine — sorry, this is my custom. An ancient rabbi insisted that his colleagues were overthinking a danger. But it is precisely in the face of danger that such impatience is, well, dangerous. Hesitation is not always born of indecision, and "getting on with it" can be stupid. There are better and worse ways, more effective and less effective ways, more costly and less costly ways, more justifiable and less justifiable ways, to meet a threat. Strictly speaking, the blame for all this violence falls on Hamas, because if October 7 had been a quiet Sabbath all of the dead, Israeli and Palestinian, would now be alive. There is no "context" that can absolve Hamas of this culpability. It started this war. But that does not mean that any Israeli target list will do. Strategy is made by choosing between options, in both means and ends, and strategic choices must have valid reasons. The culpability of one's enemy is a historical consideration, not a strategic one, and it does not bear upon the moral analysis of war-fighting.

What makes a war just is not only its cause but also its conduct.

There was something else that troubled me about certifying the destruction of Hamas as the objective of the war — not a moral or a strategic scruple, but a practical one. I am not a military man, but I do not see how it can be done. Those infernal tunnels are sixty-five feet under large portions of Gaza, and may be the most formidable obstacle that the Israeli army has ever faced; and as I write there are almost certainly hundreds of hostages in them. How did the Israelis allow an underground city to be built? If the intention is to destroy the tunnels from the air, then the ordnance required for the task is a promise of war crimes. And if from the ground, it will take an occupation. Moreover, Hamas does not exist solely because of the patronage of Iran. It exists as a consequence of something that Israelis of almost all political persuasions have increasingly refused to face for many decades: the Palestinian problem, about which more presently. Hamas is the degenerate face of the Palestinian problem. (And the problem — I hasten to add, since in the first month of the war there were alarming fantasies of moving a million Gazans into Sinai, as if it was for their own good and they would have ever been allowed back — is not that the Palestinians dwell there, two million in Gaza and three million in the West Bank, but that they are politically disenfranchised.)

It is foolish, it invites trouble, to announce a goal that you may not be able to accomplish. Perhaps it would be smarter to seek only the punishment, the crippling, and the deterrence of Hamas, though the latter aim has suddenly become more challenging than anyone, including Israeli planners, ever imagined. I recall ruefully all those decades of calling for the destruction of the PLO, which committed many terrorist atrocities. The hard truth — hard for a state that has amassed

335

enormous military force to protect its people against strong and determined enemies who do not give a damn about Grotius — is that there is no military solution.

Threat assessment is where collective memory and empirical analysis meet. That is its difficulty, certainly in the Jewish case. The mental modes do not go comfortably together. They are, indeed, antithetical to one another. Collective memory is supremely unempirical, even though it usually has a distant basis in events. It is an editing of the past to conform to certain needs of the present. It does not treat history factually but symbolically, for the sake of the edification, or the vicarious living, or the belonging, that it can provide. Everything that is "remembered" in collective memory is less complicated than it actually was. But the force of collective memory is astounding: it is perhaps the primary instrument of coherence for a community. What was particularly wrenching about October 7 was how immediately, and how plausibly, it found a place in the collective memory of Jewish adversity: it was not without precedent. It obviously belongs on the dark and hallowed roster of our catastrophic precedents. (But it was not Auschwitz or Bergen-Belsen, and it should be beneath the dignity of a Jew to pin a yellow star on himself.)

For threat assessment, by contrast, every detail matters. The criterion of inclusion is wider, the principle of selection is broader. Every particular is relevant. Concreteness and specificity are the holy grail of the information that it seeks. The collection and evaluation of intelligence has its own epistemological protocols, and they include a ruthless hunt for biases, for assumptions and sentiments that get in the way of clarity. Collective memory must be counted among those intellectual impediments. Whatever the merit of "the lachrymose view of Jewish history," which in the aftermath

of the Hamas pogrom has become more popular in the Jewish community, it avails us nothing for an accurate understanding of a present situation. Strategists must be strangers to philosophies of history. Excitability is the wrong preparation for planning. We must operate in the weeds, and the weeds have no use for the clouds, even if we prefer to live in the clouds. (I certainly do.)

Last winter I travelled to Israel because I wanted to march with my friends against Benjamin Netanyahu's authoritarian program, and against the debasement of the state by its government of thugs and bigots. Those Saturday nights in the crowd outside the President's House in Jerusalem were exhilarating: I had never before witnessed a mass mobilization for liberalism. Liberals are usually too measured and too refined to turn up in the streets, but there they were, in large numbers, undaunted by the rain, carrying the national flag like democracy's flag, concluding every demonstration with the singing of the national anthem as if daring the other side to match them in their national feeling. Sooner or later every society must fight over its identity, because too many people want too many things that do not go together, and social peace is attainable only on the other side of conflict. The politics of first principles are volatile. The protests in Jerusalem and Tel Aviv and elsewhere represented such a struggle over first principles, rightly provoked by the prime minister's self-interested decision to break the philosophical compact between Israeli liberals and Israeli conservatives that underwrote political contention in Israel for all the years of its existence, and instead ignite the lowest and ugliest energies in Israeli life and invite them to rule. Before he was the man responsible for the

337

worst failure of security in Israeli history, Netanyahu was the man responsible for moving Israel into the company of the countries in which ethno-nationalism and intolerance was usurping liberal democracy as the public philosophy of the state. He is a curse on his country, a curse with a base. The protests are a popular attempt, even a populist attempt, to roll back the curse, and one of Zionism's finest hours.

But something was missing. I noticed its absence almost immediately. There was no mention of the Palestinians. I had heard that in Tel Aviv some people brought Palestinian flags to the demonstrations and they were harshly received. In Jerusalem, on the nights when I was present, a small group of young people with Palestinian flags stood apart from the crowd at the top of Palmach Street, because they were not welcome. In the most divisive period in the history of Israel, there has been a national consensus on one point: that there is no point in talking about or with the Palestinians. "There is no partner." The subject of the Palestinians has vanished from the discourse of the Israeli center and from a lot of the Israeli left; it is never discussed by Yair Lapid or Benny Gantz, because it would be impolitic. Whatever their consciences tell them about the Palestinian issue, their pollsters tell them that there is nothing in it for them.

The political reality of the indifference to the Palestinians is owed to an understandable exasperation, half a century old, about ever finding a solution. One of the many causes of the collapse of the Israeli left is that the Palestinians held a veto over their political fortunes, and they falsified and embarrassed the hopes of the doves. There is no partner. Oslo failed. Mahmoud Abbas is in the eighteenth year of his four-year term. And life must go on. The sizzle of the "start-up nation" is preferable to the grind of the conflict, even if no algorithm will ever solve the

most pressing problem that Israel faces. And meanwhile the Israeli right forgets nothing, and keeps the Palestinians in the forefront of its mind, in hostile and hateful ways. The settlers and the vigilantes and the annexationists have the field to themselves.

October 7 delivered a terrible blow to the Israeli sense of reality. The failure of the military and intelligence apparatus — three thousand Hamas terrorists on undefended Israeli territory! — will undoubtedly be examined by commissions of inquiry, even though the hollow man in the prime minister's chair will do everything he can to frustrate such an examination; but there is a larger historical conclusion that may not emerge from any official inquiry. It is that *mehdal 23*, or the debacle of 2023, was an ineluctable result of the decades of growing Israeli indifference to the misery of the Palestinians. There were Israelis and Zionists and friends of Israel who had warned of the perils of postponing the reckoning with Palestinian rights and Palestinian realities, who had implored the leaders and the citizens of the Jewish state to wake up to the future that lies in store for them if they fail to engage and to reconcile with the five million Palestinians with whom they live.

It is also true that the Palestinian leadership never covered itself in glory in the matter of peace. Its tragic pattern of maximalism and prevarication was apparent at the very beginning of what used to be called the peace process: if, in 1978, Yasser Arafat had accepted Menachem Begin's ideologically insulting offer of five years of Palestinian autonomy followed by statehood, a Palestinian flag would have been raised over the State of Palestine in 1983. (The real State of Palestine, not the phony one to which the United Nations bizarrely refers.) The suffering of the Palestinians has never induced them to suffer also the pains of compromise. Like the

339

Jews once were, before they fought an internecine war over partition and the acceptance of what was possible, the Palestinians are the prisoners of a dream, a tenacious and deadly dream in which the Israelis, too, are trapped.

The idealization of the Palestinians — aren't kheffiyehs cool? — is not a contribution to progress. But I hardly mean to suggest that the State of Israel in recent decades has been in hot pursuit of a peace. Not at all. While the Palestinian Authority balked and balked, the Netanyahu governments harbored deadly dreams of their own. In collaboration with the pathetic Abbas, Netanyahu did whatever he could to discredit and destroy Salam Fayyad, the Palestinian leader for whom all well-meaning people had prayed: a good and sensible man, a builder of institutions, a man without hatred. In a culture of ideological extremism, the technocrat is the real revolutionary. (I remember a meeting in Ramallah in which the extraordinary Stanley Fisher, then the governor of the Bank of Israel, was conferring with Salam Fayyad on the Palestinian Authority's annual budget. A glimpse of the end of days.)

But mainly the Israeli policy on the Palestinians has been to settle the West Bank and to do whatever it could to protect the settlements. It would be hard to exaggerate the grip of the settlements over Israeli politics and over the priorities of Israeli governments. The structure of Israeli politics, which awards large power to small parties, has enabled the settlers to determine the composition of governments, and they have been fetishized by the Israeli right. You would think they are Trumpeldor. The consequent distortions abound: on the morning of October 7, for example, seventy percent of Israel's troops in uniform were on the West Bank to protect the settlers. Whole families hid in bomb shelters armed with kitchen knives as they waited to be saved by soldiers who

were on the other side of the country doing more important service. For decades Israeli national budgets have reflected a similar distortion, in which colossal sums of money have been appropriated for the small numbers of Israelis, heroes in their own eyes and always aggrieved, who have chosen to live in occupied territory and do as they wish. They wag the dog, and wag it, and wag it. It is a long tale of madness, in which the interests of the state are nowhere to be found. This, too, was exposed by October 7: the perverse strategic concept of Netanyahu's Palestinian policy was to strengthen Hamas at the expense of the Palestinian Authority, because the Palestinian Authority governs the West Bank and might complicate life for the settlements, and it enjoys international recognition and diplomatic support. It also recognizes Israel, in blatant contradiction to Netanyahu's diabolization of the Palestinians. Hamas, by contrast, is merely a well-armed theocratic dictatorship consecrated to the annihilation of Jews — and, after all, there was a fence.

Never before has the need for wisdom in Israel-Palestine been greater and never before have the prospects for wisdom been more meager. Some of the suppositions that were shattered on October 7 should stay shattered. Aside from a thorough renovation of the foundations of Israel's security, nothing more constructive can emerge from the ashes of those kibbutzim than a new readiness to confront the Israeli-Palestinian question. If the Palestinian leadership shows no sign of a similar readiness, then Israelis should go above and around it to the Palestinian people, and create civil ties that will prepare the ground for an eventual negotiation in good faith; and if the Palestinian leadership shows even the slightest sign of a similar readiness, Israel should pursue the opening as if its life depends on it. The nasty little game of withholding Palestin-

ians' tax revenues should end, and so should the systematic humiliation of them, and more generally the entire long era of pusillanimity toward them. The Palestinian population must be weary of this conflict; they have their own bourgeois dreams. Five million people are not barbaric Judeophobes pining for martyrdom.

The military might of the Jewish state exists not only to win and deter wars, but also to underwrite a search for peace. The settlers' point of view must once and for all be distinguished from the state's point of view; but such a correction of perspective will involve a postwar reconstruction of Israeli politics and — here is where the spirit always sinks — political courage. Israel is right to insist that Palestinian behavior matters as much for a resolution of the conflict as Israeli behavior, but the time is past when pointing the finger at Ramallah counts as a serious policy.

Not even the messianic age will be an age without vigilance. Enmity is an ineradicable attribute of human affairs. Certainty will turn ugly when it tastes power. Difference will never be a natural source of comity. Ideals will disappoint, and nourish, and disappoint, and nourish. And war — does it bring wisdom? Alas, not often. Yet the Jewish tradition has some encouraging things to say about the relationship between grief and generosity, about the ethical benefits of broken hearts. It expects mourners to be improved by their mourning, to return to the world to do good. The world has need of them, even if it is not worthy of them. There is no other place where good can be done.

343

CONTRIBUTORS

CARISSA VELIZ is an Associate Professor at the Faculty of Philosophy and the Institute for Ethics in AI, as well as a Tutorial Fellow at Hertford College, at the University of Oxford. She is the author of *Privacy is Power: Why and How You Should Take Back Control of Your Data.*

RYAN RUBY is a writer living in Berlin. He is the author of *The Zero and The One,* a novel.

MICHAEL WALZER is professor emeritus at the Institute for Advanced Study in Princeton and the author most recently of *The Struggle for a Decent Politics: On "Liberal" as an Adjective.*

REUEL MARC GERECHT, a former Iranian-targets officer in the Central Intelligence Agency, is a resident scholar at the Foundation for Defense of Democracies.

A. E. STALLINGS is an American poet and translator living in Athens. She has been appointed Oxford Professor of Poetry.

DAVID A. BELL is the Sidney and Ruth Lapidus Professor in the Era of North Atlantic Revolutions and Director of the Shelby Cullom Davis Center at Princeton University. He is the author most recently of *Men on Horseback: The Power of Charisma in The Age of Revolution.*

ADAM KIRSCH is an American poet and literary critic and the author, among other books, of *The Revolt Against Humanity: Imagining a Future Without Us.*

EMILY OGDEN is a professor of English at the University of Virginia and the author of *On Not Knowing: How To Love and Other Essays*

STEPHEN DARWALL is a professor of philosophy at Yale University. His most recent book is *Modern Moral Philosophy: From Grotius to Kant.*

KIAN TAJBAKHSH is an Iranian-American scholar, social scientist, and urban planner.

ANGE MLINKO teaches English and Creative Writing at the University of Florida. Her most recent collection of poems is *Venice.*

WENDY GAN is a fellow at Radcliffe-Harvard Yenching Institue and a professor in the School of English at the University of Hong Kong.

JENNIE LIGHTWEIS-GOFF is a professor of English at the University of Mississippi and is the author of *Captive Cities: Urban Slavery in Four Movements.*

JOHN SUMMERS is a writer, historian, and the editor of *Lingua Franca Media. Inc.*

HELEN VENDLER is the A Kingsley Porter University Professor Emerita at Harvard University.

CELESTE MARCUS is the managing editor of *Liberties.*

LEON WIESELTIER is the editor of *Liberties.*

Liberties — A Journal of Culture and Politics is available by annual subscription and by individual purchase from bookstores and online booksellers.

Annual subscriptions provide a discount from the individual cover price and include complete digital access to current and previous issues along with the printed version. Subscriptions can be ordered from libertiesjournal.com. Professional discounts for active military; faculty, students, and education administrators; government employees; those working in the not-for-profit sector. Gift subscriptions are also available at libertiesjournal.com.

———————

As a matter of principle, *Liberties Journal* does not accept advertising or other funding sources that might influence our independence.

We look to our readers and those individuals and institutions that believe in our mission for contributions — large and small — to support this not-for-profit publication.

If you are interested in making a donation to *Liberties*, please contact Bill Reichblum, publisher, by email at bill@libertiesjournal.com or by phone: 2 0 2 – 8 9 1 – 7 1 5 9 .

Liberties — A Journal of Culture and Politics is distributed to booksellers in the United States by Publishers Group West; in Canada by Publishers Group Canada; and internationally by Ingram Publisher Services International.

LIBERTIES, LIBERTIES: A JOURNAL OF CULTURE AND POLITICS, is published quarterly in Fall, Winter, Spring, and Summer by Liberties Journal Foundation.

ISBN ISBN 979-8-9854302-3-3
ISSN 2692-3904

Copyright 2024 by Liberties Journal Foundation

Printed in Canada.

The insignia that appears throughout *Liberties* is derived from details in Botticelli's drawings for Dante's *Divine Comedy*, which were executed between 1480 and 1495.